CULTURAL INTERACTIONS
Studies in the Relationship between the Arts

Edited by J.B. Bullen

Volume 11

PETER LANG
Oxford · Bern · Berlin · Bruxelles · Frankfurt am Main · New York · Wien

Edited by Gillian Pye
with the assistance of Simone Schroth

Trash Culture

Objects and Obsolescence
in Cultural Perspective

PETER LANG

Oxford · Bern · Berlin · Bruxelles · Frankfurt am Main · New York · Wien

Bibliographic information published by Die Deutsche Nationalbibliothek.
Die Deutsche Nationalbibliothek lists this publication in the Deutsche
Nationalbibliografie; detailed bibliographic data is available on the
Internet at http://dnb.d-nb.de.

A catalogue record for this book is available from the British Library.

Library of Congress Cataloging-in-Publication Data:

Trash culture : objects and obsolescence in cultural perspective /
[edited by] Gillian Pye.
 p. cm. -- (Cultural interactions: studies in the relationship
between the arts ; v. 11)
 Includes bibliographical references and index.
 ISBN 978-3-03911-553-2 (alk. paper)
 1. Refuse and refuse disposal--Social aspects. 2. Recycling (Waste,
etc.)--Social aspects. 3. Material culture. I. Pye, Gillian.

 HD4482.T73 2010
 363.72'8--dc22

 2010011396

ISSN 1662-0364
ISBN 978-3-03911-553-2

Cover image: Fragments of memory in 'The Boneyard', Las Vegas, 2007.
Photograph courtesy of the Neon Museum.

© Peter Lang AG, International Academic Publishers, Bern 2010
Hochfeldstrasse 32, CH-3012 Bern, Switzerland
info@peterlang.com, www.peterlang.com, www.peterlang.net

Printed in Germany

Contents

Acknowledgements

The chapters in this book are based on a selection of papers given at an international conference held at University College Dublin on 4–6 September 2008, co-organised by Gillian Pye and Simone Schroth (University College Dublin, School of Languages and Literatures). We would like to thank all those who participated in the conference and supported its organisation. Particular thanks go to Siobhán Donovan, Anne Fuchs, Michael Märlein, Graham Ovenden, Jean-Michel Picard, Alison Ribeiro de Menezes, Jeremy Rigby and Douglas Smith. We also gratefully acknowledge the receipt of UCD Seed Funding, without which this project would not have been possible.

Illustrations

GILLIAN PYE

Introduction: Trash as Cultural Category

Context

Throughout history, the practice of waste management and disposal has been central to the organisation and structure of human societies. However, the rapid development of industrialisation and consumer culture, particularly as they gain in intensity in the late nineteenth and twentieth centuries, gives rise to an increased preoccupation with waste, trash and the obsolete (see Strasser 1999). The phenomenon of waste comes clearly into focus not merely as a by-product of manufacturing processes, but rather as an integral element in cycles of production and consumption. Alongside the ideals of industrial society, according to which the 'minimising of waste in the interest of efficiency is regarded as evidence of an effective economy: industrial, moral and psychic', dawns a heightened awareness that 'being wasteful in the ways we live is encouraged, expected and in many instances impossible to avoid' (Hawkins 2006: x). In the late twentieth century, in the context of increasing environmental awareness, this consciousness has altered yet again, and waste has 'been revalued and recoded from rubbish to recyclable resource, it has moved from the bin to the compost heap, it has insinuated itself into our lives in different ways and with different effects' (Hawkins 2006: 5).

It is hardly surprising then that over the last decades much attention has been devoted to the sociological and anthropological study of our relationship to waste. In her seminal study *Purity and Danger* (1966), Mary Douglas illuminated the centrality of waste practices in the construction and maintenance of social relationships, while Michael Thompson's 1979 study *Rubbish Theory* elaborated an understanding of rubbish as part of a flexible and shifting system of value construction, underlying notions of

innovation, creativity and social status. At the heart of studies in material culture in the last decades of the twentieth century the work of archaeologists such as William Rathje and Cullen Murphy has offered significant insights into the relationship between archaeological artefacts and garbage, exploring the function of trash as a resource for understanding cultural and social practice. At the same time, thinkers such as Zygmunt Bauman and Giorgio Agamben have shed light on the fate of the human being as a wasted or discarded element in discourses of socio-political hygiene.

In the context of a 'revaluing' and 'recoding' of trash, this book aims to offer a timely insight into its significance for representations of social, personal and cultural identity. In particular, it focuses on the ways in which our relationship to trash have influenced, and are also influenced by, cultural products such as films, visual art, museum exhibits and literature. The individual chapters in this volume therefore build not only on scholarship in cultural theory, sociology and anthropology which suggests how social and personal experience is embedded in material culture, but also on an awareness of the significance of trash as an aesthetic resource, not only since the beginning of the twentieth century, but also in earlier times. In so doing they aim to offer another perspective on a category, which, as Hawkins observes, has come to be dominated by the environmentalist movement (2006: 7).

Emerging from theories of trash in the twentieth century are two main strands of thought which, intertwined as they are, manifest themselves in various constellations throughout the essays in this volume. The first is the significance of the obsolete, outmoded and discarded as carriers of memory. In his reflections on the potency of objects against the backdrop of burgeoning consumer capitalism, Walter Benjamin described the 'immense force of "atmosphere"' contained in the outmoded, revealing 'revolutionary energies' emanating from the past (Benjamin 1999: 210). Benjamin's notion of the value of the rags and scraps of society as evidence of another, alternative, history, lies at the heart of debates about the place of material things in our understanding of time, and the relationship between memory and forgetting. In an age of post-memory (Hirsch 1997), characterised by ever-increasing consumption, both of material goods and information, the role played by things in remembering – and forgetting – takes on increased

significance. This reflects a shift in attitudes towards material culture in the late twentieth century and a renewed engagement with the complex relationships between subjects and objects which, no longer seen as antagonists in the formation of identities, give way to the concept of networks of interrelationships between humans and non-humans. Outlining the potential of things as memory banks, Bruno Latour observes that '[E]ven in our grandmother's attics, in the flea market, in town dumps, in scrap heaps, in rusted factories, in the Smithsonian Institution, objects still appear quite full of use, of memories, of instructions' (Latour in Graves-Brown 2000: 10). One of the concerns of this volume is to consider what role the outmoded or obsolete object may assume in this context. We ask what role trash might play in the representation of memory and forgetting, functioning as it does as the point of intersection between institutionalised and private memory, between the forgotten and retained, visible and invisible.

The second broad area of concern emerging from key debates relates to the question of trash as an integral factor in the construction of value systems. Building on historical materialist conceptions of the construction of social values, and also on structuralist notions of order and hierarchy as well as on more recent developments in material culture studies which reflect the role of material things in the development of ideological and social value systems, the wide-ranging works of Georges Bataille, Mary Douglas, Michael Thompson, Jean Baudrillard, Boris Groys and Bruno Latour, to name but a few, have shown that concepts of value do not simply derive from our binary relationship to that which we discard, but that the profane realm of waste actually offers an important source of potential value itself. Just as Benjamin's conception of the 'immense force' of the obsolete is unthinkable without a Freudian understanding of repression, this notion of value, too, hinges on an awareness of a psychic economy (see for example Freud 1957). The idea of the 'invisible', transitory realm of rubbish seems even more pertinent at a time of apparently unprecedented crisis in capitalism when notions of value have become increasingly virtual and globalised, often reaching proportions that are no longer readily intelligible to the layperson. The essays in this book ask how representations of the defunct and discarded may be employed as a means of critiquing or exploring the construction of value systems.

Trash as Cultural Category

The discarded and the outmoded have a longstanding function as a means of rehearsing the fundamental questions that frame human life, questions of a theological, philosophical and psychoanalytic nature encompassing themes of knowledge, vanitas and redemption. If the Baroque memento mori signals to man that he is as transitory as the man-made thing which has no value beyond the human world, then in the twentieth and twenty-first centuries our relationship to things intensifies, coming to underpin our uncertain and ambivalent origins. Psychoanalytically, this means a notion of origin which relies partly on the marking of difference from other identified objects – objects for which our desires might necessarily be wasted and recycled in an economy of repression and sublimation. Philosophically and sociologically, the turn away from theological models of ontology means an increasing reliance on our knowledge and experience of a material world, thus shifting – and even levelling – hierarchical relationships between humans and non-humans (see Latour 1993).

This complex investment in the material thing and the concern with the question of durability is played out in the aesthetic realm with particular intensity in the twentieth century, but has its modern origins at least as early as the eighteenth century. The ancient ruin as a portal linking past and future civilisations; the craft object as authentic connection to pre-industrial heritage; the modernist design object as the acme of apparently ahistorical functionality; the current preoccupation with sustainability and recycling – these are some of the guises in which material things, their origins, form and function, have appeared as part of wider efforts to address the question of rupture and continuity in the industrial world (see Lindner 2003, Mao 1998 and Outka 2009 on commodity culture and aesthetics). This intense preoccupation with the relationship between the thing, its origin and its function is part of a broad attempt to negotiate the underlying anxiety concerning the fate of the human being in industrialised society. In particular, thinking through the role of the craftsman or artist and the relationship between discarding and creating has constituted a means of approaching the constant, though ever-shifting and -changing, anxiety in

the face of the threatened obsolescence of human beings as productive and creative entities.

At least since the early twentieth century, the concern with discarded things and materials has been a recurring theme in art. Duchamp's famous urinal exhibit *Fountain* (1917) or Kurt Schwitters's *Merz* collages, for example, point to the discarded as an aesthetic resource which derives its potency from the apparent otherness of obsolete things. Such experiments with waste draw on the aura of the thing as a carrier of memory and forgetting, its potential as a 'trace' of existence possibly otherwise unrepresentable. Having resisted the 'tooth of time' ['Zahn der Zeit'] (Assmann 1999: 383), having continued to exist despite having outlived its functional life, the discarded thing appears to make the past, or at least the potential past, visible in the present. At the same time however, it also denies access to that past precisely because it has lost its function and value: it connotes absence, forgetting and loss and gives expression to melancholy (Assmann: 383–413). The obsolete thing draws its potency precisely from its ability to harbour a dual perspective on the past. As Peter Fritzsche shows in his discussion of the changing attitude towards ruins in Europe in the wake of the French revolution, the significance of the broken and dilapidated building shifts from an aesthetic view of the ruin and a concomitant melancholy recognition of 'the power of nature and the subordination of all worldly things to the cycle of death and birth, degeneration and regeneration' to a historical view of the ruin as 'evidence for abrupt endings and new beginnings, for rupture' (Fritzsche 2004: 99). My argument here is that the potential of the obsolete or discarded lies precisely in its ability to invoke the potential of both of these aspects simultaneously. On the one hand, the obsolete thing invites an ahistorical, aesthetic perspective and suggests the idea of cyclical processes (whether natural or economic). In this aspect it allows for the identification of self-sameness and the projection of private histories, invoking melancholy. On the other hand, the presence of the discarded also draws attention in the other direction, towards the historical. Even if its origins are unknown, the discarded thing is acknowledged as as having been torn from some specific time and place, as holding a specific biography, the knowledge of which might unlock an understanding of an-other existence.

The potential of the discarded thing also relies on its status as a thing approaching a 'zero point' of value. In other words, it has reached a point in transition between the world of the functioning, the useful and visible, and the realm of the invisible, the non-functioning and empty. As Michael Thompson's *Rubbish Theory* suggests, at its nadir in a cycle of consumption and production, rubbish is both ready for disappearance and yet ripe for reinvestment, reinterpretation or revaluing. Furthermore, in this transitional state, operating apparently outside the world of the useful, functioning or valued, the discarded thing may appear as autonomous, existing in and for itself. Moreover: whilst systems of order and classification depend precisely upon practices of disposal and discarding, when a mixture of wasted things of many different types and states of decay or disrepair become visible, this can begin to undermine categories of order and classification, becoming in the process threatening or even subversive. By suggesting possible combinations and mergers not foreseen by human design, by crossing the boundaries of classification, such things may appear dangerously unstable, perhaps threatening contamination and contagion, evoking the powerful emotion of disgust. This is true both in a literal and in an abstract sense, revealing the moral and political dimensions of waste. Today, our focus on separating, sorting and recycling and the environmentalist mantra of sustainability is a precarious moral highground below which lie far-reaching anxieties about the boundaries between individual and collective identities and the impact of consumption practices, both in an environmental and existential sense. More than ever, we are aware that although the wasted may be pushed to the periphery of our vision, it may nevertheless return to 'cut our feet' ['unsere Füße [...] zerschneiden'] (Flusser 2003: 22).

At the same time, however, the apparently radical independence of wasted things is tempered by an awareness that trash may also serve to reveal the opposite aspect of material things: that their existence is entirely dependent on us, that they are in a sense, 'without power of resistance to man' (Marx 1996: 94). This dependency manifests itself particularly in processes of waste disposal and, for Barry Allen, is epitomised by the trash of high consumer capitalism – such as food packaging for example – which is design-intensive, rendered quickly obsolete but yet is often difficult to dispose of (Allen in Knechtel 2007: 198). For Allen this marks the 'limits

of our ingenuity' (206). This has, of course, been interpreted by environmentalists as the key to our moral fall from grace – our failure to match the powers of our invention in creating ever more ingenious things, with a moral sense of responsibility for their ultimate fate in the landfill.

Finally, the ambiguous status of the discarded thing as the carrier of (obscure) meaning, as representative of potentially 'independent' systems of value and yet passively expectant of, and vulnerable to, human intervention, might also be seen to mark it out as an important source of authenticity in late consumer capitalism. The fact of its discarding confers on it a biography, though at least partially forgotten, which connects it to real, lived life, whilst its status as found thing may empower the finder who takes it upon him or herself to determine a new status, function and value for the thing. This status of trash as simultaneously present yet absent, empty and yet replete with potential, is what makes it especially attractive against a background of anxieties about durability and order and the relationship between self and other, present and past. Each chapter in this volume sheds light on the way in which trash, as a flexible, ambiguous category is invoked in cultural negotiations of these fields of anxiety.

Overview of Contents

In his opening chapter Kevin Hetherington explores the notion of the museum as a 'conduit of disposal', arguing that in order to function as trace, remainders must be contextualised. The transformation from remainder into trace, argues Hetherington, lies at the heart of culture itself. In response to a recent resurgence of interest in the ruin and the remaindered, he explores how we use objects in order to (re)construct a historical narrative. Building on Walter Benjamin's thoughts on the obsolete, he asks how, when wrested from their original context, remaindered items may be able to 'function as a focal point for a moment of recognition'. In so doing, Hetherington explores how trash may be employed to heighten our awareness of the tension between (historical) process and the singular moment.

The chapters by Sonja Windmüller, by Lee Stickells and Nicole Sully, and by Kathleen James-Chakraborty all consider various manifestations of trash as museum exhibit. Sonja Windmüller's chapter confirms the twentieth century's fascination with the redeemed object in an exploration of the phenomenon of the trash museum. Discussing the many trash museums which have sprung up in Germany in the twentieth century, Windmüller shows how such museums operate as border zones between intentional and unintentional history, fascination and disgust. For Windmüller, by engaging actively with disposal practice in both its private and public faces, the trash museum may play an important role in exploring and counterbalancing the anxiety engendered by the increasing pace of consumer capitalism and its accelerated production of waste. In their chapter, Stickells and Sully explore the significance of the discarded neon signs of Las Vegas and look at their status in the ongoing narrative of a city which often connotes transience and virtuality. They explore the relationship between the trashed signs of the Las Vegas strip, their resurrection as an outdoor museum and the city itself as a form of living museum, where ancient monuments (pyramids, castles) are reincarnated as palaces of kitsch. Kathleen James-Chakaborty considers the case of the Meiderich steelworks in Duisburg, Germany, whose ruins were recycled into a world-renowned public park. Her chapter illuminates the ways in which city landscape, museum and wasteland coincide. She explores the intertwining of ecological imperatives, modernist aesthetics and the socio-historical heritage of the contested industrial heartland of Germany, the Ruhrgebiet, in the 'redemption' of industrial architecture as cathedrals of industry.

The chapters by Tahl Kaminer and Douglas Smith both look, in different ways, at the relationship between production, waste and excess and the tension between cultural productivity and the creation of rubbish. Tahl Kaminer approaches the issue of trash from the perspective of (post-)industrial production and consumption, which he argues is defined by its integration of the concept of excess. Taking as a yardstick modernism's ideal of fully integrating functionality and design and its concomitant criticism of the kitsch item as one which displays superfluous ornamentation, Kaminer shows how, in late consumer capitalism, art itself, the 'insignificant' element which defies use value in its traditional sense, is a

form of trash. Arguing with Baudrillard that, since at least the late twenti-eth century, consumer culture is defined by its use of branding and design features in order to distinguish items which are otherwise functionally identical, Kaminer invokes Rem Koolhaas's description of our contempo-rary environment as a 'junkspace', which is predominantly defined by the superfluous and insignificant. Here, Kaminer identifies junk not as the by-product of contemporary post-industrial society, but as its most significant outcome. In conclusion, he considers how contemporary architecture has attempted to use the notion of the excess element to destroy value and resist the occupation of space with junk. Douglas Smith's chapter also examines the question of excess and the proximity of culture and waste, by exploring the way in which these issues are reflected in the work of Walter Benajmin and Georges Bataille. Smith explores how, in the figure of the ragpicker, two seemingly diametrically opposed concepts of culture meet. He shows how Benjamin's concept of a history pieced together from rags and scraps, offers a 'redemptive' view of trash, as a source of creativity and alternative history. At the same time Bataille's concept of culture as excess, as activity which operates beyond the boundaries of mere utility, suggests that the subversive potential of trash lies in its 'anti-redemptive' tendency, its refusal to be integrated into the sphere of the (strictly) productive. As Smith's chapter shows, such apparently opposing views of trash are in fact intertwined. Both, however, demonstrate not only the ambiguity of the concept itself, its 'intractable' nature, but also the increasing identification between people and things. If Marx and Napoleon are concerned with the Lumpenproletariat as 'the whole indefinite, unsorted mass', a potentially subversive, heterogeneous body, then the function of the artist and histo-rian (as the 'ragpicker') is to shape cultural products by means of creating, or conversely curating, waste.

Both Wim Peeters and Uwe Steiner consider the literary employ-ment of the discarded and outmoded as a means of exploring anxieties of personal identity in late consumer capitalism. Uwe Steiner's chapter takes as its starting point the complex relationship between people and things, showing how this is illuminated by the category of trash. In particular, as items that are defined by their relegation from the functioning world and often placed beyond our reach, trash objects acquire an autonomy which

illustrates the hidden truth of the agency of things in general. In his analysis of the seventeenth-century text *Simplicissimus*, Steiner's chapter shows that an interest in the agency of things by far predates modern capitalism and is already a potent category in the Baroque. Turning to Don DeLillo's *White Noise*, Steiner reveals how in the novel's portrayal of twentieth-century US society, DeLillo employs the (discarded) thing as the 'ultimate allegorical reference to death', thus exposing the the complicity between humans and non-humans and suggesting that trash incorporates the non-human which is not external to, but rather lies within, human reality. Also exploring the interrelationships between man and things, Wim Peeters's discussion of contemporary German literature takes as its point of departure the cultural activity of waste control as it affects human beings themselves. His discussion of three recent German novels looks at the extension of waste management systems to people. His analysis illustrates not only the commodification of human life in capitalist societies, but also – in the attempted musealisation of the belongings of a compulsive hoarder, or in the self-marketing processes the long-term unemployed are forced to endure before they are 'disposed of' by being sent abroad – the complicity of the aesthetic in such ordering processes.

Catherine Bates and Nasser Hussain focus their attention on another area of human activity which is often subject to demands for purification: speech. Taking the cliché as a form of linguistic trash, they look at the work of Canadian poets bpNichol and Christopher Dewdney, who radicalise the attempt to find artistic value in everyday language by recycling the cliché and revealing it as a figure which, like the trash object, is both empty of and yet replete with significance. If, as Bates and Hussain observe, it doesn't really rain canine and feline animals when we say it rains cats and dogs, then on the one hand we are wasting expression, making use of a form which appears, like the sophisticated packaging of consumer objects, to be formally complex yet quickly redundant. At the same time, as the grease which allows the wheels of social relationships to turn, the cliché is revealed as having a full biography, being replete with the stuff of life which structures our interactions. Moreover, as found objects which appear, in literary terms at least, to be approaching a 'zero point' of value, clichés are shown to offer a profane and exciting creative resource for Nichol and Dewdney.

Randall van Schepen's discussion of Ilya Kabakov's work offers another perspective on rubbish as potential creative resource. This acquires particular significance against the cultural and political background of the Soviet Union in the 1970s and 1980s. Van Schepen's chapter unravels the combination of influences which led to Kabakov's art installations, in which the artist's own garbage occupied centre stage. Van Schepen shows that Kabakov's art is a response to aesthetic criteria, such as modernist ideals of whiteness as purifying and sanctifying element and the ideals of production and universalism invoked in Constructivism. At the same time, he illustrates the way in which such aesthetic influences operate in tandem with Kabakov's experience of the (material) reality of Soviet society: the trash of the Soviet urban landscape, which he saw as an expression of a 'Soviet spiritual and economic vacuum' and the barriers to the productivity of the artist. Again, however, the appeal to the obscure, but intensely personal, biography of discarded things offers an important creative resource for the artist in his quest for individual identity in a totalitarian society.

The final two chapters in this volume both deal with the issue of obsolescence and, in particular, its employment in film. Joel Burges's contribution explores the potential of the obsolete as a potentially critical vantage point on capitalist modernity. Burges reconsiders Walter Benjamin's concept of the obsolete as a possible means of critiquing the notion of historical progress. This is seen in the light of contemporary concerns – articulated by, amongst others, Hal Foster and Andreas Huyssen – about the amnesiac nature of capitalist culture, in which obsolescence mimics historical time, becoming the defining feature of an ahistorical consciousness. In his discussion of Douglas Sirk's *All that Heaven Allows*, Burges argues for the critical potential of the outmoded, revealing how the film is structured by a story of obsolescence in which figurations of the outmoded project and reflect historical change on screen. Finally, Harvey O'Brien's chapter offers a different perspective on the value of the obsolete in contemporary film culture. O'Brien explores Tim Burton's redemption of Ed Wood in the eponymous 1994 film, showing how Burton recycles and redeems a director whose career was marked by the creation of outmoded, badly functioning films that were destined for speedy obsolescence in a cynical market; that were populated with props made of found objects; and that

often featured the broken actor, Bela Lugosi, who was himself 'wasted' on drink and drugs. In this exploration of Burton's recycling strategies, O'Brien raises questions about the status of cultural 'trash' as creative resource. In particular, in combining this with a focus on Burton's treatment of Ed Wood as transvestite and 'outsider' to 1950s Eisenhower America, O'Brien's contribution raises questions about the redemption of Ed Wood's trash biography in Burton's search for legitimation and authenticity: a search which reveals his own potential for obsolescence in a rapidly changing, and critically fickle industry.

A note on terminology: The chapters in this book feature a broad range of terms, reflecting the multifaceted and conceptually complex nature of the issue at hand. Many of these terms – such as 'trash', 'garbage' and 'rubbish' – are frequently used interchangeably. This is not least because the variety of terms reflects the variations in English and US vocabulary and thus all usages are retained as individual authors intended in order to reflect the international nature of this volume. Other related terms, such as 'ruins', 'obsolete', 'waste', 'discards' are used in a variety of contexts in each chapter. Again, these usages have been retained to reflect the focus of individual studies.

Works Cited

Agamben, G. (1998), *Homo Sacer: Sovereign Power and Bare Life*. Stanford, CA, Stanford University Press.

Allen, B. (2007), The Ethical Artefact: On Trash. In: Knechtel, J. (ed.), *Trash*. Cambridge, MA/London, MIT Press: 196–213.

Assmann, A. (1999), *Erinnerungsräume: Formen und Wandlungen des kulturellen Gedächtnisses*. Munich, Beck.

Benjamin, W. (1999), Surrealism: The Last Snapshot of the European Intelligentsia. In: Jennings, M.W. et al. (eds), *Selected Writings, Volume 2, 1927–1934*, Cambridge, MA, Harvard University Press: 207–221.

Bataille, G., (1985) *Visions of Excess. Selected Writings 1927–39*. Stoekl, A. (ed.), Stoekl, A./Levitt, C.R./Leslie Jr, D.M. (trans.). Minneapolis, MA, Minnesota University Press.

Baudrillard, J. (1996), *The System of Objects*. London/New York, Verso.

Bauman, Z. (2004), *Wasted Lives: Modernity and its Outcasts*. Cambridge, Polity Press.

Douglas, M. (1966), *Purity and Danger: An Analysis of Concepts of Pollution and Taboo*. London, Routledge.

Flusser, V. (2003), *Dinge und Undinge: Phänomenologische Skizzen*. München, Beck.

Freud, S. (1957), Screen Memories. In: Strachey, J. (ed. and trans.), *The Standard Edition of the Complete Pschological Works, Vol. XIV: On the History of the Psycho-Analytic Movement: Papers on Metapsychology and Other Works*. London, Hogarth Press: 303–322.

Fritzsche, P. (2004), *Stranded in the Present: Modern Time and the Melancholy of History*. Cambridge, MA/London, Harvard University Press.

Groys, B. (1999), *Über das Neue: Versuch einer Kulturökonomie*. Frankfurt am Main, Fischer.

Hawkins, G. (2006), *The Ethics of Waste*. Lanham, MD/Oxford, Rowman and Littlefield Publishers.

Hirsch, M. (1997), *Family Frames: Photography, Narrative and Postmemory*. Cambridge, MA/London, Harvard University Press.

Latour, B. (1993), *We Have Never Been Modern*. Hemel Hempstead, Harvester Wheatsheaf.

——(1993), The Berlin Key or How to do Words with Things. In: Graves-Brown, P.M. (ed.) (2000), *Matter, Materiality and Modern Culture*. London, Routledge: 10–21.

Lindner, C. (2003), *Fictions of Commodity Culture: From the Victorian to the Postmodern*. Aldershot, Ashgate.

Mao, D. (1998), *Solid Objects: Modernism and the Test of Production*. Princeton, NJ, Princeton University Press.

Marx, K. (1996), *Capital, Vol. I, Collected Works of Karl Marx and Friedrich Engels, Vol 35*. London, Lawrence and Wishart.

Outka, E. (2009), *Consuming Traditions: Modernity, Modernism and the Commodified Authentic*. Oxford, Oxford University Press.

Rathje, W./Murphy, C. (2001), *Rubbish! The Archaeology of Garbage*. Tucson, University of Arizona Press.

Strasser, S. (1999), *Waste and Want: A Social History of Trash*. New York, Henry Holt.

Thompson, M. (1979), *Rubbish Theory: The Creation and Destruction of Value*. Oxford, Oxford University Press.

KEVIN HETHERINGTON

The Ruin Revisited

Everywhere, it seems, a fascination with the remains of the past, with its remainders, is in evidence. But what happens to ruins in this process is less certain. Sometimes discarded if they are of little interest or dressed in the garb of annotation, indexing and interpretation if they have some appeal, ruins appear to be visible only if they can be written within a heritage story. Ruins now have conservation and heritage written all over them (see Miles 1997; Dicks 2003). Societies now rarely just tear down the past to make way for the new as they did in earlier, more progress-oriented times. Now when a part of the built environment needs regeneration because of decline or because of new opportunities, one will often find a museum, heritage trail, or some kind of visitor centre dedicated to interpreting the past at the heart of it. The success of the Guggenheim museum in transforming the old declining industrial city of Bilbao is the often cited case study for success. The regeneration of Berlin after reunification is another (Till 2005). But there are many other cases.

No doubt, the economic crisis of 2008–9 will have an impact on this process of managing the past for a while; slowing down investment in regeneration and development schemes in some places, squeezing public funding in the arts and heritage sector, and creating new areas of decline, new discarded spaces, in others. But once recovery comes, however slow, partial or geographically uneven, the cultural concern to conserve the past, at least the best or most interesting of it, and to incorporate it into the cultural life of the present in a way that is understandable as a heritage narrative of time and place, is likely to remain for the foreseeable future.

We have been living with a version of the culture industry informed by issues of heritage for some decades now and most commentators on it have sought to address it through a critique in which the museum as an

institution and the heritage industry in general is seen to create a consumer-oriented, fetishised, dead story of the past. Simply just letting things be, letting them fall into decay or be appropriated outside of official heritage discourses informed by a desire to regenerate, is offered instead as an alternative and more living version of how we might respond to the past (Lowenthal 1985; Wright 1985; Hewison 1987; Samuels 1994; Huyssen 1995; Smith 2006). There can be no doubt that what Huyssen has called the memory industry (1995) is at work in towns and cities across the western world, repackaging forgotten fragments of the past for diverse audiences who find fascination in the storytelling approach to earlier times (see Degen 2003). For this critique of the writing of the ruin into the museum – seen as a source of amnesia and alienation of a true, living past informed by issues of inequality, injustice and marginalisation – asserts an alternative, counter-memory of an unwritten appreciation of the ruined past as found object, just awaiting discovery as event in itself. Promoting the cultural and political power of evocation as a resource for historical awakening is the underlying the aim here (see in particular Benjamin 1973a; 1999).

From the late eighteenth century, this Romantic perspective, that first found fascination in the ruins of classical antiquity, saw ruins as an historical topos for the modern subject's self-recognition as a judging subject. The ruin in this tradition is the pre-eminent space of political Romanticism (Schmitt 1988), the space of the occasion, or event, in which that subject comes to recognise him or herself as a *flâneur*-subject, separate from the material world as (political and cultural) agent of history; producer of a bourgeois critique of the alienation of bourgeois culture in the process.

From the pedagogic and aesthetic power of ancient civilisations emerging out of the jungle, to the haunting effect of lost cultures, to the surreal potential of the overlooked juxtapositions and fragments of the discarded city, the evocative relationship between materiality and history is at the centre of this fascination with the ruin that has developed in the European imagination since the late eighteenth century.[1] The making of this subject-

1 Antiquarian ruins had been of interest before the eighteenth century with early
 topographical guides that discussed the ruins of the ancient past becoming a feature

as-*flâneur* often celebrates the evocative power of a past as the terrain of an oppositional, counter-modern subjectivity that can speak to us directly through chance encounter with the found object or ruin. From Baudelaire (1960) to Breton (1961); Aragon (1987) to Benjamin (1999); Debord (1989) to Sinclair (1998), the tragedy for this emancipatory approach to the past is inevitably that it becomes a form of curatorial mediation, against itself, even when the intentions are of direct, unmediated contact with the past through a found materiality of broken and discarded fragments. Surrealism was always a form of curatorial practice. A chance encounter with the past through the figure of the ruin rather than the discourse of the ruin can have a powerful, evocative effect but only for the person who was there. To broaden knowledge of that effect requires that it be communicated discursively in some way. Therein lies the betrayal of its translation from something evoked, a distant voice from the past, into something known and curated.

Why, then, at the beginning of the twenty-first century should this earlier interest in the ruin come to prominence again? It is around the issue of the occasion, expressed through ideas of the powers of evocation and event, where something from the past can have the power to alter perception, that we have seen a recent resurgence of interest in ruins, the discarded, disposed of, the ghostly and the remaindered (see Derrida 1994; Huyssen 1995, 2003; Gordon 1997; Ladd 1997; Jaguaribe 1999; Edensor 2005; Hawkins 2006). It is not as if this approach has the same kind of confidence in the Romantic subject as before. But what is perhaps at stake is not so much Romanticism's conception of the subject as alienated maker of history but rather its fascination with the past as a source of refuge in uncertain times.

Ruins as evocations of a hidden or lost past are always written as such, translating their figural power into something else (Lyotard 1997). The main issue that is of interest here has to do with the power of the materiality of

of the sixteenth and seventeenth centuries. However, as a cultural phenomenon associated with ideas of nostalgia and loss that were a key part of the neo-classical revival and later Romantic movement, they are a later phenomenon.

ruins as a means of evoking the past as an event and what that might have
to say to us and the relationship that it has to the idea of heritage and the
museum. In capturing what this relationship might be about André Mal-
raux perhaps put it best: the reception of culture from past times should
be about giving voice to silence (1978). That is what evocation is all about;
about allowing absent presence, traces, ghosts, expressed in the materiality
of cultural artefacts, the opportunity to tell their story and thereby evoke
the silent lives of previous generations, their hopes and dreams, their sen-
suous human activity, so that that might be allowed to live again in ways
that can enrich our own lives and challenge some of our complacent pre-
conceptions about the present.

The challenge for me in all this has to do with the tension between
curation and disposal in the writing of the event of the ruin. This tension
at work around the ruin, between practices of curation and disposal, might
at first glance appear to have a directly oppositional character. Critics of
the museum have always sought to give voice to silence by leaving ruins
in situ as found rather than curated objects. Others, and Malraux is their
leading advocate, have seen the potential in the museum and in museum
practices to do this instead. This is something we need to explore.

A good starting point for considering these issues is to revisit Simmel's
well-known essay on the ruin (1959). It encapsulates an early but still sig-
nificant attempt to understand the cultural power of the ruin developed
around a theory of alienation. Simmel provides an outline of the ruin's
significance that concentrates on the question of the relationship between
aesthetics and creative agency that is central to this issue of evocation.
Furthermore, he situates the ruin as a key topos through which to explore
culture as a whole as something inherently tragic and alienated.

Culture, he believes, develops out of a conflict between process and
form (see also Goudsblom 1980; 1992). Once forms of culture, artworks
for example, stand outside the human creative process as things, Simmel
believes, they become alienated abstractions – ossified forms – in which
the capacity for expression contained in their making is somehow lost
(1959: 263). Except, he suggests, in the ruin. At first glance, then, Simmel's
position appears to be a typical expression of the Romantic view of culture
as one of alienation. While Simmel's theory of alienation was developed

independently of Marx (and was to be a key inspiration for the Western Marxist approach to alienation and fetishism in Lukács and Benjamin, see Arato and Brienes 1979), his conception of the Romantic subject as a sensuous, creating subject is similar. However, there is another side to his approach that gives it a continuing relevance. Not only is the human capacity to produce something lost in the formal properties of the artwork, Simmel believes, but so too is the ongoing material agency of nature alienated in the process of becoming, in which culture and nature come to be seen as articulated in one another. In other words, it is not just the sculptor's blows against a piece of stone that express this creative process, but the stone's ability to resist and to respond to those blows that contributes to this making of culture as a process.

It is clear that Simmel privileges human agency over that of the agency of nature in this perspective, yet recognises nevertheless that the latter is needed for an artwork to be formed. It is only when a building falls into ruin, he believes, that this dual process of human-material creation is recognised and the tragic character of our desire to express ourselves over and against material form is revealed:

> This unique balance – between mechanical, inert matter which passively resists pressure, and informing spirituality which pushes upwards – breaks, however, the instant a building crumbles [...] the balance between nature and spirit, which the building manifested, shifts in favour of nature. This shift becomes a cosmic tragedy which, so we feel, makes every ruin an object infused with our nostalgia; for now the decay appears as nature's revenge for the spirit's having violated it by making a form of its own image. (1959: 259)

He goes on to suggest that other types of art do not fully convey this power of the ruin as they just decay; nature is not seen to return in them. While patina on metal (or wood) might be said, on the contrary, to convey something of this effect, its power is certainly less significant to all but the most trained eye all the same – probably because of issues of scale and visibility rather than material substance. For in the ruined building, what is evoked for Simmel is not simply nature growing in the cracks as another form – a weed – but more generally nature's agency as a reassertion against the human creative spirit that subdued it for a while in the work of art.

The ruin is a thing with power. For Simmel, this is tragic because what it shows is that human agency, which seeks to reveal itself as the sole form of agency, can never be separated from the agency of matter with which it is engaged:

> That the overwhelming of a work of the human will by the power of nature can have an aesthetic effect at all suggests that nature has a never completely extinguished, rightful claim to this work, however much it may be formed by the spirit [...] For this reason the ruin strikes us so often as tragic – but not as sad – because destruction here is not something senselessly coming from the outside but rather the realisation of a tendency inherent in the deepest layer of existence of the destroyed. (1959: 262–263)

What Simmel seems to be saying here is that in the ruin we see culture as process and culture as form not as separate but as the same thing. However, we only do so in the tragic state of decay after human investment in that process has gone.

It would be wrong to suggest Simmel's approach as some kind of proto-actor-network theory (Latour 1993; Law and Hassard 1999) in which there is symmetry between human and non-human agency. Indeed, he remains very much within the humanist tradition of celebrating the creative powers of human agency. However, his approach does suggest something akin to an idea of affordances, in which humans and the material world work together in agentic creativity (see Gibson 1986) in making cultural things meaningful to human subjects. And this is revealed in particular, Simmel suggests, under a key condition: that there remains enough human expression in what is left of the ruined building so that what it once was can still be shown, but in a state of decadence. Half a column is a ruin in Simmel's sense but just a bare stump is not. The main question, then, is how what is remaindered can persist as a trace that reveals this relationship between human spirit and material force, between process and form, that was forged in its making. Within that relationship, the past relationship with the world as a range of material forms can continue to find expression in ways that resonate in our cultural present.

What is important here is not just the complex question of agency but the relationship between materiality and time. Most cultural forms are tragic, for Simmel, because the creative spirit expressed in them is forever

lost in a process of formal separation and alienation. The ruin, however, is tragic but not alienated precisely because it offers up, as a trace, the possibility of a return of that agency in the tension revealed between nature and culture in its decayed composition.

Whereas the creative expression of most cultural works exists in a register of time-as-*chronos* in which the singular act of making something has passed, ruins which resist such chronology open up a different perspective: time-as-*kairos*, anachronic events (see Koga 2008), in which the possibility for a recovery through recognition of the creative moment is revealed as an opportunity for ongoing cultural imagining. Such a theory of culture is not one that dwells on successive stages of development and improvement (Winckelmann 1972), but on the power of a decadent decline to act as a source of cultural renewal (Bernheimer 2002).

A key theme for this decadent theory of material culture lies in the idea that the ruin is a source of temporal voice or an evocation of a forgotten past. Through the ruin that voice somehow speaks, not to the ear (as discourse), but to the eye (as figure) and it does so in material form. Such a voice demands that social science become more poetic in its imaginings of the material world haunted by that past if it is going to be able to address it. That is Malraux's voice of silence. It is the event in which process becomes real again within form. It is as if History, bound up in the material past as a medium, could somehow speak to us through ruins in ways that allow us to see things differently once we have become attuned to hearing what it has to tell us. It can do so, it is believed, because the power of the thing comes into view as some kind of absent present force, or process in the materiality of the ruined form. In sum, culture-as-process is revealed as a ghost-like trace in culture-as-form when that form can be understood as a ruin.

We see something similar to Simmel's perspective in more recent approaches to ruins, rubbish and the detritus of culture. Edensor, for example, searches for an evocative poetics (and politics) in the industrial ruins of UK manufacturing towns and cities that have gone into decline. There, in the abandoned factory with its broken windows, labour process detritus and machinic remains, he sees evoked previous material orderings – often otherwise hidden from view – that underpin social relations (2005). The factory system is more apparent in the detritus of a ruined factory, he

suggests, than in a working one. As a mode of ordering it is laid bare, made
visible as such. As with Simmel, only when the social relations that made
these factories and for which they had significance have gone into decline
and become a shell-like ruin, Edensor suggests, do we see a trace of what
held them together materially in the ruined remains (2005). Similarly, in
her work on waste Hawkins (2006) suggests that when something, a com-
modity, loses its value, when it becomes rubbish (see also Thompson 1979),
only then do we start to see it again as a material form, embodying once
more the social relations that made it, rather than as an abstract sign-value.
Before that time we see its value rather more easily than we see its material-
ity. Once that materiality is revealed again and value is translated, things
can have affect as things rather than as values and we can relate to them
in a different way (2006: 84). Waste, she suggests furthermore, operates
through this source of recognition as a provocation to act in relation to the
material world and it affords the possibility of an ethical engagement with
social issues through the micro-politics of waste-related practices.

But to tell us this, to speak of the power of the ruin effectively as event,
and that is what evocation is all about, still requires some kind of curatorial
discourse surrounding the ruin. For Edensor, that comes in the form of a
mix of evocative text and accompanying photographs (2005), for Hawkins,
more conventional academic text will do, though reference to image in
film is also important to her approach (2006: 21–23). A central tenet of
this broadly Derridean interest in the trace, the remainder and the ghostly,
is a sense of honouring a debt to the past by evoking the materiality that
remains behind the discarded and unrecognised (1994; see also Gordon
1997). To dispose of something effectively requires that act of honouring
a debt (to the past, to the ancestors) if one is to avoid being haunted. The
ghost, after all, is the figure of unfinished, unmanaged or untimely disposal
(see Hetherington 2004). And yet it is in Benjamin's work in the earlier
part of the last century, from his study of seventeenth-century tragic drama
(1985a) to the commodity culture of nineteenth century Paris and its arcades
(1999), that the evocative voice of the past found amongst the ruins reaches
is clearest theoretical expression as a key element in a developed (if itself
ruined) philosophy of history (1973a).

Benjamin, as is now well known, constructs a whole methodology for engaging with this past-evoking form of recognition – dialectics at a standstill, or dialectical images (for a detailed discussion see Wolin 1982; Buck-Morss 1989; Cohen 1995; Lindroos 1998), through which he develops his own unorthodox theory of the fetishism of commodities in capitalism (see Hetherington 2007). Benjamin understands dialectics at a standstill as a way of bringing the material culture of the ruined past and the optimistic, progressive present together in the form of a monad or constellation in which the acts of creation that are involved in the making of cultural forms are recognised as the outcome of History (sensuous human activity in the Marxian sense) rather than of Capital, as appears to be the case. His aim is to de-fetishise our 'phantasmagoric' understanding of (commodity) culture. He shares with Simmel a tragic view of culture – this fetish character is its tragedy for Benjamin – and his approach to it can be seen as something of a synthesis of the theories of alienation found in both Simmel (1990) and Marx (1938). But whereas for Simmel it is a universalised human agency that is evoked as tragedy in an encounter with the ruin, for Benjamin that tragic agency takes on a less universal human character and a more historical one befitting the Marxist influence on his thinking.

Such constellations produce, Benjamin believes, the possibility for a shock of recognition and an awakening to the sensuous, material history that is obscured by the phantasmagoric sign of value. As he puts it:

> It's not that what is past casts light on what is present, or what is present its light on what it past; rather image is that wherein what has been comes together in a flash with the now to form a constellation. In other words: image is dialectics at a standstill. For while the relation of the present to the past is purely temporal, the relation to what-has-been to the now is dialectical: not temporal in nature but figural. Only dialectical images are genuinely historical – that is, not archaic – images. The image that is read – which is to say, the image in the now of its recognisability – bears to the highest degree the imprint of the perilous critical moment on which all reading is founded. (Benjamin 1999: 463 [N3, 1])

As Lindroos has shown (1998), the key to understanding Benjamin's approach to ruins and discarded cultural forms and the importance they play within his methodology of dialectical image is to consider the kind

of time he associates with the ruin in material form and its relation to the past as cultural process. While Benjamin remains ultimately wedded to a Romantic utopianism in which time-as-*chronos* informs his belief in historical materialism, his attempt to separate that dialectical approach to history from a contagious bourgeois ideology of progress, by which he thought it had been overly influenced, led him to develop a Baroque sensibility on issues of time. This sensibility was drawn from theological debates around the idea of the event-as-monad that created moments of shock and recognition (on the difference between Romantic and Baroque perspectives see Kwa 2002). Benjamin applies both Marxist-linear and non-linear modernist-collage thinking to this issue, but underlying it, hidden within, is a much older Jewish theological concern with the evocative event, symbolised most notably in the idea of the event of the Messiah's arrival on earth and His intervention in human affairs (1973a; Wolin 1982; Lindroos 1998). The secular understanding of this event that he sought to articulate was to emphasise its singular character and it is an interest in singular temporalities, moments of *kairos*, in which Benjamin locates his approach to ruins and their relationship to the chronos of commodity culture.

Kairos, in this sense, is a singular event that disrupts the flow of time-as-chronos. It is an evocative point at which Benjamin believes an awakening to a true reality behind a false, phantasmagoric veil is made possible because in that event (historical) process is revealed as implicated in (commodity) form. While his language is theological, centred on the redemptive power of this awakening event in which the human activity that created the forms of the past is made visible in its ruined state (pace Simmel), it is the recognition of historical agency rather than the Messiah that is really Benjamin's concern.

Kairos in Greek thought referred to the idea of the qualitative time of a single revealing moment rather than chronological passing of time as a sequence of moments that become linear and directional. The event, the singular moment, has a qualitative and revelatory potentiality in this tradition. Arising from the idea of the singular moment as a device of rhetoric emphasised within Greek thought and represented as the God of Opportunity, a moment of *kairos* is a moment in which the opportunity for making a convincing argument is articulated (see Smith 2002; Kinneavy 2002).

Western thought is imbued with the figure of *kairos* as opportunity that comes in the form of the power of the singular moment that some how condenses all that surrounds it into a point of recognition and revelation. The event as *kairos* is evocative; figural rather than discursive.

The Jewish theological tradition of Messianism that Benjamin drew on in his understanding of the power of the ruin does not emphasise this figure of opportunity as such. Rather, Benjamin sought to couple it to the Jewish idea of redemption (*Erlösung*). Through this move he develops the idea of an event as an opening in which the past can be redeemed by being restored in the moment of recognition (Lindroos 1998: 37–38). In redeeming the past, Benjamin believes, we also redeem ourselves from capitalism. Benjamin draws on parallel attempts within the work of his contemporary, Paul Tillich, who was seeking answers to similar questions on the possibility of revelatory awakening in modern culture from within the Christian rather than the Jewish tradition (1951). In that approach, Tillich associated this question of awakening with the idea of the moment of recognition of God's eternal presence on earth. In that opportunity for recognition he saw the possibility for awakening to repentance from a sinful cultural as well as individual state. In effect, that moment of awakening is, for Tillich, a moment of divine *kairos* that challenges linear, chronological and secular understandings of history in which time only exists as a *chronos* of human events (Lindroos 1998: 43–45).

Benjamin's key term for addressing such issues of history is neither *Erlösung* nor *kairos* but an attempt to synthesise the two into an idea of the moment of recognition and redemption in which elements of the past and the present come together: *Jetztzeit* ['now-time'] (1973a). The dialectical image, for Benjamin, creates a singular, dense, revelatory, shocking, evocative monadological and condensed moment of now-time in which the past can be redeemed through awakening to its tragedy of alienation. In so doing he believes there is an opportunity for the future to be made whole, arising as it does out of that revelatory shock as a shattering of the power of the fetish. Such a process is, above all, revealed in the form of the ruin – Benjamin's main emblem for the ruin is the Arcade (1999) – as it is in such a material form that an opening onto the past in the moment of the now is most clearly achieved within the commodity culture of capitalism.

The ruin, for Benjamin, opens up a perspective on the materiality of history. The forgotten materiality of the past, when brought into contact with the chronos ideology of progress through which capitalism is understood, will reveal, he hopes, the latter to be phatasmagoric (fetishistic). It is an archive awaiting exploration, not as a series of texts or discursive statements (pace Foucault) but as a singular dialectical image manifest in the evocative power of ruined material remainders.

In many respects this whole approach to materiality and history runs counter to the Marxist historical tradition that Benjamin sought, some-what uncomfortably, to operate within.[2] He made clear that he saw this theological sensitivity to the past not as a break with secular philosophi-cal thought but as its puppet master that worked the puppet of historical materialism hidden from view (1973a: 245).

This is not the view of the past typically and confidently presented by Marx. In his most famous statement on the relationship between the social relations of the past (and their cultural forms) and their relation-ship to the present at the beginning of the *Eighteenth Brumaire of Louis Bonaparte* (1852), Marx presents the past as follows: 'The tradition of all the generations of the dead weighs like a nightmare on the brains of the living' (1978: 9). He gives this a material twist. In moments of revolution, the past of tradition tends to reassert itself in heroic Roman clothing and thereby deflects change from its true emancipatory path. To do that, Marx believes, requires a complete break with tradition. That is the failure of revolution in the nineteenth century for Marx. Process is ruined by form – old material cultural forms and expressions have to be discarded, swept away, if new processes are to escape their conservative hold. Yet this is also the way in which a capitalist commodity culture treats the forms of the past as well. It also seeks emancipation from the dead weight of the past to offer us novelty, fashion and progress that we want to buy. Marx's view of progress seems to mirror that of the capitalism he sought to critique (see Baudrillard 1975).

2 His ongoing exchange of letters around his methodology and approach to fetishism with Adorno are testament to this (2002).

And yet, in one of his more unguarded, note-book moments Marx offers us, against the grain of his philosophy of history, a somewhat different and more receptive (we might almost say more Benjaminian) view of the relationship between the past and the present. Using the example of Greek epic poetry and the different relationship between culture and history that the non-disappearance of the sublated past reveals, he expresses a doubt that challenges his more famous *Brumaire* position (see Lowith 1949). Sometimes, he suggests, earlier cultural forms are revealed as examples of a still higher achievement than anything that arises from later, more advanced social relations despite their formal creation within what are now outmoded social conditions:

> Is the view of nature and of social relations on which the Greek imagination and hence Greek [mythology] is based possible with self-acting mule spindles and railways and locomotives and electrical telegraphs? What chance has Vulcan against Roberts & Co., Jupiter against the lightning-rod and Hermes against the Credit Mobilier? All mythology overcomes and dominates and shapes forces of nature in the imagination and by imagination; it therefore vanishes with the advent of real mastery over them [...] From another side: is Achilles possible with powder and lead? Or the Iliad with the printing press, not to mention the printing machine? Do not song and the saga and the muse necessarily come to an end with the printer's bar, hence do not the necessary conditions of epic poetry vanish? But the difficulty lies not in understanding that the Greek arts and epic are bound up with certain forms of social development. *The difficulty is that they still afford us artistic pleasure and that in a certain respect they count as a norm and as an unattainable model.* (Marx 1973: 110–111, emphasis added)

This is not the dead weight of tradition but fragments of the (ruined) past that still live on, albeit in tragic form, because of their outmoded placement. Marx does not elaborate such a point but Benjamin works it up into a philosophy of history centred on the ruin that, while Marxist in inspiration, works against the grain of an acceptance of the bourgeois trope of progress that underlies all recent attempts to develop a philosophy of history, including those of Marx (1973a). In the ruin, then, we see another relationship to the past, a counter-memory of sorts in which the event affords the possibility of a kind of awakening to its forgotten, silent voice.

The problem for Benjamin, however, is the problem of the event as a source of revelatory and de-fetishising evocation. We are all capable of experiencing moments of shock when we encounter something seemingly out of time – 'uncanny' in Freud's terms – and it may lead to a subtle reorientation towards that which we see. But making that into not just a methodology for studying the past but a revolutionary one capable of social change requires that it be communicated effectively. And in so doing much of its power is lost. The half-life of evocation is a short one. The form of *The Arcades Project*, albeit unfinished – made up of a palimpsest of bits of text from the past – with the intention that their appearing out of time will have an awakening effect on the reader, is not one that works particularly well. The aphoristic model of his more accomplished book *One Way Street* on which it is based (1985; see Buck-Morss 1989) does not in this later Arcades case convey the power of evocation as effectively because it requires too much interpretive, archival work on the part of the reader. Benjamin might have done better if he had turned to film in which to present images from the past in constellation form. But even then in turning the event into filmic discourse, or into any form, the power of shock is going to be quickly subdued. A description of the event, the moment of singular time, is never the same as the actual experience of it. A new de-fetishised way of seeing does not automatically emerge from his methodology except as a utopian ideal.

If this is the case then what power does the ruin have? Does it provide any opportunity at all for cultural critique? Ruins, as Lyotard shows, are nothing without stories attached to them. What is left behind from the past, what is remaindered, can speak to us but in so doing and in our recognising that in any way beyond immediate embodied sensation, requires that it be made discursive in some manner – so that what is left behind as a forgotten remainder be turned into a meaningful trace. For Lyotard, this is not a betrayal of the ruin but its real power and its real potential significance, even if it is a significance somewhat removed from the hopes of those who look to ruins to evoke an alternative sense of the past that might overturn the present:

Disappeared as existing, durable as written. They must be written in order not to forget that they are forgotten as existing. Such is the metamorphosis of the remainder into a trace. Trace: the nothingness of the existent is transformed into the being of the non-existent. (Lyotard 1997: 170–171)

When Lyotard wrote these words he was principally engaging in a dialogue with the ghost of André Malraux in trying to understand the importance of the museum as a space for appreciating artefacts from the past and from a range of different cultures (Malraux 1978). While it is Malraux's suggestion that the photographic reproduction of artworks as images in books creates the possibility for a new kind of museum experience – the *musée imaginaire* – is what he is best known for when we think of his writing on museums, he nevertheless had a broader understanding of museums and their role than that. Malraux's approach to the museum was one that focused not only on the possibilities of access derived by technological advances in copying (notably photography) and in making available access to the truth of artworks through reproduced images of them (he shared an optimism with Benjamin around the liberating effects of the loss of aura in this respect, see also Ivins 1953), but also a celebration of the bourgeois museum's monumentalizing of art out of context.

For Malraux, the museum takes the artefact out of its everyday context. Whereas for the cultural critics of the museum and other heritage spaces this is precisely the problem with their role, and this is why they seek out ruins and their evocative power beyond the spaces of heritage in order to recapture a sense of authentic history out of time, for Malraux it is the museum that is the space of the event; a space where the voices of silence within art might be heard. For Malraux, decontextualising artworks provides the opportunity that they might assume the character of the event rather than the betrayal of the event. Unlike most critics of the museum for whom process and form are alienated from one another in culture, Malraux has a different view. This is Lyotard's view too; of engaging with a past outside of the flow of time such that the event might be written and recognised as such:

> The museum monumentalizes. It is the mind concerned about what it might have
> been and done. It sets up and hangs its remainders. It turns them into traces, which
> are remainders snatched from inattention. (Lyotard 1997: 167)

And yet Lyotard openly acknowledges that in presenting artefacts within
this space as monuments to the past in the ways that the museum does, the
event does not speak unaided, such display is an act of writing the event.
But to not engage in such writing, to seek instead the evocative power of
the event outside of writing, is an impossibility:

> It is said that works of art are imprisoned in the museum. On the contrary, they
> are incarcerated within reality, within cult or cultural objects; and the museum, by
> distancing them from the contingency of their occurrence, can write and deliver
> what there is of writing and of the cry within them. Monumentation suspends the
> course of the deaf and blind world that cast the work, like every object, into the
> inert. (1997: 175)

This is a rather different approach to the relationship between the museum
and history to that found in Benjamin or in the work of more recent com-
mentators on museums and heritage, who take inspiration from him in
developing a critique of the museum and heritage as an embodiment of a
bourgeois ideal of cultural heroism in which the past is saved from oblivion
and bourgeois culture monumentalised in phantasmagoric form as the cul-
mination of history (see for example Saisselin 1985; Huyssen 1995, 2004;
Maleuvre 1999).

If we were to take at face value the conceited bourgeois story that
museums, most notably history and art museums, have told about them-
selves and sought to practice – that they are spaces for conserving and
preserving culture, whether in universalist or nationalist form; that they
are places of interpretation of artefacts where a better understanding of
the past can be gained; that they are conservers of things against ruin so
that future generations might be able to see and appreciate artefacts from
their past – then we would want to agree with the critique of the museum
and side against Malraux and Lyotard. This kind of historicism, often asso-
ciated with an over-interpretation of artefacts, has the event as its enemy
as Lyotard himself acknowledges (1997: 175–177). But that is not all that

museums do. What Malraux and Lyotard have in mind instead is a challenge to the museum such that the event might be allowed to live, not as event, but precisely as a written event – as a trace rather than a remainder – within their walls.

It is certainly the case that few museums always do this work very effectively. The collecting imperative creates a curatorial space in which the conservation of things, as much as the opportunity for encounter and interpretation, is often seen as paramount. The question is: how might museums engage in a self-critique of this position without losing their significance as museums? Lyotard does not provide us with an answer in the way that Malraux does (the art-book full of photographic reproductions of artworks) other than to suggest that to monumentalise art (*monu-mentum*) has the capacity to ambiguously produce a space that can reflect either the mind of a guard or its opposite – a guard of the mind (1997: 166–167). It is the latter, of course, that he wishes to acknowledge while challenging critics who reduce the museum function in their critiques to the former role. But he at least poses the question, to which we might answer: how can we find the event within the museum? How can we write it as a trace such that the past might speak and alter our perspective – even if that does not lead to the revolutionary overthrow of capitalist society? An answer to this is to suggest that museums should see themselves primarily not as *chronos*-spaces of conservation but as *chronos*-spaces of disposal in which their custodianship of artefacts is recognised as temporary rather than eternal.

There are very few museums that are more than two hundred years old, even fewer that have a history of more than three hundred years unaltered. Yet these modern museums typically see themselves as space of perpetuity – spaces where things will be conserved forever so that the past will remain available to whatever kind of visiting public might enter through their doors in the future. And yet we know that this must be a false hope, a bourgeois fantasy of eternity that can never be fully realised. The museum is always-already a space in ruins before the fact. The history of that much older and longer established institution, the library, is instructive in this respect (see Polastron 2007). In long historical perspective and, despite the clear and conscientious intentions and practices of generations of librarians, if you want to destroy books, erase them from existence and leave

only a few remains, then the best way to do so is to collect them together in one space and call it a library. War and revolt, fire and flood, humidity and aridity, looters or careless cataloguers will do the rest.

The same is the case for museums where it is artworks and other material artefacts that are collected rather than books. Whether it be the library of Alexandria in 48 BCE or the museum in Baghdad in 2003, bringing things together in one space can ultimately only have one effect: it makes it easier for them to be disposed of in some way or other. Museums, like libraries, while they do not always become incinerators (though they can be very effective in that role when the flames take hold) or sites of final burial, are, above all, spaces-between, conduits of disposal (Munro 1998). In particular, they are spaces between first and second burial (Hertz 1960); between the removal of things from their living social and historical context (first burial – usually in the site of the market, shop or auction house) and their final irrevocable destruction and loss to the world (second burial). That space-between is the space where the dead, the artefacts, are honoured (interpreted) so that they can pass on in a culturally managed way. As conduits of disposal (from both the things as material forms and as culturally and historically specific values and interpretations), museums are spaces where artefacts become ruins over time and where that ruined state invokes the possibility of recognition as such.

In long historical perspective we can only know cultures through the few ruined remains that are left behind in the charred rubble of libraries and palaces or dug out of the ground in spaces of ritual disposal. History is nothing but that which radiates from the barely warm glow of these cultural embers. Over time, few collections escape the fate of decay, partial destruction or dispersal in some form or other. It is through disposal rather than conservation that we know what cultures are, certainly literate and artefact-rich cultures.

The reason we can say this is because disposal means two things: to get rid of something – to dispose of it – and to make something available, to have it at our disposal (Hetherington 2004). It is this ambiguity of removal/availability that is central to the role of the museum. We know civilisations through their catastrophic fires (Goudsblom 1992), their plunder and commoditised booty. The cultural biography of things is such that

it is disposal in some form – an act of placing in some kind of abeyance as much as irrevocable removal – that inscribes their character, rather than conservation and holding in place for all time. Things move, and they change as they move in time if not in space. As Mauss (1990) and Bataille (1991) knew, to dispose of something in societies that are characterised by an abundance of goods is always the most socially creative of acts. It is above all creative not just because of what it gets rid of but because of what it leaves behind as a remainder. Culture is that which is turned from a remainder into a trace, and that requires that there be an acknowledgment that what is there is already a ruin or will become one. In societies of the utmost abundance known, capitalist societies, it is museums that assume this culturally significant role (Hetherington 2007).

As all collectors know, all the hard work and investment they have put into building their collections is likely to be undone at some point in the future: by theft, the need to sell, because of some destructive event in their lifetime, or through dispersal to, or disposal by, their philistine heirs after they are gone. That is why so many try to stall that from happening by bequest of their collections to places like museums where they think they will be safe.[3] Museums risk assuming the role of the over-protective collector too. Our task must be to ask them to relinquish that role in the long term and see their position as a transitory and inherently tragic one – as creative betrayers of the idea of perpetuity rather than its guardians. That is where a radical critique of the museums that defends their importance rather than castigates them for existing might develop. What such a perspective might argue is this: culture is not the event itself but the writing of the event in such a way that its *kairos*, or moment of opportunity, is revealed as a part of the *chronos* story and not just as a point of critical departure from it.

3 Something that is increasingly unlikely as most museums no longer have the space to store new collections let alone display them. Most museums now have to develop de-accessioning policies whereby they can effectively and legitimately get rid of things in their collections.

It is not, then, that process becomes alienated form and that this is revealed in the ruin, but that process and form are inextricably the same thing when taken in a temporal rather than simply spatial context. That is what the ruin shows us, that is what the voice of silence tells us. The opportunity of the museum, then, is to recognise that it is a conduit for the disposal of things – a transit lounge for objects awaiting departure into oblivion – and thereby the revealer of cultural process, and that it may find ways of writing that into our culture so that we might better know not only the past but perhaps even our own future too.

Acknowledgments

I would like to thank Gillian Pye, John Law, Tony Bennett, Nick Bingham, Nigel Clark and members of the materialities group at the Open University for their comments on an earlier version of this essay.

Works Cited

Adorno, T. et al. (2002), *Aesthetics and Politics: The Key Texts of the Classic Debate Within German Marxism*. London, Verso.

Aragon, L. (1987), *Paris Peasant*. London, Picador.

Arato, A./Brienes, P. (1979), *The Young Lukács and the Origins of Western Marxism*. London, Pluto Press.

Bataille, G. (1991), *The Accursed Share*. New York, Zone Books.

Baudelaire, C. (1970), *Paris Spleen*. New York, New Directions.

Baudrillard, J. (1975), *The Mirror of Production*. St Louis, Telos Press.

Benjamin, W. (1999), *The Arcades Project*. Eiland H./McLaughlin K. (trans.). Cambridge, MA, Belknap Press.

——(1985a), *On the Origins of German Tragic Drama*. London, Verso.

——(1985b), *One Way Street and other Essays*. London, Verso.

—— (1973a), Theses on the Philosophy of History. In: *Illuminations*. London, Fontana: 245–255.

—— (1973b), The Work of Art in the Age of Mechanical Reproduction. In: *Illuminations*. London, Fontana: 211–244.

Bernheimer, C. (2002), *Decadent Subjects: The Idea of Decadence in Art, Literature, Philosophy and Culture of the Fin de Siècle in Europe*. Baltimore, Johns Hopkins University Press.

Buck-Morss, S. (1989), *The Dialectics of Seeing: Walter Benjamin and the Arcades Project*. Cambridge, MA, MIT Press.

Cohen, M. (1995), *Profane Illumination: Walter Benjamin and the Paris of the Surrealist Revolution*. Berkeley, University of California Press.

Crimp, D. (1997), *On the Museum's Ruins*. Cambridge, MA, MIT Press.

Debord, G. (1989), Report on the Construction of Situations and on the International Situationist Tendency's Conditions of Organization and Action. In: Knabb, K. (ed.) (1990), *The Situationist International Anthology*. Berkeley, Bureau of Public Secrets: 17–25.

Degen, M. (2003), Fight for the Global Catwalk: Formalising Public Life in Castlefield (Manchester) and Diluting Public Life in El Ravel (Barcelona). *International Journal of Urban and Regional Research* 27: 867–880.

Derrida, J. (1994), *Spectres of Marx: the State of the Debt, the Work of Mourning, and the New International*. New York, Routledge.

Dicks, B. (2003), *Culture on Display: The Production of Contemporary Visitability*. Maidenhead, Open University Press.

Edensor, T. (2005), *Industrial Ruins: Space, Aesthetics and Materiality*. Oxford, Berg.

Gibson, J. (1986), *The Ecological Approach to Visual Perception*. London, Erlbaum.

Gordon, A. (1997), *Ghostly Matters: Haunting and the Sociological Imagination*. Minneapolis, University of Minnesota Press.

Goudsblom, J. (1992), *Fire and Civilization*. London, Allen Lane.

—— (1980), *Nihilism and Culture*. Oxford, Basil Blackwell.

Hawkins, G. (2006), *The Ethics of Waste: How We Relate to Rubbish*. Lanham, MD/ Oxford, Rowman and Littlefield.

Hertz, R. (1960), *Death and the Right Hand*. London, Cohen and West.

Hewison, R. (1987), *The Heritage Industry*. London, Methuen.

Hetherington, K. (2007), *Capitalism's Eye: Cultural Spaces of the Commodity*. New York, Routledge.

—— (2004), Secondhandedness: Consumption, Disposal and Absent Presence. *Environment and Planning D: Society and Space* 22: 157–173.

Huyssen, A. (2003), *Present Pasts: Urban Palimpsests and the Politics of Memory*. Stanford, Stanford University Press.

—— (1995), *Twilight Memories: Marking Time in a Culture of Amnesia*. New York, Routledge.

Ivins, W. (1953), *Prints and Visual Communication*. London, Routledge and Keegan Paul.

Jaguaribe, B. (1999), Modernist Ruins: Nationalist Narratives and Architectural Forms. *Public Culture* 27: 294–312.

Kinneavy, J. (2002), Kairos: A Neglected Concept in Classical Rhetoric. In: Dietz Moss, J. (ed.), *Rhetoric and Praxis: The Contribution of Classical Rhetoric to Practical Reasoning*. Washington DC, The Catholic University of America Press: 79–105.

Koga, Y. (2008), 'The Atmosphere of a Foreign Country': Harbin's Architectural Inheritance. In: Cronin, A./Hetherington K. (eds), *Consuming the Entrepreneurial City: Image, Memory, Spectacle*. New York, Routledge: 221–253.

Kwa, C. (2002), Romantic and Baroque Conceptions of Complex Wholes in the Sciences. In: Law, J./Mol, A. (eds), *Complexities: Social Studies of Knowledge Practices*. Durham, Duke University Press: 23–52.

Ladd, B. (1997), *The Ghosts of Berlin: Confronting German History in the Urban Landscape*. Chicago, University of Chicago Press.

Latour, B. (1993), *We Have Never Been Modern*. London: Harvester Wheatsheaf.

Law, J./Hassard J. (eds) (1999), *Actor-Network Theory and After*. Oxford, Blackwell.

Lindroos, K. (1998), *Now-Time/Image-Space: Temporalization of Politics in Walter Benjamin's Philosophy of History and Art*. University of Jyvaskyla, SoPhi.

Lowenthal, D. (1985), *The Past is a Foreign Country*. Cambridge, Cambridge University Press.

Lowith, K. (1949), *Meaning in History*. Chicago, University of Chicago Press/Phoenix Books.

Lyotard, J.-F. (1997), A Monument of Possibles. In: *Postmodern Fables*. Minneapolis, University of Minnesota Press: 163–181.

Maleuvre, D. (1999), *Museum Memories: History, Technology, Art*. Stanford, Stanford University Press.

Malraux, A. (1978), *The Voices of Silence*. St Albans, Paladin.

Marx, K. (1978), *Eighteenth Brumaire of Louis Bonaparte*. Peking, Foreign Language Press.

—— (1973), *Grundrisse*. Harmondsworth, Penguin.

—— (1938), *Capital*. Volume 1. London, George Allen and Unwin.

Mauss, M. (1990), *The Gift*. London, Routledge.

Miles, M. (1997), *Art, Space and the City: Public Art and Urban Futures*. London, Routledge.

Munro, R. (1998), Disposal of the X Gap: The Production and Consumption of Accounting Research and Practical Accounting Systems. *Advances in Public Accounting* 7: 139–159.

Polastron, L. (2007), *Books on Fire: The Tumultuous Story of the World's Great Libraries*. London, Thames and Hudson.

Saisselin, R. (1985), *Bricabracomania: The Bourgeois and the Bibelot*. London, Thames and Hudson.

Samuels, R. (1994), *Theatres of Memory: Past and Present in Contemporary Culture*. London, Verso.

Schmitt, C. (1988), *Political Romanticism*. Cambridge, MA, MIT Press.

Simmel, G. (1990), *The Philosophy of Money*. London, Routledge.

—— (1959), The Ruin. In: Wolff, K. (ed.), *Georg Simmel*. Columbus, Ohio State University Press: 259–266.

Sinclair, I. (1998), *Lights Out for the Territory*. London, Granta.

Smith, J. (2002), Time and Qualitative Time. In: Sipiora, P./Baumlin, J. (eds), *Rhetoric and Kairos: Essays in History, Theory and Praxis*. New York, SUNY Press: 46–57.

Thompson, M. (1979), *Rubbish Theory: The Creation and Destruction of Value*. Oxford, Oxford University Press.

Till, K. (2005), *The New Berlin: Memory, Politics, Place*. Minneapolis, University of Minnesota Press.

Tillich, P. (1951), *The Protestant Era*. London, Nisbet.

Winckelmann, J. (1972), *Winckelmann: Writings on Art*. London, Phaidon.

Wolin, P. (1982), *Walter Benjamin*. New York, Columbia University Press.

Wright, P. (1985), *On Living in an Old Country*. London, Verso.

SONJA WINDMÜLLER

Trash Museums: Exhibiting In-Between

For quite some time, the boundaries between cultural production and discards have been blurred, as have those between their places of representation. Discarded things have been identified as a cultural reservoir with a special validity. In comparison with intentionally enduring works, they contribute to an unintended historical tradition. Trash provides an insight into the unimposing, the banalities and routines of daily life, and thereby can be characterised by a particular 'veracity and authenticity' ['Wahrhaftigkeit und Authentizität'] (Assmann 1996: 107).[1] Not least the inflationary mass of electronic data has caused a convergence of archives and trash-dumps. There are also theoretical reflections on a structural relation between trash-dump and museum. 'Where at the present time things are withdrawn, trash-dump and museum are current alternatives' ['Wo die Dinge gegenwärtig aus dem Gebrauch kommen, sind Müllhalde und Museum aktuelle Alternativen'] (Thiekötter 1999: 31) – this statement can be found in a brochure published by the *Museum der Dinge* ['Museum of Things'] in Berlin, which belongs to the German Werkbund. In accordance with Michael Thompson's *Rubbish Theory* museum experts occasionally suggest that only objects which 'had the status of rubbish beforehand' ['zuvor im Müllstatus gewesen sind'] (Fehr 1989: 183) may be accepted into the museum.

This perception seems to meet its everyday cultural realisation in the phenomenon of trash museums, which may be of particular cultural analytical interest because they reflect not only the symptomatic character of trash itself but also its perception and handling as a meaningful cultural expression. In the following, I will take a closer look at this phenomenon in its manifest expressions.

1 All translations from German in this chapter are my own unless otherwise stated. See Windmüller 2003.

Trash Museums: A Sketch

In Bad Säckingen, a small town in Southern Germany, a rather curious establishment opened to the general public in 1991: a so-called *Müllmuseum* ['trash museum']. It was founded by a local bulldozer operator, Erwin Thomann, who started working on the local rubbish tip in the early 1970s and shortly afterwards began to save and collect an ever increasing number of discarded objects from decay. It was a teddy bear that, as several newspapers reported, served as a start-up exhibit. Thomann fished it out of the dump in 1975 and offered it a home (Müller 2003: 673). Soon afterwards a range of different objects followed, among them a collection of still operable sewing and embroidering machines, gramophones and radios, various clocks, coffee machines, crockery, paintings, musical instruments, pre-industrial tools of every description, glasses, books, sacred objects such as rosaries, bibles and Madonna figures, stuffed animals and tin toys as well as – in two showcases – medals and ribbons of all ages. Stored and arranged by topic, these objects are on display in what is by now a 250 square metre exhibition space, situated in a growing number of disused agricultural buildings on the family's property, among them a stable, a barn and other outbuildings.[2]

To keep the *Müllmuseum* in operation, Thomann recruited his whole family – wife, children, children-in-law and grandchildren. Building materials originate from the dump, financial support has never been obtained (Müller 2003: 674). A museum café has also recently opened. Furthermore, there is a meeting room regularly used by local associations, a small education programme where trash-based objects can be crafted, and once a year the museum hosts a so-called *Schlachtfest*, where visitors can enjoy local meat specialities. Within a short period, the Trash Museum in Bad Säckingen became a regional tourist attraction, a reliable major crowd-puller attracting about 10,000 visitors each year.[3]

2 http://www.bad-saeckingen-tourismus.de/index.shtml?muellmuseum (accessed on 21 July 2008); <http://www.muellmuseum-wallbach.via.t-online.de/index.html> (accessed on 21 July 2008).

3 Ibid.

There had been a similar phenomenon some decades earlier. In the mid-1960s the local newspapers reported about the Head of the Sanitation Department in the North-Rhine Westphalian town of Wuppertal, who had set up an exhibition room right in his office with '4,000 "odd things"' ['4,000 "komische Dinge"'] (Ziegler 1964) on display that had been pulled out of the city's trash bins by the municipal refuse collection. The range of exhibits resembles Thomann's: technical apparatus and gadgets, pieces of furniture, paintings, devotional objects and old books – one of them from 1763. Presumably the most whimsical item is a prepared elephant leg (Ziegler 1964). After a short time, Wuppertal's *Müllmuseum*, which existed from 1962 until 1973, obtained its own premises on the sanitation department's property and established regular opening hours for an interested public (Saturdays, 10am to 2pm). No less than sixty radio features and nearly ten TV features covering the venue were produced in the following years, as was proudly reported by its director (*General-Anzeiger der Stadt Wuppertal* 1968).

Although the trash museums in both Bad Säckingen-Wallbach and in Wuppertal are exceptional in their size and attraction, they are not unique in themselves as a form of cultural expression. Archive-based as well as on-site enquiries reveal that rubbish disposal plants – rubbish tips, incinerators and recycling plants – consistently feature corners or small rooms in which objects extracted from rubbish are collected and presentably arranged. Trash museums as a manifestation of 'practising trash' seem to be a virtually automatic accompaniment to modern rubbish disposal since its beginnings in the late nineteenth century and this is documented in technical literature, particularly photographic documentation, and media coverage alike.[4] For instance, a compilation of large black-and-white photographs from 1929, depicting a sorting plant in Cologne that had been put into operation shortly before, includes a picture showing a weirdly equipped rack. Mainly metallic objects are arranged on five solid shelves and – in front – on the floor. Along with measuring devices and domestic appliances, it is military objects such as a spiked helmet, artillery shells, guns,

4 As this article draws on my studies on rubbish and rubbish disposal, which are based on German archive and field material, the focus of this discussion will be Germany. See Windmüller 2004.

knuckle-dusters and sabres, but also art objects – such as a little statue on the second shelf, that catch the eye.

What is represented here, accurately polished, meets its equivalent in another place. A Prague newspaper reported in 1940 on a trash museum in the facilities of the local rubbish incineration plant. According to the article:

> [...] in Glasschränken [werden] goldene und silberne Schlüssel, Münzen und Medaillons, Messer, viele Revolver ältester und neuer Bauart, Stahlhelme der Ententetruppen, Ringe, Bücher, alte Schriften und sogar einige ausgestopfte Tiere zur Schau gestellt – alles Dinge, die das laufende Band in der Maschinerie der Anstalt aus dem Müll zutage gefördert hat. (*Anzeiger der Hauptstadt Prag* 1940)

> [exhibited in glass cabinets there are gold and silver keys, coins and medallions, knives, various revolvers of oldest and newer design, steel helmets of the *Entente* forces, rings, books, old writings and even a couple of stuffed animals on display – all of these things unearthed from the rubbish by the machinery of the plant's conveyor belt.]

Likewise, a so-called trash museum has been established in the facilities of the Berlin-Schöneberger Abfallverwertungsanstalt, the sanitation department of the German capital, which has been referred to as 'maybe the strangest place in the world' (Schultz 1939).

The catalogue of trash museums in the past and present could be continued. Not only because of an apparent fascination emanating from these venues, but also because of a noticeable consistency, they are worthy of investigation from a cultural analytical perspective. In my opinion trash museums allow almost paradigmatic insight into our modern relationship with our discards, our emotional disposition. They condense and at the same time comment on behavioural strategies in respect of refuse, or, in other words: they can be understood as a cultural technique and gesture. In the following I will develop and expound these preliminary remarks.

Trash on Display: Artistic Approaches

In the common perception, rubbish and the museum are seen as opposing terms, as antipodal concepts. What in everyday culture still causes serious astonishment and appears to be odd or even bizarre – that is, the relation between rubbish and the museum – is much more intensely discussed and theoretically reflected on in the arts and art history. In this respect, artistic approaches and analogous studies in art history may serve as a basis for comparing and contrasting trash museums.

The ostentatious use of rubbish in artworks is a twentieth-century phenomenon. It goes along with the emergence and establishment of modern technical rubbish disposal – and its accompanying trash museums. As has been widely described by art historians, the disordered and unstructured has been increasingly preserved in rubbish-concerned art during the last decades. According to Rübel, this kind of trash art has aimed less at a 'poetic embroidery of rubbish and analogous re-auratisation of residuals', than at a 'disturbing loss of shape', at chaos and entropy ['nicht länger eine Poetisierung des Abfalls und eine entsprechende Re-Auratisierung der Reste, sondern in diesen selbstorganisierten Formationen tendiert Abfall zu einer unendlichen Variabilität und entwickelt einen beunruhigenden Verlust an Form'] (2002: 14). Actually, in rubbish art, rubbish tip and museum have physically closed ranks. Artists like Louis Weinberger in Tel Aviv or Vito Acconci in Breda literally work on and with landfills, which they declare to be venues (Rübel 2002: 16), and for an artwork called *The Beauties*, Swiss artist Tina Hauser went into a rubbish bunker to take photos of evolving trash sculptures (Hauser 2004: 88–95).[5]

In Sweden, artists Gunilla Bandolin and Monika Gora installed a rubbish exhibition, entitled 'Garbage Museum', in a trailer which for several

5 Rubbish has also become the subject of several cultural historical exhibitions. See for example the recent exhibition on 'the cognitive, practical, and cultural role of garbage in contemporary life' in New York City, as a result of a collaboration between New York University (museum studies and cultural anthropology) and the New York City Sanitation Department (see Rothstein 2008).

years toured to a total of 55 venues. The exhibition 'combined elements of
art and archaeology and featured 30 items of garbage rotating on moving
belts inside six showcases' (Westerlund/Jansson 2008, n.p.). As explained
by the curators, 'the items were intended to represent life in the 1970s and
were retrieved from garbage dumps' (Westerlund/Jansson 2008, n.p.).[6]
Guest contributors, including writers, artists and journalists, were invited
to develop narratives and interpretations relating to the things on display.
They were requested to produce virtual memories (Susanne Hauser 2001:
115), which were translated into interactive multimedia programmes inte-
grated into the exhibition. But even in this re-aestheticised and poeticised
exhibition concept Bandolin and Gora implemented the theme of sensual
unpleasantness and the provocation offered by trash in its heterogeneous
compactness: 'The walls of the trailer were lined with showcases full of gar-
bage, the smell of which visitors could sample through special boxes' (West-
erlund/Jansson 2008; see also Susanne Hauser 2001: 114–115). According to
Hauser, 'perception expands towards the unperceived and the unstructured
and does not shrink away from the preoccupation with nauseating things.
Nothing must be lost and what is already lost must be re-adopted' ['Die
Wahrnehmung greift aus in ein Gebiet des Nicht-Wahrgenommenen, des
nicht Strukturierten, scheut hier auch nicht vor der Befassung mit ekelbe-
setzten Dingen zurück. Nichts darf verloren gehen und was schon verloren
ist, ist wieder anzueignen'] (Susanne Hauser 2001: 115).

'Turning Trash into Treasure': Strategies of Revaluation

Despite sharing the same name – Bandolin and Gora, as already mentioned,
entitled their project 'Garbage Museum' – at first glance trash museums,
as introduced previously, seem to be completely different in conception.
They are supported by a different mode of handling rubbish. It is not the

6 Objects on display included a scrapped diaper, the door knob of a fridge, a Barbie
 doll missing its head and one leg (see Susanne Hauser 2001: 115).

unformed bulk they are representing, but the attempt to set something against it. Their matter is not rubbish in toto, but separated individual artefacts. Trash museums are fixed on special, peculiar disposed objects, which they strive to re-integrate into social space. Nor do they attempt to capture rubbish in general, but to express an irritation, a strong feeling of amazement, that certain things were thrown away in the first place. Even in its headline, one of the newspaper articles concerning the 1930s Berlin *Müllmuseum* articulates its astonishment at the lack of judgement, which, as the author writes, leads to 'thoughtlessly consigning the most useful and precious things to the rubbish' ['[...] die brauchbarsten und wertvollsten Dinge gedankenlos dem Abfall überantwortet hat'] (*Mainzer Anzeiger* 1942; see also *Königsberger Tageblatt* 1938).

In this respect, trash museums of the kind considered here are symptomatic expressions of a behavioural uncertainty in the relationship of modern industrialised societies to material objects and, even more, of a fragile utilitarian categorical system of things and the concomitant loss of influence of a stable consensus on the definition of modern rubbish disposal. Trash museums appear as an impressive proof of the fact that decisions on 'value' or 'no value' are not always traceable and universally valid. In fact, trash museums are meaningful expressions of subsequent revisions, quasi final rescue agencies, which by their very existence announce emotional expenditure in dealing with rubbish. Recalling his first exhibit, a teddy bear he found on the dump, Eric Thomann describes how he just couldn't bring himself to knock it over (cit. in Vogelsang 2007: 9). Trash museums are instances of revaluation, targeting selected items and aspiring, by stripping away their rubbish status, to eliminate as far as possible all rubbish attributes. From a perspective focussing on the single artefact, rubbish objects are not at all exhibited as rubbish objects.

In conclusion, trash museums as a cultural project are implemented with recourse to a repertoire of strategies, which explore elemental questions of aesthetics and representation. In the following, this repertoire of strategies will concentrate on three core concepts: purgation, consistency, and auratisation.

Purgation

Not by chance, self-portrayals and newspaper reports about trash museums consistently emphasise that the objects' affiliation and integration into the exhibition is preceded by extensive cleaning activities. In Erich Thomann's *Müllmuseum*, in which the whole family is involved, his wife is in charge of cleaning the objects, and he himself of restoring them, before they attain the status of an exhibit. Visual documentations of previous establishments all show solely accurately cleaned items – a fact once more highlighted in accompanying texts. For instance, an article covering the Berlin *Müllmuseum* reports:

> Man darf sich nun nicht etwa vorstellen, dass alle diese Stücke so sauber und wohlgeordnet, wie sie hier an den Wänden hängen, im Hausabfall vorgefunden wurden. Die meisten von ihnen waren verbeult, zerrissen und bis zur Unkenntlichkeit verschmutzt. Es bedurfte daher erst eine sorgfältige [sic] Reinigungsarbeit bis die Kriegsandenken und sonstigen Trophäen öffentlich zur Schau gestellt werden konnten. Manche Helme waren sogar in ihre sämtlichen Bestandteile zerlegt und mussten erst Stück für Stück wieder zusammengesetzt werden, bevor man sie in die Sammlung einreihen konnte. Heute noch müssen die Schauobjekte ständig gepflegt und vor Rost und Mottenfraß bewahrt werden, sollen sie nicht früher oder später gänzlich verkommen. (*Königsberger Tageblatt* 1938)

> [One should not imagine all those items, so clean and well-arranged as they hang on the walls here, were found this way in household rubbish. Most of them were dented, distorted and soiled beyond all recognition. It therefore required careful cleaning work until wartime souvenirs and other trophies could be displayed in public. Some of the helmets were even fragmented into all their components and had to be reassembled bit by bit before they could be included in the collection. Even today the exhibits must be looked after and protected against corrosion and moth damage, if they aren't to decay entirely sooner or later.]

For trash museum curators, part of the cleaning process is the desired reconditioning of broken technical devices,[7] even though it is undeniable

7 Accordingly, the online self-portrayal of the Bad Säckingen Müllmuseum emphasises: 'The Thomann family has not merely put items on display. First everything was

that they will never return to their regular contexts of use. Trash museums work on the elimination not only of dirt, stickiness, defect, but of 'anything that might provoke revulsion and disgust' ['alles, was Ekel oder Abscheu provozieren könnte'] (Susanne Hauser 2001: 101). Not effrontery, but brightness and order are put on display. This basic principle applies also to the material nature of the objects. Items which tend to decay or rot will hardly find their way into the collections, whilst, particularly in the early rubbish museums in the first half of the twentieth century, metallic objects were considerably over-represented. Although there are technical reasons for this – the Cologne facilities for instance featured an electromagnetised sorting system which extracted such items – these prove to be insufficient if looking at semantic attribution.

Consistency

It has been emphasised that in addition to a fuller, material-dependent brightness, metallic objects – as opposed to the trash mode – possess sturdiness and durability, a quality of historicity, and are, at the same time, discursively assured. By stressing the age of the objects and their function as long-time 'witnesses', not only an economic but also a museal value is generated. Here, a double strategy may be seen: though the establishment of a material value and a prospective return of the objects into the economic order is pursued, it is at the same time intentionally impeded. Robert Poth, 'director' of the Wuppertal trash museum, for instance, was asked in an interview in 1968 about two of his trash objects – both copperplate

thoroughly cleaned and some things were repaired. For example, there are, among the two hundred record players, some that still work.' ['Die Familie Thomann hat dies nicht nur einfach aufgestellt. Zunächst wurde alles blank geputzt, manches instandgesetzt. So gibt es unter den zweihundert Plattenspielern und Radioapparaten auch noch funktionierende Exemplare.'] Müllmuseum in Bad Säckingen-Wallbach http://www.bad-saeckingen.de/v2/deutsch/2-Buergerservice-Wirtschaft/1_40_Kultur-Bildung/10_Museen/f_Muellmuseum.php (accessed on 21 July 2008).

engravings with medieval motifs: "'Recently, somebody offered me a nearly four-figure sum", he says, amused. He rejected the offer, however, "because I don't sell anything, as a matter of principle"' ["'Kürzlich bot mir jemand eine fast vierstellige Summe", erzählt er vergnügt. Er lehnte jedoch ab. Aus Prinzip, "Weil ich grundsätzlich nichts verkaufe.""] (*General-Anzeiger der Stadt Wuppertal* 1968). The same article talks about another group of objects:

> Die beste Abteilung im Müllmuseum ist die Bücher-Rubrik. Dort lagern etwa 1000 Folianten, mal in Schweinsleder gebunden, mal in Leinen. Kostbarstes Stück ist vermutlich eine Ausgabe von Machiavelli-Schriften aus dem Jahr 1782. Ein Band hatte vor Jahren schon einen Liebhaber-Preis von 280 Mark. Doch, wie gesagt, verkauft wird nichts.

> [The trash museum's best department is the book section. About 1,000 folio-volumes are stored there, some bound in pigskin, some in linen. The most precious piece is probably an edition of writings by Machiavelli from the year 1782. Years ago, one volume realised a connoisseur's price of 280 Marks. However, as stated, nothing is sold.]

There are similar statements about Erich Thomann's object inventory. For example, a report about the collector states, 'almost everyday there's an antique dealer at Thomann's door who offers plenty of money for his "rubbish". Erich only chuckles and says: "Not a single trouser button leaves the barn"' ['Fast täglich steht bei Thomann ein Antiquitätenhändler vor der Tür und bietet viel Geld für dessen "Müll". Der Erich lacht nur milde und sagt: "Kein Hosenknopf verlässt diese Scheune"'] (Vogelsang 2007: 10).

Statements like this indicate the intention of accumulating things as a museal collection (for instance, as distinguished from flea-markets). They create an aura of institutionalised consistency, reflecting a popular concept of the museum as a place which – according to cultural historian Susanne Hauser – 'in many respects stands against an all-dominant outside economy, which in ever shorter intervals transmits values, ideas and objects to rubbish or recycling' ['[...] in mehrfacher Hinsicht gegen eine außerhalb herrschende Ökonomie steht, die Werte, Vorstellungen wie Gegenstände in immer kürzeren Zyklen dem Abfall oder dem Recycling überantwortet'] (Susanne Hauser 2001: 94).

While museum theorists – as mentioned earlier – consider the inner ties and structural correspondences between trash and museum, trash museums persist in categorical differences. The museum status of rubbish collections is actively constituted by adopting (and communicating) museal forms, most relevant among them the classification of objects and the identification of familiar museum sections: for example, the Berlin *Müllmuseum* includes a war section, an ethnographic section and a natural history section (*Königsberger Tageblatt* 1938). More recent facilities also display – most prominently – a technical section.

Auratisation

Not only the expression 'cabinet of curiosities' commonly used to describe trash museums (Windmüller 2004: 305), but also the range of exhibits and the mode of representation force us to draw a comparison with an early form of cultural historical museum: the *Wunderkammer*, which reflected an interest in 'rarities' ['Raritäten'] (*Mainzer Anzeiger* 1942) and 'curiosities', in 'mysterious and extraordinary things' ['geheimnisvollen und außergewöhnlichen Dingen'] (Hulten 1995: 10), as a place which 'in the microcosm of the collection represents the macrocosm of earth and heaven' ['der im Mikrokosmos der Sammlung den Makrokosmos der Erde und des Himmels repräsentieren sollte'] (te Heesen/Spary 2001: 9).

In accordance with the *Wunderkammer* concept, trash museums are built up around 'an eye for the curious and the rare' ['Blick für das Kuriose und Seltene'] (Krempel 2005: 158), for the particular and the unique, and a corresponding attitude of amazement (Andrea Hauser 2001: 32). It is particularly noticeable here that collecting criteria as well as object inventories of modern trash museums are very much alike both in the operators' preference of items to be displayed and in media coverage. In his basic reflections on *The System of Objects*, Jean Baudrillard refers to a particular range of things which, in a systematic representation of modern artefacts, refuse to be part of the predominant function-based paradigm of

interpretation. According to Baudrillard, some groups of objects appear to be out of the ordinary in the utilitarian system, in concrete terms 'unique, baroque, folkloric, exotic and antique objects' (Baudrillard 2005: 77). These 'appear to run counter to the requirements of functional calculation' and instead undertake 'symbolic' tasks: they 'answer to other kinds of demands such as witness, memory, nostalgia or escapism. It is tempting to treat them as survivals from the traditional, symbolic order', although they 'do play a part in modernity' (Baudrillard 2005: 77).

One may, from a differentiated cultural analytical standpoint, argue against this schematic approach to the modern relationship between humans and objects but nonetheless – in Baudrillard's words – the 'mythology of the antique object' (Baudrillard 2005: 80) serves as an ideal template for the collection principles and object inventories of trash museums. At the outset, by describing the range of objects exhibited I aimed to highlight this canonisation, which shows an astonishing overlap with Baudrillard's classification of mythological objects. With Baudrillard, trash museum objects refer back to a differently organised and oriented past. Despite their exact historical identification of objects, trash museums, analogous to the *Wunderkammer* principle, disregard chronologies.[8] The Wuppertal exhibition for example, according to the local newspaper in 1964, 'talks about *the old days*' ['erzählt von alten Zeiten'] (Ziegler 1964, emphasis added).

Besides their role as preserver and witness of collective history (Vogelsang 2007: 10), trash museums serve as a powerful 'treasure trove for one's own memories' ['eine Fundgrube für eigene Erinnerungen'],[9] which means that they may reveal fictional potential as well. Particularly the collections' exotica and the amazement evoked by them invite the telling of stories. The objects thereby gain a quality to irritate, they nurture insecurity and concern. In 1938, the *Königsberger Tageblatt* reflected on the Berlin *Müllmuseum*:

8 Jannelli points to this fact with regard to small, voluntarily established and -run
 museums, like those described here (Jannelli 2006: 603–614).
9 'Themen/Abfall/Müllmuseum' http://www.innovation-tours.de/deutsch/themen/
 abfall.html#muellmuseum (accessed on 21 July 2008).

Einigermaßen verständlich ist es noch, wenn sich Handgranaten, entladene Granaten, alte Gasmasken, Pistolen, Pulverhörner und ein Maschinengewehrlauf im Hausabfall vorfinden; wie aber heutzutage noch eine geplatzte – schwere Mine in die Mülltonne kommt, ist schlechterdings unerfindlich.

[It is somewhat understandable to find grenades, used artillery shells, old gas masks, handguns, powder horns and machine gun barrels in household rubbish: but how, still today, a badly damaged heavy mine could find its way into a dustbin is thoroughly incomprehensible.]

Secrets and Suspicious Facts

Until now, trash museums, based on their name and explicit localisation, were considered against a museal background and typified as representational rooms of cultural stabilisation. But a closer look reveals another reading. The picture of the Cologne trash museum (see Figure 1) reveals an additional, as yet ignored aesthetic congruence, which furthermore irradiates the trash character of the exhibits and assigned semantisations. The way of staging is not only museal, but also criminalistic. The linear composition on a simple rack is reminiscent of criminalistic evidence rooms, where court exhibits are kept. They are also reminiscent of photographic documentation for tracing evidence in connection with property offences – a type of picture dating back to the mid-nineteenth century.[10]

From this criminalistic point of view, the apparent focus of the militaria-rubbish displays acquires a new dimension. It is hardly surprising that in a Cologne newspaper article from 1930 concerning the local trash museum the author refers to '*murder* weapons' ['Mordwaffen'] (*Kölner Tageblatt* 1930, emphasis added). In this article a suspicious fact has crept into the description: in the trash museums of the early twentieth century, items of rubbish that are fully functional, maybe even as good as new, arouse

10 William Henry Fox Talbot, one of the pioneers of photographic history, reflected on such a photographic practice. See for example his photograph 'Articles of China' (The Pencil of Nature: Plate III).

distrust – particularly if they are weapons. But even 'sterling cutlery, rings, golden bracelets' ['Silberbestecke, Ringe, goldene Armbänder'] found in the rubbish could be indications of a criminal offence. A journalist in Leipzig suggests that, in the case of theft by domestic servants, dustbins are an ideal hiding-place (*Leipziger Neueste Nachrichten* 1942).[11] Thus, rubbish in its massive physical presence seems almost to attract and exude criminal power. Accordingly, each irritating finding may be perceived suspiciously and preserving it in one's own exhibition room provides potential for later access.

This suspicious quality of valuable discards, as seen in the criminalistic mode of interpretation, cannot be simply stripped off when things are re-transferred into social space and order. The traces of an object-biographical connection with rubbish cannot be wiped away – even after careful external cleaning it still sticks to the objects and seems to be decisively responsible for their failure to enter the established institution of the cultural history museum, despite claims to the contrary: every cultural history museum – it is often stated – would be jealous of such treasures (see for example *Königsberger Tageblatt* 1938). Only in very exceptional cases does a direct transfer from rubbish tip to museums of local history occur (see *Norddeutsche Zeitung* 1957). Consequently, the trash museum as an institution of cultural repatriation becomes an indissoluble interim solution in an undefined space.

Even recent trash museums which, because of their wide range of artefacts including many objects of everyday material culture, appear quite innocent, can be adjusted to the mode of suspicion and danger. The collection and exhibition concept *Wunderkammer*, with its observable urge

11 Even victims of homicide are 'disposed of'. An article about the rubbish disposal plant in Munich-Großlappen from the early 1950s reports: 'Sometimes, however, horror rises from the foul-smelling emissions from the city: corpses of newborns slide onto the conveyor belt, torn up by glass splinters and smeared with black mud. "The last one I found on 25th April at a quarter past 12", said worker Olga St. "It was my third."' ['Manchmal aber steigt auch das Grauen aus dem übelriechenden Ausstoß der Großstadt: Leichen von Neugeborenen schlittern über das Förderband, von Glassplittern zerfetzt und von schwarzem Schmutz besudelt. "Das letzte fand ich am 25. April um 12.15 Uhr", sagte die Arbeiterin Olga St. "Es war mein drittes."'] 'Millionen Mark stecken im Müll', 8-Uhr-Blatt, Munich, 9 June 1952.

for expansion, for 'material accumulation', accommodates the obstinacy and unruliness of trash. With the expansion of collections, trash in itself – against all endeavours – pushes into the social sphere. The comforting order of things threatens to turn into its opposite.

The Wuppertal trash museum was reportedly full to bursting soon after its foundation: 'Supervisor Robert Poth [...] has to clear a modest space on his desk each and every morning to be able to work and use the phone' ['Oberaufseher Robert Poth [...] muß sich morgens stets aufs neue einen bescheidenen Raum freischaufeln, um an seinem Schreibtisch arbeiten und telefonieren zu können'] (*Wuppertaler Stadtnachrichten* 1965). One reads the following about Erich Thomanns' facilities: 'As the piles of rubbish grow, the rubbish museum is constantly expanded. The depot in the outbuilding is so full that a new special exhibition is organised every year' ['So wie die Müllberge wachsen, wird auch das Müllmuseum ständig erweitert. Das Lager im Nebengebäude ist so vollgefüllt, dass man jedes Jahr eine neue Sonderausstellung veranstaltet.'].[12] And elsewhere we learn:

> Nachdem er die ersten Puppen gerettet hatte, konnte Thomann mit dem Sammeln nicht mehr aufhören, 'nichts mehr liegen lassen'. Seine Obsession beschreibt er in vier Worten: 'Gesehen, eingepackt, alles behalten. [...] Irgendwann war die Wohnung voll. Aber ich wollte nichts wieder hergeben'. (Vogelsang 2007: 9–10)

> [After he rescued the first dolls, Thomann couldn't stop collecting, he was unable to 'leave anything behind.' He himself describes his obsession in four words: 'Seen, bagged, everything kept.' ... 'At some point my home was entirely filled. But I wouldn't give anything away.']

The 'excessiveness of collection and collecting' (and exhibiting) ['Exzessivität der Sammlung und des Sammelns'] (Susanne Hauser 2001: 96) pushes against an already 'precarious line, which [every] museum draws between the object worth gazing at and the discarded' ['prekäre Grenze, die das Museum zwischen dem Anschauungswürdigen und dem Verworfenen zieht'] (Susanne Hauser 2001: 114).

12 Müllmuseum in Bad Säckingen-Wallbach http://www.bad-saeckingen.de/v2/ deutsch/2-Buergerservice-Wirtschaft/1_40_Kultur-Bildung/10_Museen/f_ Muellmuseum.php (accessed on 21 July 2008).

Hybrid Forms and Structural Ambivalence

The aim of this chapter has been to approach rubbish, its semantics and aesthetic configurations, by exploring a concrete form of appearance, in this case trash museums. From an analytical perspective on everyday culture, this discussion has focussed on this widely neglected and marginal objectivation, which must be taken seriously in its hybrid and transitory potential. In particular, the operators' 'sensual-intuitive approach' ['sinnlich-intuitive Herangehensweise'] (Jannelli 2006: 606), which at the same time, however, reverts to familiar cultural practices, makes trash museums appear as symptomatic expressions of our modern relationship with our discards – and with the material world in general. Although they are conceived as a meaningful comment on our modern throwaway society, trash museums are at the same time its immanent attribute and expression. As a final rescue agency in the removal process they not only serve as a sedative, but also stand for a fundamental questioning of common discarding practices. Trash museums, by their mere existence, sensitise us to the cultural reshaping of a long-established and by now habitualised set of actions.

In this context, it is not about evaluating a quality of museal standards. Whether trash museums are unprofessional imitations or maybe even parodies of the formal vocabulary of cultural history museums, or whether they adopt the social duties and responsibilities of museums, the reference is undeniable – as is its fragility: the venues form an objectified interface between places of disposal and institutionalised places of remembrance and aesthetic production. Like their exhibits they themselves remain in an interim status, on the threshold of society and the discarded, between final exclusion and attempted reintegration, still very near to rubbish, whose dynamic and provocative potential they capture and display.

Works Cited

Assmann, A. (1996), Texte, Spuren, Abfall: die wechselnden Medien des kulturellen Gedächtnisses. In: Böhme, H./Scherpe, K.R. (eds), *Literatur und Kulturwissenschaften. Positionen, Theorien, Modelle.* Reinbek bei Hamburg, Rowohlt: 96–111.

Baudrillard, J. (2005), *The System of Objects.* London, Verso.

Fehr, M. (1989), Müllhalde oder Museum: Endstationen in der Industriegesellschaft. In: Fehr, M./Grohé, S. (eds), *Geschichte – Bild – Museum: Zur Darstellung von Geschichte im Museum.* Cologne, Wienand: 182–196.

Hauser, A. (2001), Staunen – Lernen – Erleben: Bedeutungsebenen gesammelter Objekte und ihrer musealen Präsentation im Wandel. In: Ecker, G. et al. (eds), *Sammeln – Ausstellen – Wegwerfen.* Königstein im Taunus, Helmer: 31–48.

Hauser, S. (2001), *Metamorphosen des Abfalls: Konzepte für alte Industrieareale.* Frankfurt am Main, Campus.

Hauser, T. (2004), Kunstschlacke. *Kunstforum international* 168: 88–95.

Hulten, P. (1994), Zur Ausstellung. In: *Wunderkammern des Abendlandes. Museum und Sammlung im Spiegel der Zeit. Kunst- und Ausstellungshalle der Bundesrepublik Deutschland in Bonn. 25. November 1994 bis 26. Februar 1995.* Bonn, Kunst- und Ausstellungshalle der Bundesrepublik Deutschland: 10.

Jannelli, A. (2006), Wilde Museen: Erkenntnisformen und Gedächtnisarten in Ausstellungen. In: Hengartner T./Moser, J. (eds), *Grenzen und Differenzen: Zur Macht sozialer und kultureller Grenzziehungen. 35. Kongress der Deutschen Gesellschaft für Volkskunde, Dresden 2005.* Leipzig, Universitätsverlag: 603–614.

Krempel, U. (2005), Das Museum und die Reste. Vom Sammeln, Bewahren und vom Übrigbleiben. In: Becker, A. et al. (eds), *Reste: Umgang mit einem Randphänomen.* Bielefeld, Transcript: 157–165.

Müller, P.C. (2003), Müllmuseum in Bad Säckingen-Wallbach: Ein Spiegelbild der Konsumgesellschaft. *Badische Heimat* 4: 673–677.

Rothstein, E. (2008), Nothing's Wasted, Especially Garbage. *The New York Times,* 31 March 2008. http://www.nytimes.com/2008/03/31/arts/31conn. html?ei=5124&e> (accessed on 21 July 2008).

Rübel, D. (2002), Abfall. In: Wagner, M. et al. (eds), *Lexikon des künstlerischen Materials: Werkstoffe der modernen Kunst von Abfall bis Zinn.* Munich, Beck: 13–17.

Schultz, J., Der Türkensäbel im Müllkasten. *Hamburger Fremdenblatt,* 31 August 1939.

Thiekötter, A. (1999), Müllhalde. In: *Museum der Dinge.* Werkbundarchiv, Berlin: 31.

te Heesen, A./Spary, E.C., (2001), Sammeln als Wissen. In: te Heesen, A./Spary, E.C. (eds), *Sammeln als Wissen: Das Sammeln und seine wissenschaftsgeschichtliche Bedeutung*. Göttingen, Wallstein: 7–21.

Thompson, M. (1979), *Rubbish Theory: The Creation and Destruction of Value*. Oxford, Oxford University Press.

Vogelsang, L. (2007), Alles meins! Eine Reise zu den verrücktesten Sammlern der Republik. *Go* 2: 9–17. http://www.reportageschule.de/PDF/G02007/08.pdf (accessed on 21 July 2008).

Westerlund, S./Jansson, I. (2008) *Riksutställningar/Swedish Travelling Exhibitions: From kits to Internet projects*. See. http://www.riksutstallningar.se (accessed on 21 July 2008).

Windmüller, S. (2003), Zeichen gegen das Chaos: Kulturwissenschaftliches Abfallrecycling. *Zeitschrift für Volkskunde* 2: 237–248.

——(2004) *Die Kehrseite der Dinge: Müll, Abfall, Wegwerfen als kulturwissenschaftliches Problem*. Münster, LIT.

Ziegler, E.-A., Das Müllmuseum erzählt von alten Zeiten. *General-Anzeiger der Stadt Wuppertal*, 4 January 1964. See <www.wuppertaler-muellmuseum.de> (accessed on 13 August 2008).

Newspaper Articles* and Websites (authors unknown)

Siebentausend Schätze aus dem Müll: Wuppertaler Müll-Museum enthält Fundsachen aus drei Jahrhunderten/ Weite Ausstrahlung. *General-Anzeiger der Stadt Wuppertal*, 7 September 1968.

Müllmuseum platzt schon aus allen Nähten. *Wuppertaler Stadtnachrichten*, 14 January 1965.

Nicht alles im Müll – ist Müll. *Norddeutsche Zeitung*, Hanover, 24 January 1957.

Millionen Mark stecken im Müll. *8-Uhr-Blatt*, Munich, 9 June 1952.*

Wer Glück hat, findet was... *Leipziger Neueste Nachrichten*, 1 January 1942.*

Besuch im Museum der Abfälle. *Mainzer Anzeiger*, 17 March 1942.*

Prag hat eine 'Wundermühle'. *Anzeiger der Hauptstadt Prag*, 1 August 1940.*

Das Museum der Berliner Abfälle. *Königsberger Tageblatt*, 4 December 1938.

Als Schatzsucher im Kölner Müll. *Kölner Tageblatt*, 16 February 1930.*

http://www.innovation-tours.de/deutsch/themen/abfall.html (accessed on 21 July 2008).

http://www.bad-saeckingen-tourismus.de/index.shtml?muellmuseum (accessed on 21 July 2008).

http://www.muellmuseum-wallbach.via.t-online.de/index.html (accessed on 21 July 2008).

*Early twentieth-century newspaper articles cited are from the Erhard Collection, The Federal Environment Agency (*Umweltbundesamt*), Dessau, Germany. See Windmüller 2004: 55–60.

LEE STICKELLS AND NICOLE SULLY

Haunting the Boneyard

Introduction

Much of the iconic neon signage of the Las Vegas Strip, immortalised in countless films and photographs, lies unplugged and decaying in a parking lot known colloquially as the 'Boneyard' (see Figure 2). For many years the voracious development cycles of the city treated these signs as temporary, disposable commercial signifiers. The eternal present of the Strip – an environment dominated by a continual unfolding of new, ever-more spectacular attractions – enforced what seemed a total erasure of its outmoded built fabric. More recently though, the significance of the signage as an element of Las Vegas's built and cultural heritage is being rediscovered and the salvaged and donated contents are being resurrected as part of the city's Neon Museum project. The Boneyard has become one of the city's spectacles, being the site of popular guided tours through the mounds of discarded signs – the melancholy of these unintended monuments providing another type of allure. There are also plans for a more extensive, permanent display of restored signage when the Neon Museum complex is eventually constructed.

The history and projected future of the signage and architectural fragments that lie in the Boneyard demonstrate a complex interplay of spectacle, obsolescence, abandonment, resurrection and memory. The processes of consumption and disposal at work provide fascinating examples of ways in which the characterisation and valuation of the objects is continually shifting and often contradictory. This chapter will outline that history and some of the issues that emerge, particularly in relation to notions of heritage. It will also draw on recent scholarship that points out the ambiguous categorisations of waste and the complexity of processes of disposal – particularly

their dynamism and importance to wider social processes (Hetherington 2002; DeSilvey 2006; Edensor 2005a; Edensor 2005b).

Adapting Kevin Hetherington's use of the concept of haunting, it will be suggested that the Boneyard is occupied by the 'ghosts' of unfinished or improper disposal. Simultaneously the relics of the Boneyard are city icons, outmoded technology, industrial waste, captivating ruins and cultural heritage: both trash and treasure. The idea of haunting in relation to the varying resonances and differing valuations at work in the Boneyard will be used as a way to recast processes of disposal in relation to contemporary heritage practice.

The Boneyard

> Las Vegas never was more than the largest lightbulb in the world.
> — BALLARD 1981: 187

Just to the north of the Las Vegas downtown area and its City Hall, bordered by busy roads on two sides and low-scale Vegas suburbia on the others, lies the Boneyard. Behind a chain-linked perimeter, large piles of signage and other architectural elements from the city's lost casinos, motels and diners lie quietly in the baking Nevada sun. The masses of bent glass, wires and transformers offer surreal sights, such as a giant heeled shoe that once sparkled with thousands of bulbs (from the Silver Slipper casino), a five-metre high martini glass with a neon olive, and playful stacks of huge neon letters. Very slowly, the frames are rusting, the paint is peeling and fading, and occasionally old light bulbs 'pop' in the intense heat; an air of melancholy pervades these crumbling icons (see Figure 3).

The environment in which the Boneyard resides is itself part of the prosaic shadow of the iconic Strip – a sprawling, car-oriented, suburban

metropolis that is in fact very much like other American cities.[1] This, then, is the unremarkable resting place for the remnants of a spectacle that Tom Wolfe vividly described in 1964:

> Such shapes! Boomerang Modern supports, Palette Curvilinear bars, Hot Shoppe Cantilever roofs and a scalloped swimming pool. Such colors! All the new electrochemical pastels of the Florida littoral: tangerine, broiling magenta, livid pink, incarnadine, fuchsia demure, Congo ruby, methyl green, viridine, aquamarine, phenosafranine, incandescent orange, scarlet fever purple, cyanic blue, tessellated bronze, hospital-fruit-basket orange. And such signs! Two cylinders rose at either end of the Flamingo – eight stories high and covered from top to bottom with neon rings in the shape of bubbles. (Wolfe 1995: 8)

The Las Vegas that Wolfe (and so many others) described has largely disappeared – a victim of the Strip's intense development cannibalism. The historian Hal Rotham described a visit to the newly opened Paris Las Vegas in 1999 that emphasises this characteristic:

> Eerie and exhilarating, the view from the Eiffel Tower didn't exist a decade before. I couldn't see anything that had been on the Strip in 1990. None of the past was there; no Sands or Dunes, two mainstays of the old Strip; no low-cut motel or beach-club casinos on the Strip of the 1950s or 1960s. (Rotham 2003: 317–318)

Further, the conception of visual experience and spatial organisation that post-modern architect and theorist Robert Venturi and his associates valorised in the early 1970s (in their seminal monograph *Learning From Las Vegas*) has been rendered absurd by the Strip's gridlocked traffic and shifts in the way its entertainment complexes are designed. Now it is not a matter of cruising past the neon and buildings at speed but of strolling along the footpath and being immersed in the three-dimensional, theatrical environments of the mega-resort complexes: enjoying the hourly pirate spectacular at Treasure Island or punting down canals in a gondola at the Venetian. Ironically, the heritage fabric of 1950s and 1960s Las Vegas – the period that

1 Anderton and Chase (1997). The Strip is not actually within the City of Las Vegas; it, like many of the residential communities nearby, lies in an unincorporated area. However, it is commonly referred to as part of Las Vegas. We will discuss it in the same way.

perhaps provided the most iconic images of the city – has made way for the development of the Strip as a fantasy world created from the heritage of elsewhere and resulting in what Giovanna Franci describes as the virtual Grand Tour.[2] New York-New York, Paris Las Vegas and The Venetian are not simply themed in the manner of other locations but are supposedly family-friendly (adjusted) reconstructions of their built fabric.[3]

A journey along the Strip from the south, where the famous 'Welcome to Las Vegas' sign is positioned, to the northern end, where Downtown continues its attempts at regeneration, reveals a little of the city and the Strip's history. Towards the north the age of the buildings becomes more diverse, venues such as the drive-through wedding chapels of the 1960s become more apparent. However, so do pawn broking shops and bail bond agencies; the chronological depth of the built fabric here is more a result of a development caesura than concerted preservation.

Beyond the struggle of Downtown, behind a security fence, piled up on the dusty desert floor, the Boneyard gives a powerful sense of the recent history of the city and the waves of change it has undergone. The signage dates back to the 1940s and takes in all manner of businesses, from casinos to wedding chapels. The collection began because the Young Electric Sign Company (YESCO) routinely stored broken and obsolete signs (sometimes re-using components and materials in new projects). Part of that process underscores the ephemeral nature of Las Vegas's built fabric: the signs were rarely owned by the casinos but instead were leased from the sign company. When a casino was remodelled or destroyed – a frequent occurrence – the signs made their way back to YESCO Boneyard. While this external ownership was in many ways responsible for the transient and temporary nature of the signage, it has also been responsible for the

2 Nancy Reed (2001: 152) suggests that Las Vegas's historical reconstructions might serve some public educational purpose.
3 Although Venturi's and his co-writers' conceptions of the spatial experience of Vegas may have been superseded, much of the original analysis still holds; it's just that now the architectural template on the Strip has shifted from Decorated Shed (where 'conventional' building form has symbolism applied to it, e.g. the extravagant signage of the original Stardust) to Duck Building (where the building itself becomes the symbol, e.g. The Luxor Pyramid).

retention of these artefacts. In the 1990s, a number of concerned private donors and the city developed the idea of the Neon Museum, recognising the importance of the signage to the character of Las Vegas.[4]

Although Las Vegas is intimately associated with its neon, the idea of a neon museum is not unique to the city. In the 1980s a number of museums dedicated to the technology were founded, including the Museum of Neon Art (Los Angeles) and the Neon Museum of Philadelphia. However, these museums have a different relationship to the history of the city in which they are located. Neon signage in Las Vegas, and attempts to retain it, are less about a general history or celebration of the technology and more bound up with the identity of the city itself; for example, the incorporation of Las Vegas's neon heritage within the Fremont Street Experience.

The Las Vegas Neon Museum has also produced unique approaches to displaying the neon. YESCO donated their Boneyard and from 1997 onwards the Neon Museum began installing restored signage in Downtown Las Vegas. The eventual plans for the Neon Museum go further: an outdoor neon 'campus' will allow people to walk amongst more restored signs and the iconic lobby recently rescued from the demolished La Concha Hotel will be recast as the visitor centre.

The Boneyard is currently home to over a hundred pieces, only a tiny fraction of the signs that have been removed, replaced and destroyed since Las Vegas boomed after World War II. Still, the large number of pieces indicates the scale of redevelopment and the juxtapositions of the various signs evoke stories of boom and bust, changes in technology, shifts in style and the ever-mutating character of the casinos. Interestingly, despite coming to be emblematic of capitalism and technological modernity, the construction of these signs was, and is, a surprisingly hand-crafted process. The heated glass tubing was bent by a craftsperson, known as a 'bender', by hand and without gloves.[5] However, shifts in architectural design along the Strip and the growing use of computerised signs employing LEDs mean that, although still present, the use of neon is declining (Koeppel 1999: 44).

4 The signage display at the Flamingo hotel in 1944 has been credited with transforming the approach to using neon as signage and serving as the catalyst for its popularity in Las Vegas. See Crowe 1991.

5 For a description of the construction process see Crowe 1991: 34.

The significance of the signs to an understanding of a vanished Las Vegas is perhaps summed up by the claim in *Learning From Las Vegas* that: 'if you take away the signs there is no place' (Venturi et al. 1977: 18).

Las Vegas seems to thrive on its malleability and the idea that it has no fixed identity – consistently obliterating its past in order to provide an environment for visitors that is a constant present, even when it is a reconstructed past. While this is often framed as a virtue, it is problematic for conventional understandings of heritage. Bruce Bégout has asserted that Las Vegas has no 'memory' and that its history is dismissed in the boosting of the spectacle:

> Thus nothing in the city commemorates the Paiute Indians, the first inhabitants of the region, nor the Spanish farmers who gave it its name, the Prairies, nor the Mormon colony that settled in the valley in the late nineteenth century [...] nor even less the resourceful, imaginative men of the Mafia (Siegel and Lansky) who transformed a mere railroad town on the Los Angeles – Salt Lake City line into an oasis of gambling, loose living and luxury. (Bégout 2003: 21)

The character of the huge agglomeration of residential developments that surround the Strip suggests a society with little urge to recognise or preserve the fabric relating to that history. Since World War II the population of Clark County (the municipality that the city proper sits within) has grown enormously. In 1940 it was less than ten thousand people; in 2006 it was over half a million (Las Vegas Community Profile, 2006). By that time the population of the wider Las Vegas area was estimated by the United States Census Bureau at around 1.8 million. The ever-growing collection of gated subdivisions that houses this population, with its abnormally transient character, largely turns its back on the notion of a collective culture.[6] The development of public spaces and public facilities in these areas is haphazard and demonstrates what Hal Rotham describes as the 'distinctive traits in the postmodern United States' (Rotham 2003: 293). Lacking the historical layering or historic cores of cities that grew into the mid-twentieth century, instead they are a sea of sameness:

6 For discussion of the development and character of Las Vegas's wider urban area see for example Littlejohn 1999; Rotham 2003; Schwartz 2003.

> They revolve around a series of indistinguishable centers, all providing the same commercial entities. These fixtures mirror one of the problems of the future, the way in which private, commercial space stands in for public space. Without such private space – stores, coffee shops, and restaurants – most suburbs would have no social space. (Rotham 2003: 293)

The restless urge for redevelopment in Las Vegas, the shedding of history, the valorisation of expansion and the new, transience and withdrawal from the non-commercial public realm, have produced a profoundly ambiguous relationship with the idea of consciously maintaining an historic built fabric. In some ways it seems that Las Vegas does not want or need 'heritage'; dismembering its built environment with few misgivings. Significantly, pre-World War II sites dominate the small number of Clark County entries in the State Register of Historic Places and the National Register of Historic Places. There is little officially recognised of the postwar development and the various heritage organisations (such as Preserve Nevada and The Preservation Association of Clark County) are primarily focused on extant buildings from the early settlement of the city. Those that are concentrated on the more recent, spectacular Vegas (for example the website www.ClassicLasVegas.com and the Las Vegas Archive organisation) have placed an emphasis on other forms of historic documentation – gathering oral histories, photographs, films, gambling ephemera and merchandise. Perhaps inevitably, the latter approach, even when making serious attempts at documenting the city's history, tends towards the sensational. The ClassicLasVegas website states: '[T]he real history of Las Vegas is the story of incredible courage and of desperation; of tragedy and heroic deeds; of injustice and of compassion. And ultimately, of good guys trumping the bad guys.'

The Boneyard and the Neon Museum can be similarly placed within a framework of heritage as spectacle; the reconstructed signs arrayed through Las Vegas's Downtown conjuring an uncanny display of fragmentary relics. One of these, the Flame Restaurant sign, evokes the mood of the 1960s diner while its long, arcing pink arrow points to a void where the diner once sat. Such disjunctions, and the transient, overlapping significances of the signage, point to the way, as Caitlin DeSilvey has described it, 'objects [we would include buildings and places] generate social effects not just in their preservation and persistence but in their destruction and disposal'

(DeSilvey 2006: 324). The Boneyard is perhaps very aptly named: as the resting place for outmoded objects that have, following the terminology of Kevin Hetherington, returned as Las Vegas's 'ghosts' (see Figure 4).

Ghosts

> We encounter the unexpected presence of absence as a ghost. In consumption prac-
> tices there are many ghosts. Things we threw out before we should, things we held
> on to long after they should have been disposed of [...] Ghosts do not only moan
> and rattle their chains, they also speak the language of credit, debt and value. Com-
> monly we understand haunting as an unacknowledged debt and feel a sense of guilt
> in its presence. It is a debt that we, heirs to past consumption, owe for the failure to
> dispose of in the proper manner. (Hetherington 2004: 170)

In developing this idea of haunting, drawing on the work of Jacques Derrida and Avery Gordon, Kevin Hetherington notes that its connotation of 'debt' refers not only to the language of credit cards. He also relates it to 'an ethics of how we "consume" each other as responsible social agents' (171). Social practices relating to the conduits of disposal – managing the transitions of value from one form to another – can produce representational instabili-ties when they are ineffective or incomplete. Within this discussion, this framing of disposal and 'doorkeeping' processes is extended to the field of heritage, specifically through the 'ghost stories' of the Boneyard.

The earlier description of the marginal status of heritage fabric in Las Vegas, and an often-dismissive attitude to the historical qualities of the signage, initially suggests an uncomplicated process of obsolescence and elimination.[7] However, an example of the demolition process that provides the Boneyard's contents, described by Lauren Wilcox in *Smithsonian*, starts to suggest how the disposal of Las Vegas's neon invokes ambiguities and complications in their status as unwanted material. After unceremoniously

7 Steve Weeks of YESCO described the rapid rate of obsolescence of the signs and
 the lack of concern for retention in Harris 2001/2002.

cutting down the 'Tropicana Mobil Park' sign a demolition worker was asked if he was going to transport it along the Strip – the most congested, though direct, route to the Boneyard. He replied enthusiastically, 'hell, yeah!' (Wilcox 2006: 26). Although the sign was in one sense outmoded scrap the driver still sensed the visual power and spectacle involved in the tall neon letters and their kidney-shaped frame parading up the Strip on a flatbed truck in something akin to a funeral procession. This and other responses to the neon remains of the Boneyard point to difficulties of heritage that will be framed here as issues of disposal. A brief overview of some varying processes of consumption and disposal in relation to the neon leftovers will help evoke the complications in recognising, ordering and assigning status and value to the remnants of 'Neon Vegas'.

For the developers and operators of Las Vegas's casinos and entertainment complexes the signs have been most often understood as waste – unwanted debris from outmoded or failed enterprises. Replacing and transforming the physical environment in order to sustain commercial success has required swift and unsentimental changes. For example, the Stardust Resort opened in 1958 and the signage alone was remodelled in 1964, 1965, 1977, 1991 (when the iconic 'Electra-Jag' lettering was replaced by a far more subdued Helvetica font), and 1999. In 2006 the Stardust finally closed, to be rebuilt as Echelon Place, and almost the entire complex was auctioned, including the neon signage (Las Vegas Strip Historical Site 2008).

Sign companies similarly regarded the discarded neon as essentially scrap from their commercial enterprises; it was not typically thought worth saving, although some companies would cannibalise jettisoned neon for use in maintenance. For example, in 1976 YESCO recycled 600 tons of old signs, deeming them of no historical value. However, like other companies they did maintain a boneyard and they also exercised some judgement when retaining signs for it. Steve Weeks of YESCO noted: 'anything that had a little class to it we saved' (Harris 2001/2002: n.p.). The attitude of Charles Barnard, a designer at sign company Ad Art, also suggests that disposal in this realm was not entirely straightforward; he confessed to being 'heartbroken' at modernising the Stardust sign with Helvetica lettering: 'We basically screwed up our own sign' (Harris 2001/2002: n.p.). The YESCO Boneyard built up a jumbled collection of twisted metal, neon, glass and plastics over many years and, although it was not officially open

to the public, it developed an enigmatic allure – the detritus of consumption attracting thousands of curious visitors. However, in 1996, uninterested in managing an inadvertent tourist site, YESCO closed the graveyard and eventually donated the contents to the Neon Museum project (Hall 1999: 36).

For the wider public the remnant signs can and have elicited a broad range of responses and associations. Reactions can range from disinterest to delight and the signs may be regarded as kitsch or serious heritage. Most of Las Vegas's many visitors, and even its residents, are unlikely to give much thought to the significance or fate of the Boneyard: the suburban environment of Clark County described above, and the faux-historical fabric of the Strip place little value on the city's historical fabric. However, that sense of collective disinterest is countered by donation of signs and the passionate concern that those involved with the Neon Museum project have for the material. In 1998 the museum's executive director Barbara Molasky stated that '[W]e want to make sure that not another piece of neon in Las Vegas is lost [...] The whole city will become a museum' (Koeppel 1999: 44).

The Neon Museum project thus seeks to order and stabilise the narrative power of the Boneyard materials – transforming their uncertain, haunting value and returning them to productive use as an orthodox tourist attraction. Drawing on both Nicholas Thomas and David Sibley's work, Tim Edensor has described the way in which heritage sites, museums and other exhibitionary spaces, like the Neon Museum, engage in such processes:

> In these ordered settings, objects are spatialized so they may serve, for instance, as commodities, icons of memory, cultural or historical exemplars, aesthetic focal points or forms of functional apparatus. Objects are situated in a web of techniques including highlighting, mounting, window display and labelling, spatially regulated, selective procedures which banish epistemological and aesthetic ambiguity and disguise the innumerable ways of using objects, thereby limiting the interpretative and practical possibilities for those who encounter things. (Edensor 2005a: 312)

The current Neon Museum exhibit is a series of restored and reconstructed signs spread through the Las Vegas Downtown and accessed by a walking tour. The structuring of the museum in this way blends the typical notion

of an in-situ heritage fabric with the idea of a cultural entertainment experience – a public Pop-Art gallery. The eventual Neon Museum 'campus', more ambitious in its scope, is planned as an open-air museum focused on an extensive display of restored signage. The concrete, shell-shaped lobby of the La Concha Hotel (demolished in 2003) is to be restored as its visitor centre; Barbara Molansky noted that '[T]he lobby would make a perfect visitors center because it's a building and a sign rolled into one' (Deluca 2005: 16).

These plans for the Neon Museum and the intense focus on the processes of recovery and restoration emphasise the effort that is devoted to stabilising objects assigned such historical status. They reflect what Caitlin DeSilvey (in discussing museum and material culture studies) has observed as 'a pervasive identification between the social significance of an artefact and its physical permanence' (DeSilvey 2006: 324). The selection, reconstruction and spatial ordering of the neon signs – the prescribing of a museum space and associated interpretative modes – attempts to consolidate a set of meanings and associations for the material within. It is a fixing and managing of the representational instability of the Boneyard's ruins. The neon is re-invested with a role in the glamorous, spectacular visual language of Las Vegas and its escapist experiences. Barbara Weeks of the Neon Museum has suggested: 'It reminds me of what Vegas was like in the seventies. I think a lot of people long for the good old days when things were not so disposable. The neon sign is our heritage, I guess' (Hall 1999: 37). Once associated with the decadence and debauchery of the city, the signs are now embedded in a nostalgic strategy to revitalise its deteriorating downtown (Koeppel 1999; Hall 1999).

Against the idealised, fixed narrative projected by the Neon Museum, the Boneyard's evocations and ambience are more volatile and ambiguous. The neon ghosts have their own fascinations and thrills – derived from the potency of the mutable, degraded and fragmented signage. Very particular associations, evocations and material narratives flow from the contents of the Boneyard, articulated even through their very constitution as glass, timber, plastic, steel, or fibreglass and the various processes of decay they are subject to. Both Tim Edensor and Caitlin DeSilvey have discussed this power in relation to ruins. Reflecting on sifting through the remains of a

derelict homestead in Montana, DeSilvey sought interpretative approaches to the site that could positively draw on process of decomposition and decay for alternate registers of memory. She argued that '[S]trategies to arrest decay always destroy some cultural traces, even as they preserve others. And decay itself may clear a path for certain kinds of remembrance despite (or because if its?) destructive energies' (DeSilvey 2006: 324). Similarly, in exploring the disordering effects at work in industrial ruins, Edensor suggested that they 'contain manifold surplus resources with which people can construct meaning, stories and practices' (Edensor 2005b: 171).

The Boneyard, with its buckling frames, faded and peeling paintwork, dismembered lettering and the pockmarks of empty light bulb sockets, creates sensuous and cryptic configurations. The ensembles of derelict signs offer up peculiar combinations and associations, new narratives and subversive commentary on the history of Las Vegas as glamorous playground. Hal Foster has noted the particular properties of the outmoded object in this regard, suggesting they might 'spark a brief profane illumination of a past productive mode, social formation and structure of feeling – an uncanny return of a historically repressed moment' (Foster 1993: 54). In the case of the Boneyard, this is reflected in descriptions like that of Neil Barrett (a documentary filmmaker), discussing the original site: 'It was an immensely sad place [...] a carnage of hype' (Hall 1999: 36).

Exorcism/Forgetting

The Boneyard is not simply a ruin or a waste management centre. Throughout its life it has been subject to processes of ordering and curation: from YESCO's selective disposal processes through to the aesthetic choices made in organising the piles of stored signs.[8] Occupying an uncertain position,

8 Dan Romano, a staff member at the Neon Museum, has stated that when donated
 pieces arrive and are placed in the Boneyard: 'I am trying to aesthetically play and

it is a liminal space between museum and ruin – a curated chaos that is always in the process of shifting status. The broken and decaying material that forms the Boneyard (see Figure 5) provides a confrontation with the rude materiality of the Las Vegas spectacle and its industrial fabrication. It is also layered evidence of successive generations of discarded, failed or remodelled ventures. There are melancholy associations and often a sense of loss when the nostalgic image of 'Classic Vegas' is invoked. However, there are also the more uncertain impressions conjured by the lost purposiveness of these industrial artefacts. The 'haunted' quality of the Boneyard – in Hetherington's terms – is generated by these disruptive, unruly qualities of its contents.

If those sentiments and evocations point towards the ghostly quali- ties of the Boneyard, the Neon Museum project can be seen as a move to exorcise those ghosts. The restoration and formal arrangement of the signs within a museum setting represents a process of reordering: conservation and interpretative strategies move to fix the signs within an agreed histori- cal narrative. Alongside that process the physical restoration also smoothes over the confrontational qualities of the degraded signs; particularly the uncanny spectacle of the desiccated material lying exposed in the harsh desert sun. In the Neon Museum vision they are returned to their role as luminous spectacle – disembodied and immaterial icons of the night. In that way they are recovered for consumption within the smooth space of Las Vegas's entertainment industry – an environment of seamless transi- tion, polished and gleaming surfaces, controlled and regulated landscapes, soundscapes and experiences.

The Boneyard thus raises issues about processes of conservation and curation in the face of decay. The discarded signs of the Boneyard were consigned to the status of waste but the memories, desires and fantasies they provoked in their dissolution have maintained them as a spectral presence. Their persistence disrupts the normative aesthetic and sensory apprehen- sion of Las Vegas. Their power in this regard makes the simple restoration

have fun with each piece, as well as make it safe and secure' (email communication, 14 August 2008).

of the signs problematic. As DeSilvey and Edensor have variously argued, entropic processes open up other valid possibilities for interpretation and understanding sites and artefacts. They particularly note the foregrounding of materiality and sensual experience when engaging with the ruined and discarded (Edensor 2005a; Edensor 2005b; DeSilvey 2006). At least some of these issues have driven the Neon Museum's decision to maintain the Boneyard within the project. It is certainly a pragmatic response to the lack of funding and space required to fully resurrect all the signage. However, it is also a conscious recognition of the powerful experience of walking through the Boneyard and the particular pleasures it brings.[9] Thus, the conduits and circuits of disposal at work in the Boneyard and Neon Museum open up interesting possibilities for reconsidering heritage sites and artefacts in relation to processes of conservation and reconstruction.

Conclusion

Even recognising Riegl's theorisation of age-value, the idea of deliberately allowing processes of disintegration to take hold within a museum or herit-age site is contentious.[10] The loss of physical integrity is seen as commen-surate with a loss of memorial efficacy. Memories of experiences are most readily thought of as 'place-specific' and tied to the material persistence of sites; as emphasised in the writings of, amongst others, Edward Casey, Aldo Rossi and Christine Boyer.[11] However, it is also possible to suggest

9 Courtney Mooney (an Historic Preservation Officer with the City of Las Vegas) and Nancy Deaner (a director of the Neon Museum), email communication, 30 January 2008 and 31 January 2008.

10 In his 1903 essay 'On the Modern Cult of Monuments' Riegl defined 'age value' as the general sense of the passage of time produced by the contemplation of monu-ments (1903: 24).

11 On the embedding of memory in place see Casey 2000. On the city and collective memory see Rossi 1982; Boyer 1994.

that the maintenance of personal memory is not inextricably linked with the existence of the place. In his book *Returning to Nothing*, Peter Read examines the processes – both physical and mental – of returning to lost places. While Read's work is primarily concerned with the trauma and grieving involved for individuals who lose loved places, his research also exposes a myriad of ways in which people cultivate 'place memory' in the absence of the place itself. His interviewees used photographs, keepsakes, furniture, poetry and stories to maintain associations and to keep places extant through their memories (Read 1996).

Further, in *The Art of Forgetting*, Adrian Forty has argued that the relationship between objects and memory is not a straightforward one. Drawing on the example of non-Western 'ephemeral monuments', Freud's analysis of memory as an active force, and the difficulties for physical memorialisation that the Holocaust provoked, he has observed that '[W]e cannot take it for granted that artefacts act as the agents of collective memory, nor can they be relied upon to prolong it' (Forty 1999: 7). Architecture has been particularly concerned with the notion that the preservation of built fabric preserves memories from mental decay; that buildings might stand for memories. Forty observes that processes of remembering and forgetting are far more complicated and unpredictable than this. Whatever mnemonic potential objects (including buildings) might have, their role in the memory of place is bound up in processes that intertwine it with forgetting (Forty 1999: 16).

It can be seen that an embedded understanding of the nature of a place as transient and provisional disrupts routine approaches to preserving its status. In the context of Las Vegas, where the social, economic and political forces that drive its continual re-invention are bound so closely to the city's identity, those more fluid techniques for maintaining references to lost places, or negotiating the processes of collective forgetting and remembering, become very relevant. They may even productively inform and shift the site-focused, conservation-driven practices of heritage. The powerful experience of walking amongst the neon fragments complicates questions about the retention of built fabrics, and qualities of varying heritage 'experiences', while the material processes of decay at work open up new interpretative possibilities. The relocation and recasting of Las Vegas's

signage in the Boneyard and the forthcoming Neon Museum provides a powerful, instructive experience. Although it is also complicated by questions about the recasting of the material as a heritage spectacle, the Neon Museum example points to potential explorations of other means by which to recognise and approach the historical fabric of such places – including the 'entropic heritage' practices suggested by DeSilvey (2006: 335).

However, it is most important to finish by noting that whatever possibilities might arise or be sought for alternative heritage practices there are also emergent tensions. Places defined by flux, like Las Vegas, may force the development of innovative techniques for recognising, recording and maintaining heritage, but the loss of the embodied experience should not be taken lightly. The excisions, decontextualisation and obliteration of the past on Las Vegas's Strip allows for disturbing shifts and gaps to appear in the remembering and representation of place.

Works Cited

Anderton, F./Chase, J. (1997), *Las Vegas: The Success of Excess*. London, Ellipsis.

Ballard, J.G. (1981), *Hello America*. New York, Carroll & Graf.

Bégout, B. (2003), *Zeropolis: The experience of Las Vegas*. London, Reaktion Books.

Boyer, M.C. (1994), *The City of Collective Memory: Its Historical Imagery and Architectural Entertainments*. Cambridge, MA, MIT Press.

Casey, E. (2000), *Remembering: A phenomenological study*. Bloomington, Indiana University Press.

Crowe, M.F. (1991), Neon Signs: Their Origin, Use and Maintenance. *APT Bulletin* 23: 30–37.

DeSilvey, C. (2006), Observed Decay: Telling Stories with Mutable Things. *Journal of Material Culture* 11: 318–338.

Deluca, S. (2005), Vegas Seashell. *Preservation: The Magazine of the National Trust for Historic Preservation* 57/November: 16.

Edensor, T. (2005a), Waste matter: The Debris of Industrial Ruins and the Disordering of the Material World. *Journal of Material Culture* 10: 311–332.

——(2005b), *Industrial Ruins: Aesthetics, Materiality and Memory*. Oxford, Berg.

Forty, A. (1999), Introduction. In: Forty, A./Küchler, S. (eds), *The Art of Forgetting*. Oxford, Berg.

Foster, H. (1993), *Compulsive Beauty*. Cambridge, MA, MIT Press.

Franci, G. (2005), *Dreaming Of Italy: Las Vegas And The Virtual Grand Tour*. Reno, University of Nevada Press.

Hall, P. (1999), Electric Ghosts. *AIGA Journal of Graphic Design* 17/2: 28.

Harris, S. (2002), Leftovers/(G)litter. *Cabinet* 5/Winter 2001/2, www.cabinetmagazine.org/issues/5/glitter.php (accessed on 6 December 2007).

Hetherington, K. (2004), Secondhandedness: Consumption. Disposal, and Absent Presence. *Environment and Planning D: Society and Space* 22: 157–173.

Koeppel, D. (1999), Signs From Below. *Metropolis*, 18 April: 44.

Las Vegas Strip Historical Site, http://www.lvstriphistory.com (accessed on 22 August 2008).

Littlejohn, D. (ed.) (1999), *The Real Las Vegas: Life beyond the Strip*. Oxford, Oxford University Press.

Office of Business Development, City of Las Vegas (2006), *Las Vegas Community Profile*. http://www.lasvegasnevada.gov/files/community_profile.pdf (accessed on 20 February 2008).

Read, P. (1996), *Returning to nothing: The meaning of lost places*. Cambridge, Cambridge University Press.

Reed, N. (2001), The Classical Heritage in Neon Lights: Las Vegas, Nevada. *Journal of American Culture* 24/Spring/Summer: 147–152.

Riegl, A. (1903), The modern cult of monuments: its character and origin. Forster, K.W./Ghirardo, D. (trans.), *Oppositions* 25 (1982): 21–50.

Rossi, A. (1982), *The Architecture of the City*. Cambridge, MA, MIT Press.

Rotham, H. (2003), *Neon Metropolis: How Las Vegas started the twenty-first century*. New York, Routledge.

Schwartz, D.G. (2003), *Suburban Xanadu: The casino resort on the Las Vegas Strip and beyond*. New York, Routledge.

Venturi, R. et al. (1972, rev. 1977), *Learning from Las Vegas*. Cambridge MA, MIT Press.

Wilcox, L. (2006), The Best and Brightest. *Smithsonian Magazine* 36/March: 26–27.

Wolfe, T. (1995), Las Vegas (What?) ... (Can't hear you! Too Noisy) Las Vegas!!! In: Tronnes, M. (ed.) (1995), *Literary Las Vegas: The best writing about America's most fabulous City*. New York, Henry Holt and Company: 8. http://www.classiclasvegas.com/home/home.htm (accessed on 20 February 2008).

KATHLEEN JAMES-CHAKRABORTY

Recycling Landscape: Wasteland into Culture

How do we define trash and how do we decide what to recycle? The issue is larger than whether if we wash out a glass bottle or an empty can of soda, we can recoup a deposit upon returning it to the shop or drop it into a separate green bin. While most discussions focus on the scale of household garbage, I want to consider obsolescence on an enormous scale, that of the re-use of industrial installations and the larger landscape into which they are set. I am particularly interested in the intersection of aesthetics, policy, and public opinion that controls their fate after the purpose for which they were created has expired. How does that which has been understood to be trash become the valued repository of cultural memory and appreciated as art? What are the limits of such a transformation?

I will focus on a single example: the Landschaftspark Duisburg-Nord, a park in the northern part of the German city of Duisburg (see Figure 6). The Meiderich blast furnace on the site operated by Thyssen closed in 1985, leaving behind the usual industrial pollution.[1] Designed in 1991 by Peter Latz and Partner, the 750-acre park is the crown jewel of a larger effort to revitalise the Ruhrgebiet, Germany's largest rustbelt, by converting out-moded industrial installations along its northern edge into avant-garde cultural artefacts (see Hober/Ganser 1999; Lee 1999; Gunßer 1999, as well as the special editions of *Garten + Landschaft* 10/1991 and *Topos* 26/1999 devoted to the issue). Like other projects within the International Building Exhibition (IBA) Emscher Park, of which it was a part, the Landschaftspark, which opened in 1994, also aimed to repair the damaged ecology of the region. Although it is not clear to what degree locals have embraced these

1 See Diedrich 1999: 70 and also http://www.landschaftspark.de/de/home/index. php (accessed on 16 September 2008).

projects, the park certainly helped establish an influential new paradigm for landscape design (see Lubow 2004; Diedrich 1999; Hense-Ferch 2000 and Steinglass 2000).

Why consider buildings as trash? Although we speak of rock stars 'trashing' hotel rooms, we do not usually think of abandoned houses or even warehouses as garbage. Whether they are demolished or renovated is a discussion instead usually framed by a mixture of economic, aesthetic, and policy considerations. Although terms like 'outmoded and irreparable' may be employed when such decisions are being made, the fact that the entire structure is seldom disposed of at once, as is the case with even a car or an appliance, but must first be reduced to rubble, to use a term that is not exactly the same as trash, moves even vernacular architecture into a separate category. We 'preserve' buildings, at times through 'adaptive re-use', rather than recycling them.

Perhaps it is only a sleight of hand, but by introducing the word 'scrap', whether used as a verb or a noun, I would like to move into what I see as a grey area between the larger items we send off to the dump and entire structures that, if often uninhabitable, can be recycled in various ways. I do this in the context of recent news articles about thieves stripping churches in England and Germany of their valuable lead and copper roofs, gutters, rain pipes, and architectural decoration (see Kantor 2008; Lukassen 2008). Much of the Meiderich blast furnace could have been quite literally scrapped, its components sold on the open market for their metal. Few of any of them were candidates for the adaptive re-use that has elsewhere in the region seen flourmills converted into art museums, mine pitheads into discos, and train stations into cinemas.

Injecting the words 'filth' and 'filthy' into the discussion further clarifies the way in which the blast furnace was viewed before its conversion into high art. Throughout the Ruhrgebiet's economic heyday, which lasted from the middle of the nineteenth to the middle of the twentieth century, outsiders and inhabitants alike regarded the region with considerable apprehension (see Parent 1984; Streich/Voigt 1998; Rossmann 2000). First, the centre of coalmining, steel production, and related heavy industry on the European continent was extremely dirty. Most mills burned coal from the seam that came almost to the surface in Bochum. A poisonous cloud of

acrid brown smoke hung over the region on all but the best days, penetrating lungs and living rooms alike. Second, it was ugly. Although in the early twentieth century industrial buildings became a primary concern of the German architectural profession, and many talented architects built in the Ruhrgebiet, few contemporaries regarded the region's aesthetic appearance with anything but disdain. Partly as a consequence of this, mine-owners and factory workers alike tended to wax nostalgic for an imagined agrarian utopia, accompanied in the case of the former by the desire that appropriate deference be accorded to them by virtue of their newly elevated social status (see Busch 1993). Not without reason, the Ruhrgebiet was, for the first two-thirds of the twentieth century, widely regarded as a cultural wasteland, in which the raw brutality of capital trumped all else. There were few theatres and publishing houses, no opera houses or universities. The rich were all nouveaux and the poor, torn out of peasant culture, equally far removed from anything whose value was comprehensible to the country's intelligentsia. Finally, it was a place in which people were often treated as if they were expendable. While the Krupp and Thyssen dynasties were richer and more powerful than many hereditary princes, the safety and living standards of their workers was often deplorable. Mining disasters were not uncommon; thousands of slave labourers were worked to death during World War II (see Kuhn/Weiss 2003; Tenfelde/Seidel 2005). A small and inconsequential middle class did little to mediate between the two extremes; nowhere else in Germany was the threat of social unrest greater between the wars. More recently, the guest workers imported into the region from southeastern Europe beginning in the mid-1960s do not always feel valued by the larger society. Although violence is rare, issues of cultural integration are a prominent feature of local politics.[2]

Whether or not the Meiderich blast furnace was trash, as opposed to trashed, by the time of its closing, its transformation within a decade into an internationally influential public park certainly marked a momentous shift in attitude as well as use. Opened in 1903, the furnace was built atop

2 See, for instance, the controversy over the erection of a monumental mosque in the nearby city of Cologne (Landler 2007).

a mineshaft that provided the fuel to smelt iron. The required equipment was designed to function as efficiently as possible; aesthetics played no discernable role in the original arrangement, which was erected shortly before factory architecture became a central concern of the German architectural profession. This in no way deterred the Latz partnership, however, from integrating industrial artefacts into their carefully considered regeneration of the local ecology. Deployed as abstract art on a landscape gradually detoxified of the poisons that had been dumped into the surrounding land and water, the fragments of the blast furnace became subjects of contemplation, even, one might say, objects to be appreciated.

The concept of *Industriekultur*, that is of the conversion of outmoded industrial infrastructure into modern and avant-garde art, was born out of the convergence in the Ruhrgebiet of economic decline, aesthetic experimentation, and the emergence of a Social Democratic Party leadership educated to appreciate the implications of both. Knowing that the structural shift to a service economy could not be stopped dead in its tracks, political and economic leaders strove to make the region more appealing to new employers by emphasising the region's tradition of economic and technological innovation and by providing the high cultural infrastructure it had always lacked (see Ganser 1999). The faith that they placed in art to accomplish social and economic goals could be traced back to German Romanticism; its relationship to industrial design and modern art had been codified by the German Werkbund. Founded in 1906 this was an organisation that brought designers, critics, and industrialists together to transform new industrial products, as well as the environments in which they were produced and sold, into high art. Its progeny included the Bauhaus as well as the reputation that German firms such as Bosch enjoy today for good design (see Schwartz 1996; Betts 2004).

The city of Duisburg lies at the point downstream of Cologne and Düsseldorf where the Ruhr River flows into the Rhine. Beginning in the second half of the nineteenth century it boomed as the region's coal was tapped to produce iron and steel in some of Europe's most modern industrial installations. The city gained the world's largest inland harbour, and heavy industry thrived alongside the port. As was common throughout the Ruhrgebiet, many of the new mills and furnaces were situated outside

or on the fringes of historic city and village centres (see Sutcliffe 1984). Today most of the region's cities are composed of communities gradually annexed over the course of the last century and a half and still separated from one another by green belts containing farms and, more rarely, woodlands. Many of these nuclei grew up around the pitheads of coalmines or in relation to new rail lines. The blast furnace that Latz transformed into the Landschaftspark is located far from the centre of the city, although, as is the case almost everywhere in the largest metropolitan region between Paris and Moscow, the extensive public transportation network reaches its tentacles of streetcars out towards it.

Although there are still steel mills in the region, and a few coal mines remain open along its northern edge, most of the heavy industry that dominated the Ruhrgebiet's economy, employed its largely working class and polluted its environment, had already shut down by the time that the Meiderich blast furnace closed in 1986. Today, although Duisburg remains an important site for the smelting of iron, steel, and other metals, even the more recent arrivals, such as car factories and mobile phone plants in nearby Bochum, are closing, or threatened with closure, as well.[3] On the positive side of the balance sheet, the polarised politics of the first two-thirds of the century have eased as the Social Democrats gained a regular, if intermittent, role in the national government. The party also controlled the state government of North-Rhine Westphalia from 1966 to 2005 and remains in power in many city halls. The once incendiary relationship between capital and labour (more than ten percent of voters in some Ruhrgebiet cities voted for the communists in 1949) has all but disappeared (see Borsdorf 2002: 568–578). Under the Social Democrats, for instance, universities were founded throughout a region whose largest employers had once strenuously and successfully opposed the introduction of higher education.[4] By the eighties, many of the new generation of party loyalists had university degrees.

3 The Opel plant opened in 1962. In October 2004 and again in July 2008 there were strikes there in response to job cuts. The Nokia factory, which opened in 1987, closed in 2008.

4 Most notably, the Ruhr University was founded in Bochum in 1962.

The first generation of plant and mine closings usually resulted in the destruction of the outmoded industrial infrastructure. The pitheads and factory buildings that had dotted the region for over a century began to vanish already in the 1950s, when the photographers Bernd and Hilla Becher began their project of documenting such structures in part to chronicle a disappearing past (see Lange 2007). Appreciative critics tended to see in their meticulously detailed typological series of pitheads, water towers, and grain silos a revival of the industrial aesthetic that had made the Bauhaus one of the highpoints of twentieth-century German cultural achievement – that many of their subjects had been built during the Third Reich was conveniently ignored (see Foster et al. 1990: 521–526). The Bechers' students at the Kunstakademie in Düsseldorf, the renowned art school where Josef Beuys also taught, include many of the best-known German photographers active today. Their enormous aesthetic success was one of the factors that encouraged local pride in what had until recently been viewed as a blight on the once picturesque landscape.

Another symptom of changing attitudes came in 1968 when the inhabitants of the Eisenheim Siedlung in Oberhausen, the city immediately west of the Landschaftspark, fought to restore their decrepit housing rather than move into new quarters (see Beierlorzer et al. 1999). The settlement, the oldest purpose built workers' housing in the region which originally housed mostly miners and their families, dated back to 1845. Although dismissed by planners as outmoded because they lacked modern amenities, these small dwellings with their cottage gardens proved still to be extremely popular with their inhabitants, who distrusted the ability of officials and architects to provide them with quarters they would enjoy more. Their grassroots campaign for renovation instead of replacement demonstrated the gap that was opening up between the aesthetics of the Social Democratic leadership, now committed to a modernism that was widely understood by educated Germans to be the antithesis of National Socialism, and that of actual workers, who cherished the craftsmanship that had gone into their ageing houses as well as the community that had emerged there.

One critical distinction, however, between these two modes of appreciating the era's industrial heritage should be noted. The international audience for the Bechers' photographs was comprised largely of those

who appreciated the intersection of an industrial aesthetic with modernist abstraction. Many of those who campaigned for the preservation of Eisenheim were interested above all in saving modest but cherished homes. They felt alienated from the modernist towers likely to supplant the storey and a half cottages, whose design, although standardised, remained imbued with nostalgia for village life, which indeed continued to flourish in the adjacent gardens, packed as they were with chickens and vegetable patches. There was a gulf, in other words, between the tastes of those who appreciated the Ruhrgebiet's industry as art and those who sought to save its houses because they were either home or history.

This gap had important consequences for the reception of postmodernism in the Ruhrgebiet. While the style is associated in much of the English-speaking world, not always accurately, with the conservative politics of Ronald Reagan and Margaret Thatcher, many of its German advocates, such as Hans Stimmann, who led the so-called 'critical reconstruction' of Berlin, were active Social Democrats (see McLeod 1989). In the Ruhrgebiet, however, the cultural leadership, many of whom were also affiliated with the region's dominant party, remained supportive of modernism, which they continued to equate, in both cases rather questionably, with working class empowerment and resistance to fascism (see James-Chakraborty 2007). This continued allegiance assisted them in recognising the aesthetic worth of the region's obsolete industrial infrastructure.

The legacy of Max Imdahl was crucial (see Imdahl 1996). Appointed the founding professor of art history at the region's first university, the Ruhr University in Bochum, in 1965 at the age of forty, Imdahl pioneered the teaching of contemporary art in Germany. He was an early supporter of the American sculptor Richard Serra. *Terminal*, installed outside the main Bochum train station in 1979, was one of Serra's first major public works; already two years earlier a Serra piece had been installed in a Bochum gallery.[5] Although Serra, who himself worked in steel mills early in his career,

5 Douglas Crimp (in Krauss 1986) claims that the workers who returned the socialists to power in the city government following Christian Democratic criticism of Terminal appreciated the work, but the many Bochumers with whom I have discussed the subject all vehemently disagree.

is best known for his minimalist sculptures created out of enormous and extremely heavy pieces of steel, much of his oeuvre is site-specific. In this he was inspired in part by Robert Smithson, whom he had helped stake out Spiral Jetty (see McShine/Cooke 2007: 26). The interlinked legacy of Smithson and Serra as fostered by Imdahl would prove crucial to the creation of the Landschaftspark. So would the need to popularise an aesthetic so suited to appreciating the Ruhrgebiet. As the controversy over Serra's *Tilted Arc* – which was removed in 1989 from New York's Federal Plaza after office workers complained that it obstructed their use of the Plaza – demonstrates, such art was seldom comprehensible to the masses.

Economic decline, aesthetic success, and the presence of a new socialist cultural policy elite combined to save many of the choice examples of the region's industrial heritage which, like the blast furnace in northern Duisburg, had continued to function for their original purpose into the mid-1980s. The IBA Emscher Park, launched in 1989, created the auspices through which these could put to new uses. They were knitted together through the creation of a Route of Industrial Culture. Other examples of recycling undertaken under IBA auspices include the Gasometer in Oberhausen, which has been the site of both popular exhibitions and avantgarde art installations; the Zeche Zollverein in Essen, a pithead placed on the UNESCO world heritage list and the home of a design museum and school for the combined study of design and management; and the Heinrichshütte, the Hattingen mill where the steel for Serra's earliest sculptures was rolled. However, none of the IBA Emscher Park projects has attracted more attention, or spawned more imitations, than the Landschaftspark.

In 1991 the IBA Emscher Park sponsored a competition for a park on the site of the blast furnace. Peter Latz, the winner, was already over fifty. Professor of Landscape Architecture and Planning at the Technical University in Munich-Weihenstephan, he has practised since 1968 in partnership with his wife Anneliese. Their previous work included most notably a city park on the River Port Island in Saarbrücken, completed in 1989. Here they converted a clogged port into a public park that is in their

words 'the heart of an ecological urban renewal.'[6] A series of waterfalls help purify the water while providing a soothing sound, which dulls the roar of a nearby motorway. The civic nature of the site is marked by new, vaguely classical, walls constructed out of debris scavenged from the site. The slightly postmodern air of this scheme distinguishes it from the more rugged character of the Landschaftspark site.

The Latzs' approach proved perfectly suited to the goals and also the finances of the IBA, which in turn helped prompt Peter Latz's emergence as one of the world's most esteemed and influential landscape architects. Instead of demolishing the blast furnace, Peter and Anneliese Latz advocated the preservation of as much of possible of it. Nor did they espouse expensive and radical interventions in the landscape. Their incremental strategy, and the sophisticated aesthetic sense which accompanied it, set the tone in fact for the IBA's entire effort to refurbish the Emscher region, that is the northern, poorer tier of the Ruhrgebiet, by creating a network of brownfield parks (see Schwarze-Rodrian et al. 2005).

The firm's key strategies included leaving as much of the physical evidence of the site's industrial past in place as possible. The poisoned sintering facility had to be destroyed, but the partnership was able to retain much of the blast furnace's original infrastructure.[7] This they converted to abstract art, without doing anything more than was necessary to stabilise the remains or to hinder their eventual physical decay. Firstly, quietly insisting on an aesthetic approach to these ruined relics, they eschewed the insertion of didactic information that might have hindered this conversion by instead emphasising the technological, social, or even the political context in which they were originally created and used. Secondly, they made subtle interventions, such as the insertion of raised walkways, that facilitated the transformation of a working landscape into spaces for leisure, whether contemplation or play. Barriers, such as train tracks, were largely eliminated, although traces of their presence were preserved. Thirdly, they adopted a flexible approach towards planting, which balanced stately formality in key

6 See http://www.latzundpartner.de/ (accessed on 16 September 2008).
7 http://www.latzundpartner.de/projects/detail/20 (accessed on 16 September 2008).

areas with a laissez-faire attitude in others. Particularly noteworthy was their relaxed attitude towards non-native species, such as the wildflowers that seemed to have arrived with iron ore from Sweden (see Lubow 2004).

Sintering is a metallurgical process in which powder is heated past the melting point in order to form objects. The sintering plant in Meiderich was among the most contaminated parts of the site; only its ruins can be seen today. These are best viewed from the elevated walkway with which the Latzs edged the canal side of the former facility. Such walkways have become one of the signature elements of the Ruhrgebiet's new parks. The Zeche Zollverein in Essen, Nordsternpark in Gelsenkirchen, and Westpark in Bochum all feature such paths. Possibly inspired by the ones designed in 1982 by Bernard Tschumi for the Parc de la Villette in Paris, these provide the overview necessary to get a sense of landscapes whose organisation was originally governed by questions of technological efficiency rather than aesthetics, and which can thus be unnecessarily confusing at ground level.[8] They also provide convenient pathways that offer the pretence of perching atop a largely untouched meadow and alleviate the flatness of the original landscape in which most projections are the residue of industrial activity. Finally, the walkways provide visitors with a sense of empowerment and control similar to that which Norman Foster accorded the public visitors to the German Reichstag who circumnavigate the building's dome from a position atop the legislators. This is a particularly significant inversion in sites that were long closed to all but their workforces, many of whom felt themselves to be mere cogs in machinery run by and for others.

A generation ago the waterways through the Emscher Valley were notoriously noxious. Today the situation has greatly improved. The Latzs channelled the poisoned water through an underground concrete culvert, while creating a repository for rainwater at ground level. Here they retained the hard edges of the original industrial canal rather than softening them through typical creek restoration. The scene today is nonetheless relatively

8 While Tschumi inscribed his paean to Soviet Constructivism upon a blank field, Latz transposed his strategy of traces and his raised walkways to an environment whose physical history he largely preserved.

tranquil and bucolic, a place in which one can imagine boating, if not necessarily swimming.

Elsewhere the park takes on a more emphatically civic character. Here the Latzs created substitutes for the city centres so far removed from industrial installations like this one. They serve as sites for temporary events that can bring together larger publics than ever clustered in village squares or town market places, wrapping them in an effervescent, if temporary, sense of community. If their urbanity is contingent, they are nonetheless compellingly bounded spaces at odds with the open-ended character of not only much of the park but the surrounding, somewhat ill-defined cityscape. The Latzs are especially proud of Piazza Metallica, their homage to the sculpture of minimalists like Carl Andre. In their words, '[I]ron plates that were once used to cover casting moulds in the pig-iron casting works form today the heart of the park'.[9]

The Ruhrgebiet's new cultural infrastructure has not generated the hoped-for economic rebirth. Population continues to decline, in some cases by as much as thirty percent, and unemployment stubbornly remains the highest in western Germany.[10] Nonetheless, the IBA attracted enormous international publicity for the area, almost all of it immensely favourable. And no site has garnered a larger share of this attention than the Landschaftspark. It won the 2001 European Prize for Landscape Architecture; major French and American awards have followed.[11] It has also been the centrepiece of a travelling exhibition of contemporary landscape design organised by the Museum of Modern Art (see Reed 2005). By providing a new template for effective responses to the interlinked problems of urban and environmental degradation, it has inspired a profession to generate new and creative responses to both. The power of this new paradigm lies

9 http://www.latzundpartner.de/projects/detail/18 (accessed on 16 September 2008).
10 See http://www.shrinkingcities.com/standorteo.o.html?&L=1 (accessed on 16 September 2008). Monthly unemployment statistics for each city in the region are published in the Westdeutsche Allgemeine Zeitung.
11 The park has won the EDRA Places Award (2005), the 2004 Play & Leisure Award, the 2001 Grand Medaille d'Urbanisme de l'Académie d'Architecture Paris, and in 2000 the First European Prize for Landscape Architecture Rosa Barba, Barcelona.

in its attentiveness to history and ecological concerns, and in the balance it attempts to create between emphatically popular pursuits and the more rarified concepts of beauty that the Latzs share with those who admire minimalist art. It also lies in the pervasiveness of the problems it addresses.

The Ruhrgebiet is hardly the only urban area losing population as the importance of heavy industry wanes, leaving behind pollution detritus as well as the least skilled and flexible and thus the most impoverished members of the families of the original work forces. The website of the shrinking cities project announces the population of the Ruhrgebiet is projected to fall for another two decades. Other cities addressed by the project include Detroit, Liverpool, and Manchester. Even more prosperous places, such as the San Francisco Bay Area have pockets of poverty that benefit from similar attention. The Courtland Creek project in Oakland, California, by Walter Hood, combined the restoration of a creek and the provision of recreational infrastructure to one of the city's most troubled neighbourhoods (see Brown 2004).

Latz, like Hood, skilfully balances the aesthetic and the popular. Although much of the Landschaftspark offers possibilities for contemplation, spots scattered throughout it are specifically designed as places to have fun. Over 220 events a year are staged in the park.[12] These include plays and dance performances as well as exhibits and open air films. Some of the activities are more unexpected and eccentric. Rock climbers now use the walls of several bunkers, and scuba divers have staked a claim to the interior of the gasometer, which is now filled with water for that purpose. Most dramatic of all, however, is certainly the colourful night lighting developed in 1996 by Jonathan Park, a London-based lighting designer best known for his staging of rock concerts, which is especially effective when seen from the nearby motorway. Its spectacular character, rather removed from the quieter poetry espoused by Latz, makes this one of the iconic Ruhrgebiet sights, included in almost all tourist guides and souvenir books about the region.

12 See http://www.landschaftspark.de/de/eventlocations/index.html (accessed on 16 September 2008).

The Landschaftpark's local reception has nonetheless been mixed. On the one hand, it serves together with another IBA project, the renovation of the Zeche Zollverein, as one of the linchpins of the marketing campaigns that aim to increase local pride in the region and enhance its economic competitiveness in part by simultaneously enhancing attractiveness to new employers and encouraging tourism. On the other, the relatively remote location of the Landschaftspark, which it shares with most IBA projects including the Zeche Zollverein, means that, despite high overall visitor numbers, it often appears entirely abandoned. By the reckoning of its own administrators, it is a seven-minute walk from two different streetcar lines.[13] During the week, even in the summer, the park often feels appropriately abandoned unless some special event, like a rock concert, is on the schedule (in any case, the acoustics are problematic). Special events and facilities, however, combine to raise attendance to impressive levels. According to the park's own website, in 2003 the park was the most visited natural or cultural landscape in the state of North-Rhine Westphalia.[14]

Nonetheless, in the last several years, there has been a backlash against *Industriekultur* as the principal strategy of regional economic development. Great pride is still taken when a local operatic production is successfully staged, for instance, in New York, but the question of how to retain the region's newer base of light industry has become far more urgent than the preservation of sites that have long lacked substantial workforces (see Norbisrath 2008). New projects, such as quarters for the Folkwang Museum in Essen, are being built in preparation for that city's role in 2010 as one of the cultural capitals of Europe, a title it will share with Istanbul, but avant-garde installations are scheduled to play a smaller role in that celebration than the region's working class heritage.[15]

The comprehensive conversion of the means of production into avant-garde art faltered for several reasons. First, many natives of the region

13 See http://www.landschaftspark.de/de/lage/anfahrtsweg/index.html (accessed on 16 September 2008).

14 See http://www.landschaftspark.de/de/home/index.php (accessed on 16 September 2008).

15 See http://www.kulturhauptstadt-europas.de/ (accessed on 16 September 2008).

remained resistant to modernism and thus refused to accept the aesthetic qualities the Bechers and the Latzs recognized in the region's industrial infrastructure (see Scheffran 1990). Only in the 1950s and 1960s had the local working class taste, encouraged by the leadership of the Social Democratic Party, briefly flirted with modern architecture, and by the 1980s few were keen to repeat the experiment. There was little affection for the high rise housing towers, banal office blocks, and concrete campuses of the post-war decades, none of which sported the handsome detailing of corporate skyscrapers in neighbouring Düsseldorf. Moreover, nowhere in Germany was it more difficult to sustain the myth that tied modernism to anti-fascism. Almost everyone remembered the local industrialists' opposition to the establishment of the Weimar Republic and the tacit support most had given to the National Socialists (see Wiesen 2001). The return of prosperity in first the 1930s and then more durably in the 1950s, did not completely erase memories of the suicide of Albert Vögler or the imprisonment of Alfred Krupp, charged with abetting the slave labour upon which many local firms had relied during the war. Finally, even the relatively small intelligentsia who admired artists like Smithson and Serra refused to forget the original context of *Industriekultur*. Such observers were particularly likely to lament the environmental destruction industrialisation had spawned and the social oppression that had accompanied it. Unless personally brought into the process of creating and marketing these new environments, they were likely to be extremely dismissive of them, especially in private.[16]

This does not mean that the park, even when mostly abandoned, does not fulfil important purposes. The ecological situation of the park and its immediate environs has certainly improved enormously thanks to the Latzs' thoughtfulness. In a period when sustainability and other environmental issues have played a major part in German politics, this is enormously appreciated. There is no real wilderness within the park's boundaries, but there is certainly far greater biodiversity than had existed

16 This has been confirmed by my discussions of the subject with dozens of people in Bochum over the course of the last nine years.

for well over a century. The green lungs created by the Landschaftspark and its imitators throughout the region begin to heal the environmental damage wrought by its brief experience of prosperity while serving the still densely settled region's remaining inhabitants. Furthermore, by refusing to erase the physical traces of the site's industrial past, the Latzs preserved the possibility of at least some types of memory. If they and those who have written favourably about the Landschaftspark see in the Piazza Metallica and Sinter Park the sculpture of Smithson and Serra, others, and not just from the surrounding region, are free to be reminded by the same source of specific details in the history of the region's industry.[17] One cannot visit and remain oblivious to what was once here.

What it stands for remains more problematic. The IBA's celebration of the Ruhrgebiet's history of technological prowess was inevitably undercut by its simultaneous attentiveness to repairing the ecology of the region, whose water, land, and air had all been poisoned by an economic prosperity that had enriched only a select few. The issue of memory in post-1989 Germany has focused on the obvious horrors of the Third Reich, but the originality and the richness of the solutions the Latz partnership pioneered here were spurred on by the complexity of a past in which the years 1933 to 1945 comprised only a single neglected chapter. The centrality of the Ruhrgebiet's heavy industry to Hitler's war machine has been glossed over in the literature emanating from the IBA, in which technological modernity is inevitably equated with artistic modernism and, not necessarily by implication, social progress. No visitor to the Landschaftspark would learn anything about this period in the site's history from a casual visit to the park or, for that matter, about the technology of the original infrastructure or its social and environmental costs.

Focusing on the memory of the park's changing physical landscape helps to obscure older, less comfortable truths about its history. Memory is more often individual than collective and, if easily manufactured, is far less durable than the steel that was once Duisburg's main contribution

17　As Latz himself intended, at least according to http://www.thesquarecircle.net/ resources/content.php?id=23 (accessed on 29 September 2008).

to the world economy. The memories evoked for those who come to the Landschaftspark already schooled in the aesthetics of Smithson and Serra will inevitably be different from those of the children of Germans who worked here before, during, or immediately after World War II, which will differ in turn from those of the many guest workers who came to Meiderich beginning in the mid-1960s. Those of the first are more apt to be conditioned not only by their education in the history of art, architecture, and the landscape but also by what locals have written about these places in order to attract precisely such visitors. No experience is more authentic than another, but those of the workers, their descendants, and the neighbours are less likely to be filtered by the publicity machine that was a self-conscious and effective part of the IBA. Privilege, although more likely to facilitate the intellectual gymnastics that convert trash into art, is not the bearer of truth.

Works Cited

Beierlorzer, H. et al. (eds) (1999), *Siedlungskultur: Neue und alte Gartenstädte im Ruhrgebiet*. Braunschweig, Vieweg.

Betts, P. (2004), *The Authority of Everyday Objects: A Cultural History of West German Industrial Design*. Berkeley, University of California.

Borsdorf, U. (ed.) (2002), *Essen: Geschichte einer Stadt*. Essen, POMP.

Brown, P.L., He Measures Oakland's Beat, and Parks Bloom. *New York Times*, 21 March 2004.

Busch, W. (1993), *Bauten der 20er Jahre an Rhein und Ruhr: Architektur als Ausdrucksmittel*. Cologne, J.P. Bachem.

Crimp, D. (1986), Serra's Public Sculpture: Redefining Site Specificity. In: Krauss, R.E. (ed.), *Richard Serra: Sculpture*. New York, Museum of Modern Art: 49–52.

Diedrich, L. (1999), No Politics, No Park: The Duisburg-Nord Model. *Topos* 26/1999: 69–78.

Foster, H. et al. (2004), *Art Since 1900: Modernism, Antimodernism, Postmodernism*. New York, Thames and Hudson.

Ganser, K. (1999), Wandel in Schönheit: Karl Ganser über Nachhaltigkeit, Schönheit und Wandel ohne Wachstum. *Deutsche Bauzeitung* 133/1999: 101–103.

Gunßer, C. (1999), Wandel oder Wachstum: Strukturwandel durch Gestaltung? – Eine Bilanz. *Deutsche Bauzeitung* 133/1999: 66–71.

Hense-Ferch, S., Ein Biotop in der Großstadt. *Süddeutsche Zeitung*, 26 August 2000.

Hober, A./Ganser K. (eds) (1999), *IndustrieKultur: Mythos and Moderne im Ruhrgebiet im Rahmen der IBA Emscher Park*. Essen, Klartext.

Imdahl, M. (1996), *Gesammelte Schriften*. Janhsen-Vukicevic et al. (eds). Frankfurt am Main, Suhrkamp.

James-Chakraborty, K. (2007), Inventing Industrial Culture in Essen. In: Rosenfeld, G.D./Jascot, P.B. (eds), *Beyond Berlin: Twelve German Cities Confront the Nazi Past*. Ann Arbor, University of Michigan Press: 116–142.

Kantor, J., As Price of Lead Soars, British Churches find Holes in Roof. *New York Times*, 8 April 2008.

Kuhn, A./Weiss, T. (eds) (2003), *Zwangsarbeit in Hattingen*. Essen, Klartext.

McShane, K./Cooke, L. (2007), *Richard Serra Sculpture: Forty Years*. New York, Museum of Modern Art.

Landler, M., Germans Split over Mosque and the Role of Islam, *New York Times*, 5 July 2007.

Lange, S. (2007), *Bernd and Hille Becher*. Cambridge, MA, MIT Press.

Lee, H. (1999), Zukunftswerkstatt Park – IBA Emscher Park. *Deutsche Bauzeitung* 133/1999: 104–106.

Lubow, A., The Anti-Olmsted. *New York Times Magazine*, 16 May 2004.

Lukassen, S., Metalldiebe fleddern Kirchen. *Westdeutsche Allgemeine Zeitung*, 11 July 2008.

McLeod, M. (1989), Architecture and Politics in the Reagan Era: From Postmodernism to Deconstructivism. *Assemblage* 8: 22–59.

Norbisrath, G. (2008), New York feiert Bochum. *Westdeutsche Allgemeine Zeitung*, 7 July 2008.

Parent, T. (1984), *Das Ruhrgebiet: Kultur und Geschichte im Review zwischen Rhein und Lippe*. Cologne, DuMont.

Reed, P.S. (2005), *Groundswell: Constructing the Contemporary Landscape*. New York, Museum of Modern Art.

Scheffran, B. (1990) (catalogue and exhibition), *Arbeiterwohnen: Ideal und Wirklichkeit: Zur Geschichte der Möblierung von Arbeiterwohnungen 1850–1950*. Dortmund, Museum für Kunst und Kulturgeschichte.

Schwarze-Rodrian, M. et al. (eds) (2005), *Masterplan Emscher Landschaftspark 2010*. Essen, Klartext.

Schwartz, F.J. (1996), *The Werkbund: Design Theory and Mass Culture before the First World War*. New Haven, Yale.

Steinglass, M. (2000), The Machine in the Garden. *Metropolis* 20/2000: 126–131, 166–167.

Streich, G./Voigt, C. (1998), *Zechen: Dominanten im Revier: Geschichte, Gegenwart, Zukunft*. Essen, Nobel.

Rossmann, A., Rumpeldipumpel. *Frankfurter Allgemeine Zeitung*, 22 August 2000.

Sutcliffe, A. (1984), *Metropolis 1890–1940*. Chicago, University of Chicago Press.

Tenfelde, K./Seidel, H.-C. (eds) (2005), *Zwangsarbeit im Bergwerk*. Essen, Klartext.

Wiesen, J.S. (2001), *West German Industry and the Challenge of the Nazi Past, 1945–1955*. Chapel Hill, University of North Carolina.

TAHL KAMINER

The Triumph of the Insignificant

In 1968 Jean Baudrillard published *The System of Objects*, a book based on the PhD research he had carried out under the supervision of Henri Lefebvre. The book identified some of the changing characteristics of the object in the emerging post-industrial society while employing the logic of industrial society as a critique of these changes. The French sociologist approached objects from the perspective of technical competence and utility, the perspective of production, rendering the subjective attributes of objects superfluous. He wrote that the technological aspect of the object:

> is even – and I do not mean this in any paradoxical sense – the most concrete aspect of the object, for technological development is synonymous with objective structural evolution. In the strictest sense, what happens to the object in the technological sphere is *essential*, whereas what happens to it in the psychological or sociological sphere of needs and practices is *inessential*. (Baudrillard 2005: 3)

The following discussion likewise employs the logic of industrial society and industrial production as a point of departure. However, the exact definitions of the major protagonists of the story told here – the object, trash, the insignificant – transform in tandem with the changes in society and in the means and forms of production described in the following pages. It is precisely these transformations which this chapter intends to unveil en route to discussing the specific challenges to the architectural object – the building.

The major purpose of industrial production within industrial capitalist societies is creating mass-produced commodities. Trash, within the logic of industrial production and capitalist political economy, is consequently the refuse of the process aimed at creating new commodities. Thus trash is the waste of industrial production, the leftover materials after the process of production is completed, whether in the form of cinders created by

burning coal, or caustic solution and bleach remaining from the process of paper-making (Strasser 2000: 90).

This narrow definition widens once the refuse of the complete cycle of production and consumption is included. Mass-produced commodities which suffer from significant over-supply become trash once their price crashes and retailers can no longer sell them. Commodities made for temporal use, such as disposables, 'lose' their use value and become trash. These commodities exit the market and are no longer traded, instantly becoming waste just like the other refuse of industrial production. In other words, trash is the excess of industrial production which cannot re-enter the production and consumption cycle, which cannot be traded on the market and has no value. Lacking a role in the system of industrial production and capitalist political economy, trash, despite being a product of this system, stands 'outside' it.

The insignificant, understood from the perspective of industrial production, is everything which is not related to the technical and utilitarian aspects of the object, such as the psychological or sociological attributes of objects. The point of departure in this chapter is the moment in which trash, lacking use value, is considered insignificant for the cycle of production and consumption. The following pages will delineate the manner in which the excesses produced by society were transformed from being a flaw in the system to being civilisation's major product. Art, culture, collecting, recycling and architecture intertwine in a story which expresses some of the transformations society has undergone in recent decades, a story which, at least from the perspective of industrial production, reflects some of the absurdities of contemporary society.

Collecting

The creation of trash indicated an imperfect production system, a fundamental flaw: industrial production, designed to create commodities, was also responsible for producing something unwarranted, something unnecessary which undermined the integrity and seamless perfection of the system. This flaw brought about the necessity to 'solve' the problem of refuse. Whereas specialised waste-removal companies and dump-sites were created to dispose of the problem, the penultimate solution can be described as a process of rehabilitating refuse and reintroducing it into the production and consumption cycle. This rehabilitation project took a number of forms: a form related to industrial production, an ideological form, and a form correlated to post-industrial society.

Today, the idea of recycling is associated with environmentalism. However, the process of reintegrating refuse into the production-consumption cycle is also of uttermost importance to the capitalist economy, and preceded the rise of environmental concerns in the late 1960s.[1] Recycled material is no longer trash. The excesses of industrial production, once returned to the system, are assigned a value, and the problem of waste is solved in the best possible manner: by creating surplus profit. More than a century ago, for example, yeast extracts, the leftovers of beer brewing processes, were used in the United Kingdom for the creation of a new food product and commodity – Marmite.[2] Thus, leftover refuse could be made once again valuable. Trash became a source of income, and therefore ceased to be trash.

[1] Susan Strasser points out that the term 'recycle' was first used in the 1920s to connote the refinement cycle of petroleum designed to reduce waste (2000: 72). Recycling must be understood here as a practice which differs from the re-use practices of the pre-industrial era, which were the result of scarcity as opposed to the abundance which marks industrial production.

[2] The Marmite Food Company was established in 1902 following the discovery by a German scientist that brewers' yeast cells could be turned into a food product. See http://marmite.com/love/history/birth-of-marmite.html and www.unilever.co.uk/ourbrands/foods/marmite.asp (accessed on 31 March 2009).

This process of recycling in the industrial sense is the form of reintegrating refuse most associated with the idea of recycling.

The second form of reintegrating trash is ideological, and is exemplified by the practice of collecting and by art. In the seventeenth and eighteenth centuries, middle-class collectors imitated the aristocracy, accumulating an art or antique collection by buying artefacts on the market while, in contrast, the aristocrat had amassed his collection by commissioning work and by inheritance. Collecting was thus a means for the middle class of expressing its new-found status in society.

By the nineteenth century, collecting had become a common pastime among members of the middle class. As the middle class expanded, and especially once the figure of the petit-bourgeois was born, collecting grew increasingly idiosyncratic, encompassing such diverse objects as stamps, coins, model ships, badges, maritime souvenirs, trade cards, insects, or dental casts. These collections of oddities were a development from the aristocratic *Wunderkammer*, the cabinet of curiosities. The *Wunderkammer* enabled a prince to express his control and domination of the world. Similarly, the middle-class collector used the collection as a means of ordering the world; he expressed via the collection his own specialisation and individuality by becoming an expert in a specific field in a period in which specialisation and expertise were on the rise, no matter how esoteric the field of interest in question. By implementing categorising and cataloguing methodologies borrowed from sciences such as botany and zoology, the collector established a quasi-scientific mode of expertise. Categorising and ordering the collection expressed the desire of the era to order what seemed to be an increasingly chaotic, messy reality, a reality in constant flux and change. But it was also a means of giving trash a value by placing the single object in a series. The collection projects its meaning on the single object, and this meaning, in turn, bestows a value on the object. The collector assumes the role of the expert who bestows value on these refuse objects by placing them in the collection. The meaning of the collection is projected back onto the collector, merging with his identity. Subject and object intertwine, becoming undifferentiated: the collection is a mark of the individual's identity, an extension of his subjective being; 'what you really collect is always yourself,' observed Baudrillard (2005: 97).

Collecting is an activity which caters to the passions evoked by objects and sidelines the technical aspects and use value of the same objects: 'A utensil is never possessed, because a utensil refers one to the world; what is possessed is always an object abstracted from its function and thus brought into relationship with the subject' (Baudrillard 2005: 91). Thus, collecting provides an entry point for objects which lack use value, or, in other words, an entry point for trash. An object which is the refuse of the cycle of production and consumption and lacks utility and value, receives a new value by being placed in a series. Value can thus be created without the need to reintegrate the object into the cycle of production and consumption, without the need to identify a use value or create an exchange value.[3]

Art

In 1834, the poet and playwright Théophile Gautier ridiculed the middle-class obsession with use value: 'The useless alone is truly beautiful; everything useful is ugly, since it is an expression of a need, and man's needs are, like his pitiful, infirm nature, ignoble and disgusting. – The most useful place in the house is the latrines' (Harrison et al. 1998: 99). In what would become a typical avant-garde gesture, Gautier reversed the idea that the non-utilitarian is trash, transgressing bourgeois norms and ridiculing the middle-class philistine by demeaning the utilitarian object. However, if the idea that trash is the non-utilitarian object is maintained, then art, in its modern, autonomous sense, could be defined as trash: an excess of modern society.[4]

3 In the case of less idiosyncratic collectables, such as stamps, a market emerges and an exchange value is created. The more idiosyncratic collections remain outside a market system and their value is limited to the collector.

4 Freud, in his *Civilisation and its Discontents*, differentiates between two human goals: utility and pleasure. Art is described as a displacement of the libido, an excess of sorts, and as a sibling – albeit of a 'higher order' – of religion and intoxication.

Of course, art is traded in a market and has been assigned an exchange value. Nevertheless, the transformation of art caused by the collapse of the aristocratic court and the formation of an art market created a schism between the market system and the quality system in art. In seventeenth-century Amsterdam, where the art market was born, the mostly uneducated tradesmen who bought art demanded landscape painting, whereas the quality system identified landscape painting as a minor form of art while valuing academic history painting. This quality system originated in the art academies and was based on a social peer group comprised of other artists, and later on critics and institutions such as museums. The gulf separating the market and the quality systems meant a disparity between the value assigned to artwork by each of these systems: artwork which was appreciated by the peer group and thus seen as being of high artistic quality was often assigned a much lower exchange value in the art market.[5] As the art market was limited in its scale, with a marginal turnover, and as the value of an artwork was a specific point of contention between the two systems, art shared certain attributes with trash, existing in a twilight zone between its lack of utility and its position as a (minor) commodity, an excess product of society, though not of industrialisation.

Art, like the practice of collecting, served an ideological role in 'solving' the flaw in the system of production which was made explicit by the mere existence of trash. It elevated the process of reintegrating refuse into an ideal by appropriating discarded everyday objects. The reuse of trash by artists became a prominent feature of 1950s and 1960s art, including the Neo-Realists in Paris, Fluxus in New York, or Arte Povera in Italy, coinciding with 'the second industrial revolution' of the postwar years – the widespread

'The substitutive satisfactions, as offered by art,' Freud wrote, 'are illusions in contrast with reality, but they are none the less effective, thanks to the role which phantasy has assumed in mental life' (1962: 22). The author thanks Gillian Pye for pointing out the relevance of Freud for this topic.

5 Subsequently, artists, critics and philosophers of aesthetics could develop theories of artistic autonomy which legitimated this gulf, demanding that art remain unsubordinated to the market forces in order to maintain quality and authenticity (see Bürger 1996).

implementation of Fordist ideas throughout society. Jean Tinguely created machinic sculptures from metal refuse; Arman stacked junkyard cars and discarded typewriters; Constant Nieuwenhuys incorporated found bicycle wheels in his intricate models. Three precedents foresaw this development: Braque and Picasso's collages, Duchamp's urinal and Schwitters' *Merzbau*. The collage demonstrated the manner in which something new could be created from discarded objects. The early collages by Picasso and Braque, such as the former's *Still Life with Chair Caning* (1912) or the latter's *Fruit Dish* (1912), created new artwork from refuse fragments stuck on a canvas with paint, maintaining a compositional 'wholeness' and cohesion via the organisation of the fragments and by the tension between them. Thus, torn pieces of old newspapers or chair caning could be rescued from their obscurity and be given new meaning and value. Picasso suggested, regarding his 1944 *Bull's Head* created from a bicycle seat and handlebars, that turning rubbish or art into a utensil is itself a virtue:

> [N]ow I would like to see another metamorphosis take place in the opposite direction. Suppose my bull's head is thrown on the scrap heap. Perhaps some day a fellow will come along and say: 'Why there's something that would come in very handy for the handlebars of my bicycle...' and so a double metamorphosis would have been achieved. (Barr 1946: 241)

Duchamp's *Fountain* (1917) was a urinal selected by the artist for its utilitarian characteristics as a means of shocking the bourgeoisie by inserting an object with a daily function into the bastion of autonomous, 'purposeless' art. Yet while connoting the use value of a urinal, the object, which would have been set in a gallery with no connection to sewage pipe or water, was, in fact, a useless object, trash, just like the art surrounding it.[6] The work was accepted as art by ignoring this utilitarian connotation and concentrating on the object's sculptural, plastic qualities.[7]

6 The 'Fountain by R. Mutt' was, of course, rejected by the exhibition's organisers, and therefore was not 'tested' at the time in the context of a gallery.

7 A typical critical approach was expressed in Graham Collier's comment that 'we are forced to look at this utilitarian object [...] with critical eyes and perhaps even to

While many of his peers were preoccupied by the process of abstraction, busy peeling away aspects of reality in search of an essence, Kurt Schwitters preferred to collect material from everyday life and give it new meaning by embedding it in his 'total' spatial work, *Merzbau* (1923–1937), which occupied several rooms in his Hannover home. The re-use of discarded objects in art and in the practice of collecting recycled, in effect, a meaningless quantity of waste – meaningless in relation to the quantities of refuse being produced by society. Nevertheless, both art and collecting served an ideological purpose: bringing about an interest in trash, in the discarded, and, most importantly, turning the process by which refuse is reassigned value into an accepted and desirable practice, a virtue, and thus serving the demands of industrial production and the logic of surplus profit.

Branding

The third form of assigning value to trash was by turning the non-utilitarian, the insignificant aspects of objects, into a source of higher exchange value. Marx famously outlined the fetishist aspect of commodities (McLelland 2003: 472–480), and Georg Simmel described the manner in which people imbue objects with meanings they do not posses, delineating a gap between the objective, concrete existence of objects and their subjective evaluation – a subjective evaluation which is formed, in fact, not only by individual psychology but by society as well (2003: 59–130). Whereas this characteristic of objects existed well before the rise of post-industrial society, up until the the post-war years society focused primarily on the production of commodities and on their utilitarian value. This is exemplified by the focus of the advertising of the nineteenth century on the use value of the

appreciate the flow of its curvilinear surface and its overall proportions on purely sculptural terms' (1972: 202).

commodities (Williams: 2005). The tendency in the early decades of industrial production to create mass-produced commodities which imitated in their form and ornamentation the craft-made products they were meant to replace, consequently giving birth to kitsch, enabled the serial object to evoke something of the status of the hand-made or luxury product, yet primarily served a communicative role of enabling an easy passage from one system of production to another, maintaining product recognition. The advantage of selling a mass-produced commodity as though it were a singular product was hardly noticed at the time. By the 1920s, art and design could direct production towards the creation of objects which expressed a direct relation between form and function, acknowledging the utilitarian as the *raison d'être* of the object, and eliminating the contradiction between form and utility which pervaded early serial commodities.

The influx in the 1950s of a new range of household commodities such as washing machines, vacuum cleaners, or refrigerators signalled a shift from the standardisation and functionalism originally propagated by Constructivists and the Bauhaus school. Baudrillard commented in 1968 that '[o]ur urban civilization is witness to an ever-accelerating procession of generations of products, appliances and gadgets by comparison with which mankind appears to be a remarkably stable species' (2005: 1). Increasingly, exchange value became less dependent on the objective qualities of the commodity – its utility, its quality, its durability – and, instead, reliant on the desire it could evoke in the consumer. This shift of emphasis meant that the aspects of the commodity which were stressed were now those of difference, of uniqueness, of creativity. In an industrial mode of production, however, such characteristics could be created in a mass-produced object only via inessentials, via differences which were insignificant from the perspective of technical competence: by differentiation of colour or form, for example, rather than in terms of utility or durability. Industrial design was no longer assigned the role of creating a 'total' object, in a sense of relating form to utility, but was a means of inserting marginal differences into mass-production (Sennett 2006: 144). Thus, the ascent of post-industrial society meant that the non-utilitarian was increasingly accorded value, a change from which trash directly benefitted. This form of reintegrating refuse follows the logic of post-industrial society, leveraging the imaginary

rather than objective or utilitarian aspects of the object as a means of yielding profit. Whereas many of the properties of the commodity which were responsible for its 'difference' could be often located in the real object, as in the case of a unique colour or form, such 'difference' could be measured only when placed in relation to other commodities rather than by an objective assessment of the singular, concrete product. The disjunction of the properties which enabled 'difference' from the commodity's objective qualities and the role of such properties in conjuring a subjective desire locate them, effectively, in the imaginary realm, in the territory which is, from the perspective of industrial production and technical competence, inessential and insignificant. The passage from an interest in the concrete object to an interest in an abstracted object paralleled the passage from the industrial emphasis on the physical production of commodities to the post-industrial fascination with immaterial information as a commodity, and, in the case of trash, from the real refuse of industrial production to the immaterial excess of the commodity – the insignificant. This last form of reintegrating trash is the most radical of the three described here; it is also a more recent phenomenon and requires further explication, to which I will turn shortly.

Accompanying, if not preceding, these changes were transformations in the status of the artefact. By the 1960s, the quality system and the value system of art coincided, with work which was highly valued by the art institutions also enjoying a high exchange value. This meant that society, and especially the art market, accepted the premise that art be purposeless, creative, free and individual. The provocative and contrarian positions held in the nineteenth century by members of the art for art's sake movement such as Gautier, positions which by the early twentieth century were shared by a relatively small group of progressive art enthusiasts, were now widely accepted. The quality system assumed the role of arbitrating exchange value. In this manner, art, by sharing certain properties with trash – primarily its lack of utilitarian value – was part and parcel of the general rise in the status of trash.

The ascent of post-industrial society and the emphasis on immaterial commodities such as information was buttressed by a specific 'logic' which retreated from an interest in materialism and gave Neo-Platonic and Idealist ideas a prominent position. The favouring of the immaterial, of everything

which is distant from the tactility of reality, meant that the insignificant – everything which was superfluous from a perspective of production and technological competence – was no longer shunned. These changes were manifested, for example, by the introduction of credit cards which enhanced an abstract and immaterial system. While the value of money notes is relatively obscure, the value of a credit card is completely 'invisible', located in the bank account data rather than in the physical card. Consequently, the brand of the card becomes the indication, the representation of value. As a result of such changes, society has experienced a general shift towards the immaterial, towards the insignificant.

Consequently, the insignificant was assigned a value, or, rather, the insignificant was responsible for increasing the exchange value of the object, as it related to personalisation and individuality. The insignificant – or, alternatively, the excess, the trash – became an important factor in the production and consumption cycle, an important player in the market, giving producers a quasi-monopolistic advantage via the production of difference. The insignificant ceased to be a flaw in the system.

The transformations described above, supported by the neoconservatives and neoliberals of the 1970s and 1980s, undermined the idea of a 'real' economy, of 'real' exchange values, an idea which is one of the basic premises of neoclassical capitalism. Value had become totally detached from the object itself and its use value, and this was seen as a manifestation of the postmodern condition and the supposed collapse of a direct relation between signifier and signified. Once the quality, the utility or the durability of a commodity were no longer the basis for its exchange value, an idea of a rational consumer and a 'real' – or 'correct' – price for a commodity dissipated. The excesses of society became its main source of revenue.

The iPod could serve as an example here: it commanded a significant advantage in the market not by offering utilitarian features which exceeded those of its competitors, but via its form, colour, material and brand. It became the best selling music player due to its fetishist aspects rather than due to its function (Smith 2006; Arthur 2005; Fried 2005). Once the market was saturated, once its over-supply and availability meant that its image as a coveted, unique object was undermined, the growth of sales began slowing down, and the Zandl Group, a trends forecaster, commented that '[s]ome backlash is against the ubiquity of the iPod – everyone

has those white headphones on the train' (Smith: 2006). Whereas the iPod is an example of a state-of-the-art manipulation of consumer desires via design and branding, the iPod represents the change of priorities and transformation in the demands of society resulting from the passage to a post-industrial age.

The possibility of selling products via branding meant that something detached from the material aspect of the object had become the major source of surplus value. This situation reached its nadir with the dot com bubble and companies like the infamous Enron. Now, companies could completely avoid production. In hindsight, it is possible to notice that art and collecting not only encouraged 'real' recycling in the industrial sense by turning the rehabilitation of trash into a virtue, but discovered the possibility of circumventing the laborious and costly process of reintegrating trash into production. Art and collecting delineated the practice of bestowing value and, consequently, of replacing industrial production with the production of meaning.

The ideological role of art in the dissemination of the idea of recycling as a virtue was exhausted once the recuperation of trash became ubiquitous, taking place on a grand scale via the wide implementation of recycling processes and the bestowing of meaning on the insignificant via branding. Art, instead, turned to recycling itself, using art and culture as an endless source for its material. The major inspiration was no longer Duchamp's urinal, but his 1919 disfiguration of the Mona Lisa, *L.H.O.O.Q.* Whereas some artists, such as Cindy Sherman, cited mass culture in their work, others, such as the painter Pat Steir or the conceptual artist Sherrie Levine, cited directly from art's canon.[8] The artistic project of reintegration focused now on culture, and especially on the tensions between high and low culture, with diverse 'meanings' flowing in both directions. By attempting to capitalise on the quality associated with high art while also incorporating elements from mass culture, art attempted to be both classical and 'of its time', and to boast

8 Such as Pat Steir's *The Breughel Series*, a reworking of Breughel the Elder's *Flowers in a Blue Vase* (1599), and Sherrie Levine's 'appropriation art', including her 1991 bronze urinal citing Duchamp's Fountain.

of both quality and popularity. Whereas classic art is deemed irrelevant to the zeitgeist, art which relates to the spirit of the age becomes obsolete in the near future. By veiling the contradiction, postmodernist art which cited from its own past and from mass culture could claim to be both 'of its time' *and* eternal. The artistic project of recycling was no longer directly related to the reintegration of refuse into the cycle of production and consumption, but rather to transforming the artistic object, the artefact, from a minor commodity to a major one and to preventing the trivialisation of art by the progress of time.

Architecture

The passage from an industrial to a post-industrial society was accompanied by economic and social turbulence, including the oil crisis, inflation, high unemployment, and social unrest. Already in the May 1968 uprising in Paris the students and the ultra-left criticised the assembly-line, rebuked consumer society, and castigated the commodity. Catch-phrases such as *cache-toi, objet!*, a piece of May 1968 graffiti in the Sorbonne, represented the students' anguish. The critique of objects was echoed by the conceptual art of the period, which perceived the artefact as a commodity and preferred to locate the essence of art in the supposed safety of the artist's mind, in the idea rather than in its material expression – the artist's mind supposedly sheltering art from commodification.

Within architecture, the critique of utilitarianism was expressed in the critique of modernism. The modernist movement in architecture was vilified as bureaucratic, functionalist and de-humanising. The Corbusian idea that housing should be a *machine à habiter* came to symbolise the implementation of discredited Fordist ideas within architectural production; the modernist archetypal slab was no longer tenable. The disgust with objects was manifested in the work of groups such as Superstudio and Archizoom, which, in their more radical projects from the late 1960s

and early 1970s, completely dissolved the architectural object, the building. Archizoom's *No-Stop City* described vertically stacked, infinite car park plateaus, ordering and organising within them all aspects of human life. The neutrality of the infinite plateau and the absence of personalisation were a pre-condition for the individual's self-realisation imagined by the architects. Objects were reduced to a bare minimum. Utilitarianism was prominent, but exaggerated to the level of the absurd, and architecture became superfluous.

The Superstudio project *Five Fundamental Acts* described a grid-plateau, a 'super-surface', an environment rather than a tangible building. The super-surface became the substitute for architecture, hiding beneath its reflective surface technology which supplied via socket-nodes all human needs; the utilitarian aspects of daily-life turned invisible, relegated to an underground infrastructure and allowing imagination and life to reign. Mankind rediscovered its true essence, an authentic way of living without wants or objects.

Other groups, such as UFO, Group 9999, or Haus Rucker Co., developed pneumatic inflatables – ephemeral, temporary objects, substitutes for the solid, burdened presence of traditional buildings. The radical French group Utopie, comprising of sociologists and architects – including the young Baudrillard – found itself in the 1970s at an impasse, with the group's theoretical section refusing to legitimise the creation of any object, no matter how ephemeral, by the architects (see Violeau 1999). However, these groups ended up solidifying and sanctioning via their critique the trajectory already taken by post-industrial society. By attacking the object itself, they diminished its material aspects. Their remonstrations only furthered the appeal of the intangible and insignificant aspects of the commodity at the expense of its use value; the real object, in post-industrial society, could be easily circumvented via its excesses, via the insignificant.

The critique of modernism led to a growing interest in architectural 'meaning'. The building was no longer understood as a utilitarian object, but as a means of communication. The essence of architecture was thus placed at a distance from the concrete object (see Jencks and Baird 1969; Jencks 1977). The architecture which followed – including the neorationalism of Aldo Rossi, the postmodernism of Michael Graves and the experimentation

of Peter Eisenman – disguised its idealism with a veneer of reverence for the object. Rossi, who called for a return to disciplinarity, was fascinated by the ideal type rather than the real building and claimed that type is 'the very idea of architecture, that which is closest to its essence' (1991: 41). Postmodernist architecture, like its artistic sibling, cited both from mass culture and disciplinary history as a means of constructing complex meanings and achieving popularity and quality, identifying architecture as a cultural artefact. Eisenman created supposedly authorless, technical descriptions of formal transformation, providing a 'design log' which resembled a DIY manual. In effect, he depicted imaginary rather than real transformations, taking place in the mind of the designer rather than in reality. Issues such as the tactility of materials, the social relevance of architecture and the functional aspects of buildings receded from view, marginalised by ideas which were based on the understanding of architecture as an abstract essence which transcends material reality. The evolution of the postmodernist style into deconstructivist architecture in the 1980s primarily involved recuperating an idea of aesthetic quality while sidelining the interest in popularity; deconstructivist practices remained uninterested in the technical competence, use value or concrete aspects of the architectural object. Phenomenology, which provided a solution to the schism of subject and object by suggesting 'experience' as a mediation between the two, was imported into architectural practice, however, as a means of buttressing individual, subjective experience. By 2002, the experiential aspects of the buildings of Daniel Libeskind and Steven Holl were superseded by Diller and Scofidio's *Blur Building*, a structure which produced a cloud of fog, replacing the concrete object with an experience, an atmosphere.

Whereas the work of Superstudio, Archizoom, Eisenman and many of their peers was construed as a critique of consumer society, by the mid-1990s architectural design, and particularly the design of landmark buildings, was increasingly becoming responsible for creating surplus profit. The iconic Guggenheim Bilbao, designed by Frank Gehry, initiated a tourist industry in a decaying former industrial town on the margins of the Iberian Peninsula, and generated a growing demand for 'city branding'. The building-idea came to symbolise the city; the creativity and uniqueness of the design was projected onto Bilbao, affecting its identity. The aspects of

the building which were insignificant from the perspective of industrial production – the design choices related to form, material and colour which were not an outcome of programmatic, technical or production necessities – became responsible for the building's efficacy. The success of the Guggenheim Bilbao was followed by a global rush to realise unique buildings, whether in Dubai, Birmingham or Beijing (see Kaminer 2007).

In these years architecture began producing work which already accepted the ideas at the heart of post-industrial society, exemplified by the work of Rem Koolhaas and especially by the projects of the Dutch architecture studio MVRDV. Koolhaas founded AMO as a consultancy bureau rather than as a firm interested in realisation, in other words, inferring that architecture could circumvent building altogether. In his own writings and in interviews, Koolhaas has consistently demanded architectural deference to the intangible forces of the market; his preference for the abstract rather than the concrete is manifested in the Dutch architect's description of the Seattle Library by OMA as 'an information store', in the value he found in the analysis of Universal Studios – despite its failure to produce a building – and in his collaborations with companies such as Prada.

MVRDV developed quasi-scientific methods of manipulating absurd data as a means of exposing the subordination of the realised building to abstract, intangible forces. Tax differences between the Netherlands and Belgium, for example, appeared in MVRDV's Datascapes as the agency determining architectural development along the borders between the two countries rather than the decisions of the architect. Consequently, MVRDV's work inferred that absurd information is the major force in society, with material objects, such as buildings, becoming merely a representation of this information.

The information overload, the bizarre regulations and absurd data all led Winy Maas of MVRDV to declare that 'the world, it seems to me, is now composed of an endless quantity of "shit"' – exposing the anxiety created by the indefatigable manipulation of data and information (cit. in Patteeuw 2003: 133). Such an anxiety takes centre stage in Koolhaas's 2001 essay 'Junk Space'. 'Junk Space' exposes the extremity and darkness pervading the work of the Dutch architect. It is a distressing summary of

the failures of modernity. Its ecstatic Baudrillardian language is a prophecy of the present, a prophecy of doom:

> Because we abhor the utilitarian, we have condemned ourselves to a life-long immersion in the arbitrary[...] 'Identity' is the new junk food for the dispossessed, globalization's fodder for the disenfranchised... If space-junk is the human debris that litters the universe, junk-space is the residue mankind leaves on the planet. [...] Junkspace is the Bermuda triangle of concepts, a Petri dish abandoned: it cancels distinctions, undermines resolve, confuses intention with realization. It replaces hierarchy with accumulation, composition with addition. (Koolhaas 2004: 162–163)

'Junk Space' is a tangled stream of consciousness, creating in the labyrinthine text feelings of disorientation and of excess which parallel those of the contemporary civilisation which Koolhaas describes. The ellipsis repeated throughout the essay – almost one hundred times – suggests a repetition ad infinitum of the essay's diatribes against architecture, against modernity, and against civilisation. 'Junk Space' renders every action, every construct, every thought, useless: it is a text which leads to total paralysis, suggesting that the creation of excess, in the form of junk space, is the end result of modern civilisation. The essay spares nothing, and targets the things Koolhaas loves as much as the things he loathes. The essay erases everything, creating a tabula rasa, a clean slate, by an act of total demolition. The junk space which Koolhaas criticises is merely another form of excess, of trash, of the insignificant, elevated to the position of an all-encompassing phenomenon, an aporia marking the suffocation of society by its own refuse.

Works Cited

Arthur, C., iPod Nano Owners in Screen Scratch Trauma. *The Register*, 23 September 2005. www.theregister.co.uk/2005/09/23/ipod_nano_scratching/ (accessed on 31 March 2009).

Barr, A. (1946), *Picasso: Fifty Years of His Art*. New York, MOMA.

Baudrillard, J. (2005), *The System of Objects*. London/New York, Verso.

Bürger, P. (1996), *Theory of the Avant-Garde*. Minneapolis, University of Minnesota Press.

Collier, G. (1972), *Art and the Creative Consciousness*. Englewood Cliffs, NJ, Prentice-Hall.

Freud, S. (1962), *Civilization and its Discontents*. New York, W.W. Norton.

Fried, I., Suit Filed over Nano Scratches, *CNET News*, 21/10/2005. Cf. news.cnet.com/Suit-filed-over-Nano-scratches/2100-1047_3-5906399.html (accessed on 31 March 2009).

Gautier, T. (1998), From Preface to *Mademoiselle de Maupin*. In: Harrison, C. (ed.), *Art in Theory 1815–1900*. London, Blackwell: 96–100.

Jencks, C./Baird, G. (eds) (1969), *Meaning in Architecture*. London, Barrie and Rockliff.

Jencks, C. (1977), *The Language of Post-Modern Architecture*. London, Academy Editions.

Kaminer, T. (2007), Autonomy and Commerce: The Integration of Architectural Autonomy. *Architecture Research Quarterly* 11/1: 63–70.

Koolhaas, R. (2004), Junk Space. In: OMA/AMO & Koolhaas, R., *Content*. Cologne, Taschen: 162–171.

Marx, K. (2003), The Fetishism of Commodities. In: McLelland, D. (ed.), *Karl Marx: Selected Writings*. Oxford/New York, Oxford University Press: 472–480.

Morel, P. (2003), We're All Experts Now. In: Patteeuw, V. (ed.), *Reading MVRDV*. Rotterdam, NAI Publishers: 122–135.

Rossi, A. (1991), *The Architecture of the City*. Cambridge, MA/London, MIT Press.

Sennett, R. (2006), *The Culture of New Capitalism*. London/New Haven, Yale University Press.

Simmel, G. (2003), *The Philosophy of Money*. London/New York, Routledge.

Smith, D., Why the iPod is Losing its Cool. *The Observer*, 10 November 2006. Cf. www.guardian.co.uk/technology/2006/sep/10/news.theobserver1 (accessed on 31 March 2009).

Strasser, S. (2000), *Waste and Want: A Social History of Trash*. New York, Holt.

Violeau, J. (1999), Utopie: in Acts... In: Dessauce, M. (ed.), *The Inflatable Moment: Pneumatics and Protest in '68*. New York, Princeton Architectural Press: 37–59.

Williams, R. (2005), Advertising: The Magic System. In: *Culture and Materialism*. London/New York, Verso: 170–195.

DOUGLAS SMITH

Scrapbooks: Recycling the *Lumpen* in Benjamin and Bataille

This chapter sets out to examine the question of recycling in aesthetics and politics on the basis of an exploration of the contrast between the work of Walter Benjamin and Georges Bataille. Throughout the 1930s, Benjamin worked on an untidy overspilling manuscript about recuperating trash, *The Arcades Project*, while in 1949 Bataille published a neatly organised book in praise of waste, *The Accursed Share*.[1] *The Arcades Project* is essentially a scrapbook of materials relating to nineteenth-century Paris, a collection of diverse notes and quotations organised loosely under a number of headings. As assembler of the scrapbook, Benjamin implicitly follows Baudelaire in casting himself as a *chiffonnier* or *Lumpensammler* or ragpicker, someone who recycles waste or discarded materials and so exists outside the utilitarian world of bourgeois capitalist production and consumption. *The Arcades Project* took shape through the 1930s, the same period in which Georges Bataille was developing a different approach to the themes of waste and value that would culminate in the publication of *The Accursed Share* in 1949. According to Bataille, all human societies generate an economic surplus that needs to be expended or 'wasted' in sacred activities, if social turmoil is to be avoided. For Bataille, in contrast to Benjamin, the aim of culture is to waste what has been saved, not save what has been wasted. Rags are not recycled but torn to (further) shreds. To Benjamin's scrapbook, then, Bataille opposes a book about scrap. In sum, Benjamin and Bataille appear to advance diametrically opposed models of culture, redemptive on the one hand and anti-redemptive on the other, to use the terminology of Leo

1 See W. Benjamin, *The Arcades Project* (1999a) and *Passagen-Werk* (1982), hereafter *AP* and *PW*, and G. Bataille, *The Accursed Share* (1982) and *La Part maudite* (1967).

Bersani (1990). In order to explore this contrast and its implications, this chapter will investigate the concept of the *Lumpen* in relation to Benjamin and Bataille, with a particular focus on their readings of Baudelaire.

Lumpensammler and Lumpenproletariat: Baudelaire, Benjamin and Marx

The ragpicker was a common figure in nineteenth-century French literature, an emblem of urban abjection. In Victor Hugo's *Les Misérables* (1862), the ragpicker was equated with the sewer worker as French society's lowest of the low: 'ces deux êtres auxquels toutes les choses matérielles de la civilisation viennent aboutir, l'égoutier qui balaye la boue et le chiffonnier qui ramasse les guenilles' [those two creatures with whom all the things of material civilization come to an end, the sewer sweeper who brushes away the mud and the ragpicker who collects shreds of clothing] (Hugo 1951: 610).[2]

The ragpicker's abjection was not simply a question of his business, the recycling of refuse, but also of social behaviour, and in particular the abuse of alcohol. Thus Baudelaire's references to the ragpicker occur in texts that are devoted in part to the effects of alcoholic intoxication, as in 'Du vin et du haschich' ['On Wine and Hashish'] and 'Le Vin des chiffonniers' ['The Wine of the Ragpickers']. The ragpicker is then an ambiguous figure, one of recuperation and dissipation, accumulation and expenditure. The poem 'The Wine of the Ragpickers' (1852/1857) emphasises the drunken song of the ragpicker, while the prose text 'On Wine and Hashish' (1851) stresses his business:

> Voici un homme chargé de ramasser les débris d'une journée de la capitale. Tout ce que la grande cité a rejeté, tout ce qu'elle a perdu, tout ce qu'elle a dédaigné, tout ce qu'elle a brisé, il le catalogue, il le collectionne. Il compulse les archives de la débauche, le capharaüm des rebuts. Il fait un triage, un choix intelligent, il ramasse, comme un

2 My translation. Unless otherwise attributed, all further translations are my own.

avare un trésor, les ordures qui, remâchées par la divinité de l'Industrie, deviendront des objets d'utilité ou de jouissance. (Baudelaire 1851: 381–382)

[Here is a man whose task is to gather the day's rubbish produced in the capital. Everything that the big city has rejected, everything it has lost, everything it has scorned, everything it has broken he catalogues and collects. He consults the archives of debauchery, the capharnaum of waste. He sorts things out and makes an intelligent selection; he collects, as a miser does treasure, rubbish that will be restored as objects of use or pleasure having passed through the jaws of the goddess of Industry.]

In 'The Wine of the Ragpickers', Baudelaire suggests a parallel between the ragpicker and the poet: 'On voit un chiffonnier qui vient, hochant la tête,/ Butant, et se cognant aux murs comme un poète' ['A ragpicker can be seen approaching, nodding his head,/Bumping and knocking into walls like a poet'] (Baudelaire 1852/1857: 106). For Benjamin, this simile provides a key to Baudelaire's poetic project, and the poet's description of the ragpicker is to be read as an indirect self-portrait: 'Diese Beschreibung ist eine einzige ausgedehnte Metapher für das Verfahren des Dichters nach dem Herzen von Baudelaire. Lumpensammler oder Poet – der Abhub geht beide an' (Benjamin 1974: 79). [This description is one extended metaphor for the poetic method, as Baudelaire practised it. Ragpicker and poet: both are concerned with refuse (Benjamin 1973: 73–80)].

Benjamin elaborated on this remark in a comment in *The Arcades Project*:

Der Chiffonnier ist die provokatorischste Figur menschlichen Elends. Lumpen-proletarier im doppelten Sinn, in Lumpen bekleidet und mit Lumpen befaßt [...] Baudelaire erkennt sich, wie aus dieser Prosaschilderung von 1851 des Lumpen-sammlers zu ersehen ist, in ihm wieder. (*PW*, I: 441)

[The ragpicker is the most provocative figure of human misery. 'Ragtag' Lumpen-proletarier in a double sense: clothed in rags and occupied with rags [...] As may be gathered from this prose description of 1851, Baudelaire recognizes himself in the figure of the ragman.] (*AP*: 349–350)

Beyond Baudelaire's identification with the ragpicker, what is important here is Benjamin's association of the *Lumpensammler* (ragpicker) with the Lumpenproletariat. This association is not just a question of a shared

prefix but of a political association. The term 'Lumpenproletariat' was developed by Karl Marx and Friedrich Engels in the late 1840s to designate a motley group of social outsiders who fell through the net of the class system, a parasitic criminal subculture whose political allegiances were for sale to the highest bidder (see Draper 1972: 2285–2312). The prefix *Lumpen* mobilised two related meanings – 'rags' and 'rogues' – since the raggedly dressed had come to be identified with the morally reprehensible. The term effectively operated to distinguish a 'good' revolutionary proletariat from a 'bad' morally dissipated pool of casual workers and social parasites. As Robert Bussard has shown, the use of the term by Marx and Engels expresses attitudes of social revulsion similar to those manifested by conservative critiques of the 'mob' or 'dangerous classes' in the wake of the French Revolution (Bussard 1987: 687).[3] For Dominick LaCapra, the notion of the Lumpenproletariat gives oblique expression to the anxiety that the European working class might not be as revolutionary as Marx and Engels hoped (LaCapra 1983: 284). In a further ironic twist, Jacques Rancière has suggested that the motley character of Marx and Engels's Lumpenproletariat reflects the social status and straitened circumstances of the community of revolutionary intellectuals to which they belonged during their English exile (Rancière 2007: 151).

The climax of Marx and Engels's exploration of the Lumpenproletariat occurs in Marx's *The Eighteenth Brumaire of Louis Bonaparte* (1852), his extended analysis of the French coup d'état of December 1851, when Louis Bonaparte overturned the Second Republic to inaugurate the Second Empire, transforming himself from President into Napoleon III. For Marx, Louis Bonaparte's success derives from his astute mobilisation of the Lumpenproletariat against more progressive elements of society. Napoleon III's rise to power rests on a patchwork coalition of the marginal, the self-serving and the parasitic, a diverse band of social outcasts, a non-class that paradoxically manages to block any class-based movement. Marx's description of Napoleon III's unusual constituency is worth quoting at length:

3 On the discourse of the 'dangerous classes', see Chevalier 1958.

Neben zerrütteten Roués mit zweideutigen Subsistenzmitteln und von zweideutiger Herkunft, neben verkommenen und abenteuernden Ablegern der Bourgeoisie, Vagabunden, entlassene Soldaten, entlassende Zuchthaussträflinge, entlaufene Galeerensklaven, Gauner, Gaukler, Lazzaroni, Taschendiebe, Taschenspieler, Spieler, Maquereaus, Bordellhalter, Lastträger, Literaten, Orgeldreher, Lumpensammler, Scherenschleifer, Kesselflicker, Bettler, kurz, die ganze unbestimmte, aufgelöste, hin- und hergeworfene Masse, die die Franzosen la bohème nennen [...] Dieser Bonaparte, der sich als Chef des Lumpenproletariats konstituiert, der hier allein in massenhafter Form die Interessen wiederfindet, die er persönlich verfolgt, der in diesem Auswurf, Abfall, Abhub aller Klassen die einzige Klasse erkennt, auf die er sich unbedingt stützen kann, er ist der wirkliche Bonaparte, der Bonaparte sans phrase. (Marx/Engels 1961–1968: 160–161)

[Alongside decayed roués with dubious means of subsistence and of dubious origin, alongside ruined and adventurous offshoots of the bourgeoisie, were vagabonds, discharged soldiers, discharged jailbirds, escaped galley slaves, rogues, mountebanks, lazzaroni, pickpockets, tricksters, gamblers, maquereaus, brothel keepers, porters, literati, organ-grinders, rag-pickers, knife-grinders, tinkers, beggars – in short, the whole indefinite, disintegrated mass, thrown hither and thither, which the French term la bohème [...] This Bonaparte, who constitutes himself chief of the lumpenproletariat, who here alone rediscovers in mass form the interests which he personally pursues, who recognizes in this scum, offal, refuse of all classes the only class upon which he can base himself unconditionally, is the real Bonaparte, the Bonaparte sans phrase.] (Marx/Engels 1979: 149)

Peter Stallybrass and Allon White have noted the rhetorical relish with which Marx enumerates the disparate groups that make up his Lumpenproletariat, arguing that this 'linguistic productivity' points to the fantasmatic or imaginary importance of a heterogeneous other for the writers and thinkers of mainstream society – of which Marx in many respects counted himself a member (Stallybrass/White 1986: 129). As we shall see presently, Georges Bataille was to explore this aspect of the *Lumpen* in the 1930s. But in terms of its relevance to nineteenth-century culture, Marx's list of the *Lumpen* is remarkable not only for its sprawling proliferation, but also for its specifics. While in certain respects Marx arraigns the usual suspects (the reactionary scions of a decadent aristocracy, for example), there are some surprising inclusions: notably, that of the ragpickers and the literati. By lumping together, so to speak, writers and recyclers, Marx

gives further force to Baudelaire's self-identification with the ragpicker: the
poet and scrap merchant are one. On another level, of course, *The Eight-
eenth Brumaire* provides an altogether different analogy for the *Lumpen-
sammler*: as the master politician behind the coalition of the 'refuse of all
classes', Napoleon III becomes the ultimate political ragpicker, recycling
a range of disparate subcultures into the basis of a new political regime.
The Emperor's new clothes are sewn together from rags he has himself
reconditioned. The ragpicker is simultaneously the lowest of the low and
his imperial majesty.

The remark by Benjamin quoted earlier demonstrates his awareness of
the link between *Lumpensammler* and Lumpenproletariat, but, as Irving
Wohlfarth has observed, not only did Benjamin view Baudelaire as a rag-
picker but he also tended to characterise his own critical project in similar
terms (Wohlfarth 1986: 142–168). Thus *The Arcades Project* was conceived
as a work in which archival materials would as far as possible speak for
themselves, once rescued from the oblivion of history:

> Methode dieser Arbeit: literarische Montage. Ich habe nichts zu sagen. Nur zu zeigen.
> Ich werde nichts Wertvolles entwenden und mir keine geistvollen Formulierungen
> aneignen. Aber die Lumpen, den Abfall: die will ich nicht inventarisieren sondern
> sie auf die einzig mögliche Weise zu ihrem Rechte kommen lassen: sie verwenden.
> (*PW*, I: 574)

> [Method of this project: literary montage. I needn't say anything. Merely show. I
> shall purloin no valuables, appropriate no ingenious formulations. But the rags, the
> refuse – these I will not inventory but allow, in the only way possible, to come into
> their own: by making use of them.] (*AP*: 46)

Benjamin's project is then to restore the artefacts of the past to use, assem-
bling them without appropriating them. In spite of its ethical precautions,
however, this recycling is far from unproblematic. There are three interre-
lated problems. First, in terms of the internal dynamics of Benjamin's work,
the model of ragpicking sits uneasily with the model of collecting that at
other points seems to inform *The Arcades Project*. In his essays on book-
collecting and on Eduard Fuchs, Benjamin had posited connoisseurship
and collecting as socially dissident activities because of the way in which
they withdrew objects from the world of use, the prime value of bourgeois

capitalism and the basis of exchange. For Benjamin, the collector enjoys
'ein Verhältnis zu den Dingen, das in ihnen nicht den Funktionswert, also
ihren Nutzen, ihre Brauchbarkeit in den Vordergrund rückt, sondern sie als
den Schauplatz, das Theater ihres Schicksals studiert und liebt' (Benjamin
1966: 62) ['a relationship to objects which does not emphasise their func-
tional, utilitarian value – that is, their usefulness – but studies and loves
them as the scene, the stage of their fate' (Benjamin 1999b: 170)]. Thus
the gratuitous artefact cherished by the collector subverts the commodity
status ascribed to all objects under capitalism. As Leo Bersani has remarked,
this critique of capitalism ironically takes the form of a 'vindication of pri-
vate property' and sits oddly with Benjamin's Marxism (Bersani 1990: 63).
But, as we shall see, a similar paradox resides in Benjamin's recourse to the
ragpicker. On a more straightforward level, to begin with, the ragpicker
contradicts the collector. To reconvert materials to use in the manner of
the ragpicker is to recycle the object that has escaped from use back into
the circuit of utility, and so runs counter to the logic of the collector as
analysed by Benjamin. This leads on to the second problem, one identified
by Theodor Adorno in his correspondence with Benjamin on the subject of
The Arcades Project. For Adorno, Benjamin fails to articulate the economic
function of ragpicking, namely its reintegration into the cycle of capitalist
exchange of objects that have been discarded:

> Am Lumpensammler hätte der Einstand von Kloake und Katacombe theoretisch
> entziffert werden müssen. Ist meine Annahme jedoch übertrieben, daß dieser Mangel
> damit zusammenhängt, daß die kapitalistische Funktion des Lumpensammlers,
> nämlich noch den Bettel dem Tauschwert zu unterwerfen, nicht artikuliert wird?
> (Scholem/Adorno 1961: 787)

> [The coincidence of the sewer and the catacomb in the ragpicker would have to be
> deciphered. Am I making an exaggerated assumption in thinking that this lack is
> connected to the fact that the capitalist function of the ragpicker, namely the sub-
> ordination even of begging to exchange value, is not articulated?]

In these terms, ragpicking is the ultimate form of capitalism, wringing the
last drops of exchange value from material that seems already exhausted.
For Adorno, to adopt ragpicking as a methodological model is not to resist
capitalism but to surrender to it. The third problem reproduces the second

in terms of politics rather than economics. If, as we have seen, Napoleon III's reactionary regime is the product of expert political ragpicking, then Baudelaire's aesthetic and Benjamin's cultural criticism are potentially the cultural equivalents of an extreme conservative politics, capable of harnessing the socially abject to an authoritarian project.

Expenditure and Heterogeneity: Bataille

As Benjamin was developing his model of cultural criticism as recycling in the 1930s, Georges Bataille began to elaborate a very different economy of culture. In many ways, the key text is 'The Notion of Expenditure', an article of 1933 recycled as the preface for the re-edition of *The Accursed Share* in 1967.[4] Basing his argument on recent research in anthropology, Bataille criticised the basis of traditional Western economic thinking in the principle of utility, arguing that from a wider perspective all human cultures are characterised not by their basis in use value but by their operation of an economy of expenditure. According to Bataille, all human societies produce some kind of surplus beyond the requirements of physical subsistence. In pre-modern societies, this surplus is traditionally expended in more or less gratuitous activities of a religious or cultural nature that define the dimension of the sacred (sacrifice, ritual performance). In modern capitalist society, however, increasing rationalisation and secularisation have banished the sacred and replaced expenditure with accumulation, as any surplus is reinvested in production. For Bataille, the emblematic form of pre-capitalist exchange is the potlatch, the agonistic exchange of gifts among the native American peoples of the Pacific Northwest, where rivals seek to humiliate each other through the donation or destruction of ever-larger quantities

4 See 'La Notion de dépense' (Bataille 1967: 27–54) and 'The Notion of Expenditure', (Stoekl 1985: 116–129). Subsequent references are given in the text using the abbreviations *ND* and *NE*.

of property. In France, such practices persisted until the 1789 Revolution, but in its aftermath the newly ascendant bourgeoisie reacted against the conspicuous consumption of the *ancien régime* and came to define itself by its 'hatred of expenditure' (*NE*: 124) ['haine de la dépense' (*ND*: 46)]. In this context, spendthrift behaviour among the lower classes became an anti-bourgeois practice, and for Bataille in the early 1930s, social revolution itself promised a convulsive expenditure and a return to the basic principles of social life as he understood them.

According to Bataille's view of the cultural economy, poetry occupies a particular place within bourgeois capitalist society. As a gratuitous art that dissents from the prevailing values of utilitarian society, poetry represents nothing less than the modern form of expenditure itself: 'Le terme de poésie [...] peut être considéré comme synonyme de dépense [...] il signifie [...] de la façon la plus précise, création au moyen de la perte' (*ND*: 36) ['The term poetry [...] can be considered synonymous with expenditure [...] it in fact signifies in the most precise way, creation by means of loss' (*NE*: 120)]. The corollary of this poetics of loss and waste is that the poet himself frequently becomes a lost and wasted figure, a 'damned poet' (*NE*: 120) or 'poète maudit' (*ND*: 37) in Paul Verlaine's phrase. This analysis provides the context for Bataille's view of Baudelaire.[5] For Bataille, Baudelaire's poetry represents an extension of the Romantic critique of capitalism. Romanticism had dissented from the values of utility and accumulation and articulated the malaise of an alienated section of the middle class. But whereas Romanticism still shared the individualism central to bourgeois capitalism, Baudelaire's work and career came to symbolise rather an erosion of the individual will and its commitment to the project of accumulation: his work is a paradoxical monument to waste. But this paradox of wasteful monumentality is precisely the problem: in rejecting a bourgeois ethics of deferred gratification and re-investment, Baudelaire nonetheless sought to create a lasting work that would be recognised by posterity, thus ultimately sacrificing the expenditure of the moment to the duration of accumulation:

5 See Bataille 1990: 27–47, hereafter B.

Le choix porte toujours, à toute heure, sur la question vulgaire et matérielle: 'étant donnée mes ressources actuelles, dois-je les dépenser ou les accroître?' À prendre dans son ensemble, la réponse de Baudelaire est singulière. D'une part, ses notes sont pleines de résolution de travail, mais sa vie fut le long refus de l'activité productive. (*B* 41–42)

[The choice is always, at all times, the one posed by the vulgar and material question: 'given my present resources, should I spend them or accumulate them?' Taken as a whole, Baudelaire's answer is singular. On the one hand, his notes are full of resolutions to undertake work, but his life was the long refusal of productive activity.]

In a sense, the contradiction that Bataille identifies in Baudelaire is one that besets his own work. To write of unthinking expenditure in rational and comprehensible terms as he does is in effect to submit to the economy of accumulation as embodied in the logic of the well-formed sentence. As his reading of Baudelaire suggests, Bataille was well aware of the risk of the recuperation of waste by the apparatus of production and accumulation and his work is the record of his struggle with this problem – the attempt to ensure that his ontology of waste resists recycling into a productive enterprise. Whether he always succeeds is a moot point, as his political writings of the early 1930s demonstrate.

In the early 1930s, Georges Bataille devoted a long essay to the conjunction of the socially abject and the authoritarian that in his view characterised European fascism. In 'The Psychological Structure of Fascism', Bataille argued that the economistic account of fascism provided by Marxism was inadequate, since it neglected the cultural and psychological dimensions of the phenomenon.[6] Fascism was not simply the product of a crisis in a particular phase of the development of the capitalist economy but also the result of certain cultural and psychological pressures. According to Bataille, modern capitalist society is composed of a large homogeneous mainstream constituted by the bourgeoisie, whose economic goals, as we have seen, are production and accumulation. Any social group that cannot be subordinated to these priorities finds itself excluded, part of what Bataille

6 See 'The Psychological Structure of Fascism' in Stoekl 1985: 137–160 and 'La Structure psychologique du fascisme' (1933–1934), in Bataille 1979: 339–371. Subsequent references are given in the text using the abbreviations *PSF* and *SPF* respectively.

calls the heterogeneous. For Bataille, the industrial working class occupies an ambiguous place: on the one hand, it belongs to the mainstream as a factor of production, but on the other hand, it exists outside the mainstream as the class that the bourgeoisie exploit. As a result, the proletariat are partly homogeneous and partly heterogeneous. Beyond the ambiguous working class, the field of the outrightly heterogeneous divides into two extreme groups: on the one hand, the abject criminal subculture of the Lumpenproletariat; and on the other hand, the ringleaders and agitators who seek to assert themselves as sovereign individuals above and beyond the confines of bourgeois society (*PSF*: 143–144; *SPF*: 350–355). These two wings of the heterogeneous correspond to the ethnographic categories of the high and low sacred, the sublime and the abject, whose untouchability separates them off from the profane. According to Bataille, the social and psychological origin of fascism lies in the alliance formed against the homogeneous bourgeois order by the two extreme wings of the heterogeneous, the agitators and the Lumpenproletariat, together with the partly heterogeneous working class. This alliance of the heterogeneous is then paradoxically absorbed back into a homogeneous state, once it has been wrested from the bourgeoisie by the Fascist ringleaders. Fascism, then, is the return of the repressed heterogeneous, the return of the repressed sacred, but in a form that ultimately subordinates its heterogeneous content to the discipline of a stong homogeneous State:

> la réunion fasciste [...] n'est pas seulement réunion des pouvoirs de différentes origines et réunion symbolique des classes: elle est encore réunion accomplie des éléments hétérogènes avec les éléments homogènes, de la souveraineté proprement dite avec l'État. (*SPF*: 364)

> [the fascist unification is not simply a uniting of powers from different origins and a symbolic uniting of classes: it is also the accomplished uniting of the heterogeneous elements into the homogeneous elements, of sovereignty in the strictest sense with the State.] (*PSF*: 155)

For Bataille, the most effective way to combat fascism was to redirect this return of the repressed, to recreate a different kind of sacred that would not reabsorb the heterogeneous back into an even more oppressive mainstream but instead provide an outlet for its energy and difference.

In a sense, Bataille's analysis of fascism resembles Marx's account of Napoleon III's rise to power. In both cases, a power base is constructed from a diverse and apparently incoherent or heterogeneous constituency of marginal and excluded groups. At issue in both cases is a politics of recycling. Like Benjamin, Bataille's response to a negative recycling is to propose a positive version of the same process. And this proposal is problematic for similar reasons: first, in terms of the internal coherence of his work, and second, in terms of political implications. In the first place, the recycling involved seems in some ways to run counter to other aspects of Bataille's theoretical project, namely his economics of expenditure. To waste and to recuperate are conflicting priorities. The second problem with Bataille's alternative politics of heterogeneity is that his attempt to recreate the sacred in the modern world runs the risk of reproducing what it seeks to avoid, namely fascism. As both Adorno and Benjamin pointed out in relation to the work of Bataille's collaborator Roger Caillois, the proposed creation of collective cults and exploitation of the effervescence of the crowd sound very much like the mass rallies of Mussolini and Hitler, with their re-enactment of myth and submission of reason to instinct (see Adorno 1986: 229–230 and Benjamin 1972: 549–550).

Conclusion: Redemption/Anti-Redemption

In terms of the work examined here, there seem to be three possible ways of dealing with the abject, fragmented, and heterogeneous mass of the *Lumpen*. First, Benjamin redeems the *Lumpen* through a re-instatement of its lost use value. Second, Bataille insists on the irreducibility of the *Lumpen* to homogeneous society. Third, the politics of Louis Bonaparte, as analysed by Marx, sublates both approaches, paradoxically recycling the abject into a political power base. By identifying this third possibility, Marx's earlier analysis problematises in certain respects Benjamin's and Bataille's approaches. This is not to say that Marx's approach is itself unimpeachable,

as is amply demonstrated in the arguments by Robert Bussard, Dominick LaCapra and Jacques Rancière cited earlier. It is to suggest, however, that there is perhaps something intractable about the notion of the *Lumpen* that neither Benjamin nor Bataille entirely masters, albeit in different ways.

Benjamin's entire critical project is often interpreted in terms of a redemption of the refuse of official history, a recuperation and rehabilitation of the defeated and the obsolete. According to Richard Wolin, 'it is a relentless drive for redemption which represents the inner drive behind the entirety of Benjamin's theoretical œuvre' (Wolin 1982: 31). But to redeem has economic as well as spiritual connotations – debts are redeemed, as are objects deposited with a pawnbroker – and, as we have seen, Adorno construed Benjamin's ragpicking as an unconscious submission to the law of capitalist exchange value. If we follow Adorno, there is a sense in which Benjamin implicitly endorses what he ostensibly rejects, the endless recuperation of the capitalist economy where even obsolescence is planned and recyclable.

In contrast to Benjamin, Bataille's view of culture is anti-redemptive, an affair of expenditure and waste. In opposition to the rational accumulation of bourgeois society, Bataille advocates an economics of gratuitous expenditure as the means of a return to the sacred. In one sense, then, Bataille opposes a politics of expenditure to a politics of recuperation. But expenditure necessarily presupposes a degree of prior accumulation (in order for there to be something to expend) while the very notion of waste assumes some sense of the rational distribution of resources. As a result, it becomes possible to argue that expenditure is not so much opposed to bourgeois society as in symbiotic relationship with it. Further, Bataille's theory of expenditure is itself conceived as a means to recuperate the heterogeneous captured by fascism, albeit in the mode of effervescent expenditure. Ultimately, Bataille's ontology of waste is as much a closed system as Benjamin's redemptive recycling. His politics of heterogeneity is not only parasitic on homogeneous society but actually attempts, albeit in its own terms, to retrieve what homogeneous society excludes and refuses.

In sum, the *Lumpen* as left-over can never be entirely disposed of (Bataille) nor entirely re-integrated (Benjamin), for its status as remainder ties it to the system that both excludes and subsumes it by turns. As Marx's

analysis of Louis Bonaparte's coalition of the abject and the sublime implies, Benjamin's redemptive and Bataille's anti-redemptive views of culture rejoin one another in a closed circuit, summed up in the ambiguous figure of the ragpicker, the very personification of the *Lumpen* in his alternation between recycling entrepreneur and drunken waster, conservative capitalist and subversive outcast. This has both political and cultural implications. Politics, at least in the longer term, emerges as an ongoing process of constructing and dismantling provisional coalitions, whose social elements are then, within limits, open to recombination in different formations. As Peter Stallybrass (1990) has argued, Marx's list of the *Lumpen* is only the inventory of one such successful coalition, but neither its membership nor its hegemony is fixed, and the mobilisation of the socially excluded remains a key strategy in contemporary political organisation. Similarly, culture itself appears as the result of alternating processes of accumulation and expenditure, relayed by mechanisms of recycling. Cultural traditions are overtaken by waves of innovation that then become part of the tradition and are interrupted in turn by further waves of innovation; the canon is shredded and recycled from one period to the next. This is not just a question of form and content but also of material supports. As Balzac observed in *Lost Illusions* (*Illusions perdues*, 1837/39), his great novel of the literary, newspaper and printing trades, one of the ragpicker's principal clients was the papermaker, since all European paper of the early nineteenth-century was made from the shreds of discarded fabric (see Balzac 1974: 128–129). In Balzac's vision, all books consist of rags, and culture itself is a kind of scrapheap. From this perspective, the virtue of Benjamin's and Bataille's work is their clarification of the opposing poles of cultural development, its alternating processes of destruction and conservation, waste and accumulation. In their assembly and discussion of waste materials, the scrapbooks of the *The Arcades Projects* and *The Accursed Share* point ultimately to the wider scrapheap of culture itself.

Works Cited

Adorno, T. (1986), Roger Caillois, 'La Mante religieuse'. In: Tiedemann, R. (ed.) (1970–86), *Gesammelte Schriften*. Frankfurt am Main, Suhrkamp, XX/I: 229–230.

Balzac H. de (1974), *Illusions perdues*. Picon, G. (ed.). Paris, Gallimard.

Bataille, Georges (1990), Baudelaire. In: *La Littérature et le mal*. Paris, Gallimard: 27–47.

——(1988) *The Accursed Share I*. Hurley, R. (trans.). New York, Urzone Inc.

——(1985), *Visions of Excess: Selected Writings 1927–1939*. Stoekl, A. (ed.), Stoekl, A./Levitt, C.R./Leslie Jr, D.M. (trans.). Minneapolis, MA, Minnesota University Press.

——(1970), *Œuvres complètes I: premiers écrits 1922–1940*. Hollier, D. (ed.). Paris, Gallimard.

——(1967), *La Part maudite*. Paris, Minuit.

Baudelaire, C. (1851), Du vin et du haschish. In: Pichois, C. (ed.) (1975), *Œuvres complètes*. Paris, Gallimard/Pléiade, I : 378–398.

——Le Vin des chiffonniers (1852/1857). In: Pichois, C. (ed.) (1975), *Œuvres complètes*. Paris, Gallimard/Pléiade, I: 106–107.

Benjamin, W. (1999a), *The Arcades Project*. Eiland, H./McLaughlin, K. (trans.). Cambridge, MA, Belknap Press.

——(1999b), Unpacking My Library: A Talk About Book Collecting. In: Arendt, H. (ed.), Zohn, H. (trans.), *Illuminations*. London, Pimlico: 61–69.

——(1982), *Passagen-Werk*. Tiedemann, R. (ed.). Frankfurt am Main, Suhrkamp.

——(1974), *Charles Baudelaire: Ein Lyriker im Zeitalter des Hochkapitalismus*. Tiedemann, R. (ed.). Frankfurt am Main, Suhrkamp.

——(1973), *Charles Baudelaire: A Lyric Poet in the Era of High Capitalism*. Zohn, H. (trans.). London, NLB.

——(1972), Roger Caillois, 'L'Aridité'. In: Tiedemann, R./Schweppenhäuser, H. (eds) (1972–88), *Gesammelte Schriften*. Frankfurt am Main, Suhrkamp, III: 549–552.

——(1966), Ich packe meine Bibliothek aus: eine Rede über das Sammeln. In: Unseld, S. (ed.) (1966), *Angelus Novus: Ausgewählte Schriften 2*. Frankfurt am Main, Suhrkamp: 169–178.

Bersani, L. (1990), *The Culture of Redemption*. Cambridge, MA, Harvard University Press.

Bussard, R.L. (1987), The 'Dangerous Class' of Marx and Engels: The Rise of the Idea of the 'Lumpenproletariat'. *History of European Ideas* 8/6: 675–692.

Chevalier, L. (1958), *Classes laborieuses et classes dangereuses à Paris pendant la première moitié du XIXe siècle*. Paris, Plon.

Draper, H. (1972), The Concept of the 'Lumpenproletariat' in Marx and Engels. *Économies et sociétés* 6/12: 2285–2312.

Hugo, V. (1951), *Les Misérables*. Allem M. (ed.). Paris, Gallimard/Pléiade.

LaCapra, D. (1983), Reading Marx: The Case of 'The Eighteenth Brumaire'. In: *Rethinking Intellectual History: Texts, Contexts, Language*. Ithaca, NY, Cornell University Press: 268–290.

Marx, K. (1979), The Eighteenth Brumaire of Louis Bonaparte. In: Cohen, J. et al. (eds), *K. Marx/F. Engels: Collected Works*. London, Lawrence & Wishart, XI: 99–197.

——(1961–1968), Der achzehnte Brumaire des Louis Bonaparte. In: Marx K./Engels, F. (eds), *Werke*. Berlin, Dietz, VIII: 111–207.

Rancière, J. (2007), *Le Philosophe et ses pauvres*. Paris, Flammarion.

Scholem, G./Adorno, T. (eds) (1961), Letter from Adorno to Benjamin, 10 November 1938. In: *W. Benjamin, Briefe*. Frankfurt am Main, Suhrkamp, II: 782–790.

Stallybrass, P. (1990), Marx and Heterogeneity: Thinking the Lumpenproletariat. *Representations* 31: 69–95.

Stallybrass, P./White, A. (1986), *The Politics and Poetics of Transgression*. London, Methuen.

Wohlfarth, I. (1986), Et Cetera? The Historian as Chiffonnier. *New German Critique* 39: 142–168.

Wolin, R. (1982), *Walter Benjamin: An Aesthetic of Redemption*. New York, Columbia University Press.

UWE C. STEINER

The Problem of Garbage and the Insurrection of Things

The aesthetics of trash and the problem of garbage in general strongly indicate that objects are a central issue for literary history and cultural theory. In other words, the existence of obsolete objects is an objection to cultural theory's tendency to forget about things. Things – I prefer to speak of things instead of objects – have suffered far too long from obsolescence. This problem will be the centrepiece of this chapter.

Every now and then, German literary critics or journalists indulge in a peculiar criticism of German literature: they contend that German literature lacks realism, and that German poets in particular do not know what to do with the objects of everyday life (see Seibt 1996). It could easily be shown that this criticism is part of a long and self-indulgent tradition. However, it is not the intention of this chapter to provide an account of such a tradition. Let us turn instead to a literary example which may very well testify against this criticism and will lead to the heart of the topic. Like so many of us, Ulrich Lofart, the hero of Burkhard Spinnen's 1995 novel *Langer Samstag* ['Long Saturday'], regularly falls prey to various minor mishaps in his everyday interactions with things. One of these mishaps occurs while he is taking out the garbage. A plastic bag filled with trash that had been propped up against a wall begins to slip, and very slowly falls over. Its contents fall out: a 'filter with moist coffee grounds, egg shells and the remains of egg-whites, together in a can with a jagged sharp-edged lid, a can half-full of dried-out beans in a red sauce' ['Filter mit halbfeuchtem Kaffeesatz, Eierschalen mit den Resten des Eiklars, zusammen in einer Konservendose mit scharf kantig abgespreiztem Deckel, halbvoll [*sic*] kaum eingetrockneter Bohnen in roter Soße'] (Spinnen 1997: 110)[1] – all of this

1 Unless otherwise indicated, this, and all other translations from the German, are my own.

pours out inexorably and soils the floor. The hero reacts in a peculiar way, yet one that is in tune with literary history and the problem of trash: in a rage, he begins to thrash the garbage for its unruliness. He beats the trash.

Three characteristics are worth noting in this event: firstly, the passage provides a small ontology of household waste and its physical state. We encounter a thing that has become dysfunctional after use: the can. Not only do the scraps of food stand for the thin line between consumer goods and garbage, but they also reveal the proximity between appetency and disgust. As an amorphous mass, garbage represents thingness in a state of dissolution. Secondly, however, the bizarre beating implies that the hero recognises this dysfunctional matter, i.e. the trash, as a social partner. For violence is a form of recognition. Lofart does belatedly concede that he had 'actually not beaten the trash, but rather himself' for his imprudence ['eigentlich nicht den Müll geschlagen, sondern sich selbst'] (Spinnen 1997: 110). But is this not simply a case of appeasement, a case of a retroactive anthropocentric rationalisation of a fundamental uneasiness, i.e. the uneasiness about the agency of things, and especially about the agency of garbage? For garbage seems to evade human intentionality, and even to revolt against it. Thirdly, this reading confirms a literary-historical trace that has been planted quite deliberately. In response to the story of the trash-beating, Lofart's girlfriend provides an illuminating remark: 'Du bist mir einer,' she says. And she immediately adds: 'Auch so einer' (Spinnen 1995: 150). This translates as: 'You're quite something. Another one like all the rest.'

The literary critic will prick up his ears here. He knows, namely, that the author Spinnen, who is himself a scholar of German literature, is alluding to a novel that for a long time enjoyed great success, but that is now almost entirely forgotten. I am referring to Friedrich Theodor Vischer's novel *Auch Einer* ['Another One'], which was first published in 1878. The novel introduced an expression that is familiar to all native speakers of German, namely that of the 'Tücke des Objekts' ['malice of the object']. The hero, an outsider, an oddball and a misanthrope, fights a never-ending battle against the small objects of everyday life. They are, or so he believes, conspiring against him. Misplaced eyeglasses, tangled-up shirt buttons, disappearing documents, fragile dishes, bread that naturally falls to the floor with the buttered side down and the like – all of these ordinary things, so the titular hero believes, are possessed by malicious demons. Furthermore, the hero's

body is tormented by waste products: he need only look at a painting in which a draughty building is depicted to catch a cold. Nor does he bear the burden of secretions well. With nothing short of Baroque pathos, this antihero – tormented by things and garbage – thus defines man as a 'disgraceful tube for fermenting glandular juice, a snot-machine' ['Ein Schandschlauch für vergährenden Drüsensaft, eine Schnäuzmaschine'] (Vischer 1891: 26). Vischer and Spinnen document literature's attention to the objects of everyday life. Long before the human and social sciences, literature perceived the hybrid mixture of man and things.

Perhaps one of the most famous literary treatments, of not only the hybrid mixture between man and animal, but also that between man and thing, is Franz Kafka's *Metamorphosis*. What mighty efforts have been made in attempting to explain Gregor Samsa's metamorphosis into a monstrous vermin! And how many attempts were made to uncover meaning behind that crucial opening scene that was so consciously left enigmatic. Yet the actual narrative function of the titular metamorphosis is in fact quite evident. One of the consequences of waking up in the morning as a beetle-like vermin is, for starters, that the bed has been transformed from a ready-to-hand thing into a thing that is now merely present-at-hand. I am here making use of Martin Heidegger's terminology from the epochal analysis of 'equipment' ['Zeug'] in *Being and Time* (Heidegger 1984: 66–68). Heidegger managed to show that men do not behave as conscious subjects towards objects, that is: they do not behave as subjects conscious of themselves, and certainly not as subjects conscious of things. Quite the contrary: in everyday situations, things are encountered as 'equipment' in the mode of 'familiarity' ['Vertrautheit']. Heidegger calls this 'readiness-to-hand' ['Zuhandenheit']. Only when the non-thematic functioning of things is disturbed – i.e. when the things become 'un-ready-to-hand' ['unzuhanden'] – do they appear in attention's focus. Consequently, Kafka's story can devote an entire chapter to the description of Gregor's efforts at heaving his thinglike body, his un-ready-to-hand body, out of bed, or at working a door-handle with his mouth. Handles are ready-to-hand for human hands, but not for the jaws of insects. The titular metamorphosis thus also brings about a transformation of the world of things. It lets things step out of their everyday familiarity and thus allows their otherwise overlooked everyday agency to be described. And it is therefore no coincidence that Kafka's

Metamorphosis is also a story about garbage. In the course of the story, Gregor Samsa's animal body increasingly takes on the state of a discarded thing. Having become economically useless, the vermin has become a mere object – an abject thing, to be more precise. Thus, a struggle for recognition breaks out in the family, one whose outcome is predetermined. The things that Gregor holds dear are taken out of his room, which is instead used as a dumpsite for garbage:

> The family had gotten used to storing things here that could not be put anywhere else [...] [M]any of the family's belongings had become superfluous; but while they had no prospects of selling them, they did not want to throw them out either. All these items wound up in Gregor's room – as did the ash bucket and the garbage can from the kitchen. (Kafka 1995: 172)

In the course of this struggle carried out in the medium of things, Gregor's metamorphosis continues. Gregor, who has only eaten scraps of food and garbage (if anything at all), becomes increasingly assimilated into the world of things. And more specifically, into the world of garbage:

> For now, more than ever he had reason to hide, thoroughly coated as he was with the dust that shrouded everything in his room, flurrying about at the vaguest movement. Furthermore, threads, hairs and scraps of leftover food were sticking to his back and his sides, for he had become much too apathetic to turn over and scour his back on the carpet. (Kafka 1995: 175)

In the end, Gregor's body is disposed of like trash. In a gesture that simultaneously points to trash as a figure of death, the servant checks if Gregor is really dead by poking his dried-out body with a broom: an object that is, appropriately, closely associated with dirt and garbage. Another one of Kafka's stories proceeds along similar lines by telling of one thing's unruliness: in the story *In the Penal Colony*, the execution of justice – or rather the self-administered justice of the officer – fails due to a mechanical malfunction. The monstrous machine that is supposed to tattoo the judgement into the body of the offender ultimately spits out its own cogwheels (Kafka 1995: 225–226). It is not even able to dispose of the corpse in the pit that was intended for it. The pit ['die Grube'] is to trash what the grave ['das Grab'] is to the body.

Spinnen, Vischer and Kafka attest to literature's knowledge of the resistant nature of things, even those things that were apparently made by men. They are aware of the resistance of things to human intentionality. And this is precisely my point here: since things have a tendency to refuse to obey us, refuse can be accounted for as a genuine symbol – above all, as a symbol for the agency of things. But we have to be careful here: when I call refuse a symbol, I do not mean to deny its palpable reality. On the contrary: trash is not merely a sign. Furthermore, symbolising means more than signification or representation: it is an activity which constitutes culture. Moreover, there is no gap between things and signs.

Refuse's potential for symbolism does not, however, have anything to do with human authorship. Refuse is more a product of its own specific reality – indeed, of its own agency. For refuse can be understood as a non-intentional artefact. Refuse is made, yet hardly ever for its own sake. It accumulates ('er fällt an', as one says in German), or rather it is left over ['er fällt ab']. The German word 'Abfall' can also connote 'secession' or 'apostasy'. Waste may therefore also be considered as the secession of reality itself: i.e. its secession from the anthropocentric and constructivist dogma that asserts that man creates his reality himself. As a non-intentional artefact, garbage is an existent symbol of the fact that human action is not always goal-oriented and determined by intentionality. Yes, garbage is a symbol for the agency of things themselves. Garbage makes it clear that things are not only objects, but also subjects of culture.

Biography of Things

The thesis that things are not only objects but also always subjects of culture is not as new or fashionable as it may seem. Indeed, we are dealing here with quite an old insight, and one that has been richly documented, especially in literary history. Unlike the social sciences, literature has long known of things that behave as agents, for example in that they speak. Yes, according

to this tradition, things possess – among other things – their own biography. And when they die, these things become garbage. The genre of the thing-biography can be traced as far back as the early modern period, and is quite prominent in the work of Hans Sachs, for example. In this genre, speaking artefacts (sausages, leather, money amongst other things) narrate their complex civilisational histories in the form of stories – the stories of their lives. These artefacts demonstrate the manifold interdependencies among material production, economic networks and the social sphere, while simultaneously providing moral satire and a critique of customs.

One peculiar talking object can be encountered in the most important German novel from the Baroque period, Grimmelshausen's *Der abentheur-liche Simplizissimus Teutsch* (*Simplicius Simplicissimus*); first published in 1668. In the sixth book's so-called 'Discurs mit dem Schermesser', the title hero Simplicius Simplicissimus has become a vagabond. Once, when spending the night in the house of a citizen, he feels the call of nature. He thus goes in search of a place that is usually circumscribed, the so-called washroom, which Grimmelshausen calls a 'Cantzeley' ['chancellery', 1989: 612]. It is no coincidence that this euphemism refers to the world of administration, management and law. The natural and everyday act of excretion is here directly linked to European modernisation, not just rhetorically but also with respect to its functions and symbolic infrastructures. After Simplicius has finished his business, so to speak, he engages in a hygienic act that was not always practiced during his time: He reaches for a sheet of paper – a piece of scrap paper that is – that was kept there for exactly this purpose. He reaches for the so-called 'Schermesser', a term that literally denotes a knife or razor, and that here obviously refers to the paper's lack of smoothness.

Just as this paper is about to 'fulfil the function [...] to which it has been condemned and for which it has been imprisoned in this place' ['[...] an demselbigen zu exequieren warzu es neben andern mehr seinen Kammer-rathen contemniert und daselbst gefangen war'] it begins to talk (Grim-melshausen 1989: 612–613). It loudly protests against this course of events. For did it not deserve a better fate than to wipe the behind of a tramp and, to quote Grimmelshausen, to find its 'final end in the shit-house?' ['endli-chen Undergang im Scheißhauß'] (Grimmelshausen 1989: 612). Simplicius

decides to lend the paper his ear and then make a decision about its fate. The hygienic product – destined to become waste very shortly – tells him the story of its life and sufferings.[2] This story takes up an idea that Marx would later expound, namely that of work as a certain metabolism between humanity and nature. Here, for perhaps the very first time in literary history, garbage is taken into consideration. Our hero listens to an extraordinarily detailed story of the paper's life, from its beginning as a natural raw material – hempseed – all the way to its current form. To be more precise, two stories are narrated here, two intertwined cycles of transformations that the thing experiences. For the thing is both an object of utility and a commodity. First, as a raw material with practical value – as the object of work – the thing undergoes a process of material utilisation. That is to say: human labour transforms hemp successively from yarn into cloth, and then from a shirt into a diaper; the diaper is then used as rag, after which it is taken to the paper mill. Ultimately, after first having been a page in an accounting book, it takes on its final state, namely that of toilet paper.

Second, as an object of trade with an attached exchange value, the thing goes through a non-material process of commercialisation. This material metabolism is also a social one: as a commodity, the thing passes through a complex chain wherein its value steadily increases. For almost every stage of the object's transformation, we are given an account of who profited: for the seed, the hemp, the yarn, the cloth and finally the paper. The hemp farmer, the merchant, the worker in charge of pressing and fermenting the hemp, the inspector, the customs officer, the wagon driver, etc.: each of them makes a profit through the production and trade of the thing. Indeed, all of this occurs on an international scale. As both raw material and commodity, the thing crosses borders several times. It is taken from Germany to France and Holland. The thing that will eventually end up as

2 Grimmelshausen here fulfills a requirement that would not be posed again until 1929 by the Russian avantgardist Sergej Tretjakow: from now on, the task of the novel was to deal with the biography of objects. Biographies of objects were to replace the same old idealist stories about human heroes. What Tretjakow did not know was that such stories have been making their rounds since early modernity (see Tretjakow 1972: 81–86).

toilet paper reveals the allegoric truth of both material production and global trade: namely, that their ultimate goal is trash.

Thus, this Baroque novel proceeds in a genuinely realistic fashion by foregrounding the entire social and cultural context that is shaped by the division of labour and the pursuit of profit, as well as by international relations. Whoever wants to seriously consider the political body, Grimmelshausen seems to say, has to take things into account, things and their agency, and thus has to realise that garbage is part of the social body (see Latour 2005: 63–86; Latour/Weibel 2005). Here, as early as the Baroque period, we have a German novel that attempts to decipher a reality marked by a capitalist economy; at the same time, this novel takes up the problem of garbage. But one of Grimmelshausen's more profound points is his close linking of the problem of garbage with an old and venerable tradition: with the tradition of emblematics.

According to old European emblematics, things themselves reveal the meaning they contain. Signals of resemblance communicate with the observer, who in turn deciphers the spiritual meaning contained within these signals. Earlier in the novel, in a closely related episode, Simplicius encounters a mysterious figure, who at first seems to fulfil the claims of emblematics: I am referring to the protean figure of Baldanders (whose name literally means 'soon-different'). Baldanders bears this name because he constantly changes his shape. In Grimmelshausen's original text, even his name is spelled differently each time it appears. First a statue, then a talking creature with both Roman and German characteristics, Baldanders successively transforms himself into an oak tree, a pig, a sausage, and then into biological trash – into faeces, that is – and after that into a meadow, cow-dung, a flower, a mulberry tree and a silk carpet. Through this cycle of metamorphoses, Baldanders represents the metabolic process between nature and culture. He represents recycling, as it were, and simultaneously introduces Simplicius to the mystery of the allegorical. He insists that he can teach mankind the art of speaking with silent things, and tells Simplicius of a formula whose words are said to come from a secret magical language. A closer look, however, reveals that these words are pure nonsense. Or rather, to allude to James Joyce, their letters are. These litter-letters, however, beg to be read acrostically or telestically and when the puzzle is

solved the first and last letters of these words together formulate an instruction, 'If you can imagine what happened to each thing and then formulate a discourse based on this by preserving that which seems most true, then your silly nosiness will finally have what it desires' (Grimmelshausen 1989: 604–605). Baldanders promises Simplicius insights into the deepest secret, into the allegorical code of the world, only to show that there is no deeper meaning in or beyond things. Because things are transitory, they are open to being given almost any kind of allegorical meaning. Thus even meaning undergoes devaluation. It becomes trash. Baldanders's wisdom is thus a paraphrase of the central Baroque topos itself: vanity, conceit, and transience. Such is the lore Baldanders teaches. Yet it is surpassed by the teaching of the *Schermesser*: Baldanders's doctrine of signs – which at first seems esoteric but later reveals itself to be nihilistic – has already found its realisation in the world of labour, trade and garbage. This surprisingly advanced kind of realism would not be possible without a retrospective foundation. The *Schermesser* discourse is, first, a realistic taking account of a social and transnational context in which, by means of work and trade, the agency of things is exposed. And second, it is the means by which Grimmelshausen takes a moral/theological and satirical look at fallen human nature as it finds its expression especially in work. The narrating object lends exploited and raped 'first' nature a voice. Thus because of its thing-perspective, the *Schermesser* is able to provide many a satirical witticism. As a shirt worn by a sexually active house maid the *Schermesser* learns, for example, 'that not all are virgins, who are called virgins' ['daß es nicht alle Jungfern seynd die man so nennet'] (Grimmelshausen 1989: 619). As a page in the accounting book, the sheet of paper discovers that the merchant cooks his balance sheet – and, in order to cover this up, he studies the law books like a Bible.

The material and mercantile transformations of the *Schermesser* provide the empirical verification of Baldanders's teaching, which can be reduced to a single concept: vanitas. Everything that is soon becomes different ['bald anders']; nothing – no thing – keeps its shape; everything is vain and futile; everything deserves to perish. This is the Baroque author Grimmelshausen's realistic perception of an early modern economy: labour and trade figure as realistic allegories of transience. Maybe we should consider

translating 'vanitas' as 'entropy'. As proud as the *Schermesser* may have been when it was an elegant shirt or a graceful piece of paper, it inevitably finds its end in the dirt. Yet it also prophesises that the hero of the novel will one day face the same fate. When the merciless Simplicius prepares to finally put the toilet paper to its intended use, the toilet paper admonishes him. Simplicius, it says, will one day meet the same end as the *Schermesser*. He, too, will end up as waste. In its ultimate allegorical reference, the thing thus represents death. And as a figure of death, garbage also marks the boundaries of anthropocentrism.

Devaluation of Emblematic Thingness in DeLillo's *White Noise*

The Baroque doctrine of vanitas takes on a very concrete, substantial dimension in Grimmelshausen's novel. It is linked to capitalism. As a product, the thing creates a social context that takes on both material and immaterial aspects: in the form of the emblematic, the thing releases meanings. Furthermore, the obsolete object is a social fact. Grimmelshausen demonstrates, however, that the emblematic meanings are also exposed to a process of devaluation. It is not only the material body but also the semantic body of the product that prefigures refuse. With their potential for becoming garbage, things – especially products – symbolise death.

My remarks on Grimmelshausen may strike a chord for readers of contemporary literature. For they could indeed also be valid for a work that is one of the classics of so-called postmodern literature as well as one of the greatest works to take up the issue of garbage. I am referring to Don DeLillo's *White Noise*. One of the chief concerns of this novel is a phenomenology of the modern – or rather postmodern – relationships between men and things. These relationships are astonishingly similar to the Baroque problematic: in a genuinely Baroque fashion DeLillo's novel deciphers a relation between the devaluation of physical thingness and the devaluation of emblematic thingness. To an even greater degree than the Baroque, DeLillo recognises the agency of things in garbage. Here,

I could just as easily discuss *Underworld*, a novel that not only could be considered the classic of trash-literature, but one that moreover narrates the biography of a thing – a baseball – in one of its plot lines. *Underworld* takes up a thing that acts, a moving object, and thus considers the capacity of things to gather men together. Martin Heidegger, Michel Serres and Bruno Latour repeatedly call attention to the fact that 'Ding' ['thing'] originally signified 'assembly' or 'gathering'.

Most of DeLillo's protagonists possess 'a tendency to feel estranged from the objective world' (DeLillo 1999: 6), an attitude that can be considered one of the defining features of postmodern consumer culture. The estrangement from both the objective world and the world of objects derives not least from the objects' un-readiness-to-hand, that is to say: from the ubiquitous phenomenon that equipment ['Zeug'] readily evades the intentions of its user. 'There were the things that built the world,' contends the first-person narrator Jack Gladney, only to be forced to admit his uncertainty to himself, his 'shakiness' about these things (DeLillo 1999: 234). Other than the constructivist, cultural or pragmatic zeitgeist would have it, the world of things is not – or is not merely – made by human subjects or observers. Nor is it produced through symbolic or communicative processes or actions that can be attributed solely to human agents. Rather, it is also made – and to just as great an extent – by things.

The un-readiness-to-hand of things is only one side of their problem, however: for there is also the fact that things are emblems. As is well known, Walter Benjamin had already perceived that emblems return in the form of commodities (see Benjamin 1974a: 681). His observation is overwhelmingly confirmed by every supermarket shelf. Just as the emblem makes the moral, spiritual or anagogical signification of the physical thing clear, so does the commodity emphasise not so much its practical value as its body of signification, or as Marxists would say: its fetishistic character. Murray Siskind, the Mephistophelian visiting lecturer from New York, always gladly lectures about the supermarket as a spiritual passage. He understands commodities to be emblems:

Everything is concealed in symbolism, hidden by veils of mystery and layers of cultural material. But it is psychic data, absolutely. [...] It's just a question of deciphering, rearranging, peeling off the layers of unspeakability. (DeLillo 1999: 37–38)

White Noise, as one of its plot lines reveals, is a type of campus novel. More precisely: it is a satire of the university and specifically of the fashionable domain of cultural studies. Thus, an entire department – the 'popular cultural department' – works on the project of an emblematics of modern things: 'The teaching staff is composed almost solely of New York émigrés, smart, thuggish, movie-mad, trivia-crazed. They are here to decipher the natural language of the culture' (DeLillo 1999: 9). Just as these professors subject cereal boxes to a formal method of interpretation, so did the emblematicians of the Renaissance and the Baroque period pretend to decipher the natural or rather the God-given language of things.

In a similar manner as in Grimmelshausen, all of the innumerable emblematic signifiers that emanate from things and their packaging are here grouped into one great transcendental signified: every thing, so it seems, provides death as its own ultimate meaning. It almost seems as if DeLillo's novel wants to verify that famous diagnosis that Benjamin once gave to Baroque emblematics in his book on the German *Trauerspiel*: 'So much signification, so much deathly decay, because at the deepest level death buries the jagged line of demarcation between physis and signification' ['so viel Bedeutung, soviel Todverfallenheit, weil am tiefsten der Tod die zackige Demarkationslinie zwischen Physis und Bedeutung eingräbt'] (Benjamin 1974b: 343).

The people in *White Noise* constantly suspect that a potential threat lies in things, and even – or rather specifically –in those things that are ready-to-hand. Both in their consumeristic availability as commodities and in their everyday presence, things prove themselves to be figurations of death. On the very first page of the book, Jack Gladney makes a thorough examination of all his household belongings. And in the face of all these things – both those that are ready-to-hand and those that are obsolete –, in the face of 'all the unused objects of earlier marriages and different sets of children, the gifts of lost in-laws' (DeLillo 1999: 6), he realises that his own historical identity lies in them, that it lies within these things. He also

realises that this identity dies with and in these things, for things contain identity, they form identity. They therefore convey the dark foreboding of death to Gladney:

> Things, boxes. Why do these possessions carry such sorrowful weight? There is a darkness attached to them, a forboding. They make me wary not of personal failure and defeat but of something more general, something large in scope and content. (DeLillo 1999: 6)

So much signification, so much death, lies in things. Towards the end of the book, Gladney will dispose of large portions of his possessions. He seeks to free himself from death, as it were, by turning these things into garbage: 'I started throwing things away. Things in the top and bottom of my closet, things in boxes in the basement and attic [...].' (DeLillo 1999: 211)

The correlation between death and signification makes clear why the things in DeLillo's novel release more than just semantic emissions ('[T]here were huge amounts of data flowing through the house', DeLillo 1999: 100). They also seem to spread toxic materials, i.e. chemical or radio-active waste products, though it is often not clear whether this waste belongs to the physical reality of things or if it is merely the result of cultural or collective psychological projections: When a grade school has to be evacuated, nothing precise is known about the causes behind the nausea and the illness that suddenly appear among the teachers and the pupils. Are rays, plastics, asbestos or chemical exhalations contaminating the air and the environment? Or is a toxic emission coming from the things themselves responsible? 'Or perhaps something deeper, finer-grained, more closely woven into the basic state of things' (DeLillo 1999: 35). It is precisely this ontological uncertainty that underpins the non-human agents' ability to act. Things possess more than merely physical causality. Rather, cultural objects are defined above all by the fact that they translate material configurations into significations, imaginations and social facts (e.g. behaviour).[3] In the technical mythology of everyday life, 'radiation' takes on the role of such

3 See Bruno Latour: 'To designate this thing which is neither one actor among many nor a force behind all the actors transported through some of them but a connec-

an agent: 'It's the things right around you in your own house that'll get you sooner or later. It's the electrical and magnetical fields' predicts Gladney's stepfather (DeLillo 1999: 167).

These things that spread 'waves and radiation' (DeLillo 1999: 103) also clarify why *White Noise* should not really be understood as a postmodern novel, but rather as a novel about an ongoing problem that then was (i.e. in the 1980s and 1990s) put under the label of postmodernism. Rather, 'postmodernism' is more the object of the novel than the essence of the novel. Postmodernism implies a certain vulgar relativism, one that the novel personifies in the figure of Heinrich, Gladney's son. 'Our senses are wrong a lot more often than they're right. This has been proved in the laboratory,' the precocious nerd says on occasion (DeLillo 1999: 23). Heinrich effortlessly supports this popular neurological constructivism with linguistic scepticism: 'How do I know that what you call rain is really rain? What is rain anyway?' (DeLillo 1999: 24).

It would, however, be a mistake to understand *White Noise* as a novel about the postmodern problem of not being able to distinguish between reality and simulation. Constructivism and some varieties of simulation theory can indeed be understood as a continuation of the great meta-narrative of the humanities, namely that reality can be reduced to the question of human access to reality (see Harman 2002). DeLillo's novel, however, takes up the entire reality of things, a reality beyond human perception. The emblematic interpretation of things, whether in the Baroque or the postmodern period, only exists because there is a meaning to be decoded that was not encoded by any human author. We are thus dealing with the entire reality of things whose agency exceeds that of human agents. (In any case, the simulation debate was nothing other than a reaction to technical dispositifs beyond the capacities of human consciousness or agency. Jean Baudrillard's first book is entitled *The System of Objects* – garbage does not, however, appear in the system it describes.)

tion that transports, so to speak, transformations, we use the word translation [...]' (2005: 108).

The postmodern problem of the interaction between simulation and reality crops up in DeLillo's novel as a problem of translation (to use one of Bruno Latour's concepts). The familiar theoretical concepts of the humanities function anthropocentrically, as I have already noted: they assert either the privilege of consciousness, culture, language and sign-systems or, in a supposedly firmly materialistic variant, that of the brain. This point of view always asserts the priority of the observer over the observed. The assurance that one does not want under any circumstances to argue either ontologically or in an essentialising way has been one of the obligatory topoi of cultural studies debates for the past couple decades, not to mention one of the indispensable entry tickets to the advanced theory circles.

With regards to the problem of trash, however, DeLillo's novel introduces a modern, medial ontology. It unremittingly makes us aware of translation processes between things and men, translations of material data into symbolic data and vice versa. Thus, in a passage that is very relevant to our discussion here, the trash briefly turns the protagonist into an archaeologist. In search of the mysterious medicine Dylar that his wife takes for her fear of death, Jack Gladney rummages through his compacted household garbage, checking everything. Although he does not find what he is looking for, he nevertheless learns much more than he had intended to. He perceives a material association in the most concrete meaning of the term: solids and liquids, animal and vegetable products, food, packaging and basic commodities are indeed all merged together in one large mass. But it is exactly this that enables them to release meanings:

> I walked across the kitchen, opened the compactor drawer and looked inside the trash bag. An oozing cube of semi-mangled cans, clothes hangers, animal bones and other refuse. The bottles were broken, the cartons flat. Product colors were undiminished in brightness and intensity. (DeLillo 1999: 246)

The semantic emissions of the commodities, their emblematic rubbish-radiation thus seems to survive even the trash compactor. Indeed, how could semantic material possibly be compacted? DeLillo continues: 'Fats, juices and heavy sludges seeped through layers of pressed vegetable matter. I felt like an archaeologist about to sift through a finding of tool fragments

and assorted cave trash' (DeLillo 1999: 246). The interwovenness of man and the world of things is revealed to the archaeologist of the household trash. While the commodities and the consumer items make reference to death, it is above all else the trash – the mass of dead objects – that evokes entire living relationships. Entire cultures can be reconstructed from their thingly excretions. DeLillo's novel conceives of trash as the white noise in the realm of haptic things, as it were. The noise, if you will, of matter. We are nevertheless dealing with noise from which information can be drawn. The sound of things possesses emblematic, even prophetic qualities. In a forgotten meaning of 'unknown origin' – according to Grimm's *Deutsches Wörterbuch* [German Dictionary] – the word 'Geräusch' ['noise, sound'] once meant 'Innereien' i.e. 'entrails' or 'innards' (Grimm 1984). Moreover, entrails were long considered a medium for prophetic practices, for divination. Trash, the cemetery of the thing-world, so to speak, is the perfect example of an emblematic burial ground. 'The amount of signification is equal to the amount of death' is not the only valid phrase here. The inverse is just as true: 'The amount of death is equal to the amount of signification': DeLillo's novel thus verifies Benjamin's diagnosis of Baroque emblematics by means of postmodern household garbage.

But we should not forget that garbage, in DeLillo's novel, has a twofold appearance: It appears as tangible trash and as acoustic trash. We already know of the strong connection between things and noise. DeLillo thus unveils an object that symbolises this relationship: the aforementioned kitchen compactor, which directly links tangible trash to trash in wave form: 'At home Denise placed a moist bag in the kitchen compactor. She started up the machine. The ram stroked downward with a dreadful wrenching sound, full of eerie feeling' (DeLillo 1999: 33).

Nietzsche once described the ear as the organ of fear (1988: 205). Acoustic trash in the form of noise thus stands for an embarrassing fact: it symbolises the failure of the project of civilisation. Amidst the noisy agency of things, mythic fear returns to the heart of civilisation. *White Noise* describes the return of mythic fear to the centre of man-made reality, a reality in which attempts to install technical products – especially those relating to communication technology – are transformed into mythic relations. Communication itself produces waste. Even the etymological history of the concept of communication preserves traces of its precarious

contaminating dimension. Like its Latin equivalent communicare, the Greek verb *koinoó* does indeed mean making common, sharing, communicating. However, it also means polluting or soiling.[4]

In the noise of the advanced modern age, the deep rumblings of a nameless fear are revealed. White noise denotes the threatening perpetual noise of floods of medial and cultural information, the ceaseless noise of the rising and falling of the acoustic remains of music, muzak, machines, things and institutions (see Saltzman 1988: 481). As if we were dealing with the infrasonic soundtrack of a David Lynch film, the very familiar roar of a supermarket overwhelms the first-person narrator, like a mythic threat from the depths of civilisation:

> I realized the place was awash in noise. The toneless systems, the jangle and skids of carts, the loudspeaker and coffee-making machines, the cries of children. And over it all, or under it all, a dull and unlocatable roar, as of some form of swarming life just outside the range of human apprehension. (DeLillo 1990: 36)

White noise is matter or garbage in wave form. It may not be tangible, but it is real. The existence of acoustic trash is thus another substantiation of my thesis that things have agency. Noise is pure agency, as it were; it is the agency of non-human reality. Garbage therefore represents the non-human within human reality.

Works Cited

Benjamin, W. (1974a), Zentralpark. In: Tiedemann, R./Schweppenhäuser, H. (eds) vol 1.2, *Gesammelte Schriften*. Frankfurt am Main, Suhrkamp: 655–690.
——(1974b), Ursprung des deutschen Trauerspiels. In: Tiedemann, R./Schweppenhäuser, H. (eds) vol 1.1, *Gesammelte Schriften*. Frankfurt am Main, Suhrkamp: 203–430.
DeLillo, D. (1999), *White Noise*. New York, Penguin.

4 As John Durham Peters comments: 'Communication crosses the border of inner and outer and can thus be common, just as meaning can be mean' (Peters 1999: 267).

Grimm, J./Grimm, W. (1984) (1854–1960I: Leipzig) (eds), *Deutsches Wörterbuch*. 32 vols, Munich, dtv, IV/1., 2. Teil.

Grimmelshausen, H.C. von (1668), *Der abenteuerliche Simplicissimus Teutsch*. In: Breuer, D. (ed.) (1989), *Werke*, vol. 1.1. Frankfurt am Main, Deutscher Klassiker Verlag.

Harman, G. (2002), *Tool-Being. Heidegger and the Metaphysics of Objects*. Chicago/La Salle, Open Court.

Heidegger, M. (1984), *Sein und Zeit*. Tübingen, Niemeyer.

Kafka, F. (1995), The Metamorphosis. In: *The Metamorphosis, In the Penal Colony and Other Stories*. Neugroschel, J. (trans.). Scribner: New York: 115–188.

—— (1995) In the Penal Colony. In: *The Metamorphosis, In the Penal Colony and Other Stories*, Neugroschel, J. (trans.). Scribner: New York: 189–229.

Latour, B. (2005), *Reassembling the Social: An Introduction into Actor-Network-Theory*. Oxford, Oxford University Press.

Latour, B./Weibel, P. (eds) (2005), *Making Things Public: Atmospheres of Democracy*. Karlsruhe, ZKM/Cambridge, MA, MIT Press.

Nietzsche, F. (1988), *Kritische Studienausgabe*, vol.3. Colli, G./Montinari, M. (eds). Munich/Berlin/New York, dtv.

Peters, J.D. (1999), *Speaking into the Air. A History of the Idea of Communication*. Chicago/London, University of Chicago Press.

Saltzman, A. (1998), The Figure in the Static: White Noise. In: Osteen, Mark (ed.), *Don DeLillo, White Noise. Text and Criticism*. Penguin, New York/London: 480–497.

Seibt, G. (1997), Wer nie sein Brot mit Erdnußbutter aß. Von der Neigung deutscher Dichter zum Kulturpessimismus. In: Seibt. G. (ed.), *Das Komma in der Erdnußbutter. Essays zur Literatur und literarischen Kritik*. Frankfurt am Main, Fischer: 180–188. (First published under the title 'Wer nie sein Brot mit Erdnußbutter aß. Kulturpessimismus als poetische Gefahr: Warum die deutschen Dichter mit den Gegenständen des Alltags nichts anfangen können'. *Frankfurter Allgemeine Zeitung*, 2 April 1996).

Spinnen, B. (1997), *Langer Samstag*. btb, Munich.

Tretjakow, S. (1972), *Die Biographie des Dings. Die Arbeit des Schriftstellers*. Boehnke, H. (ed.) (1972), Reinbek bei Hamburg, Rowohlt.

Vischer, F.T. (1891), *Auch Einer. Eine Reisebekanntschaft*. 2 vols, I, (fifth edn.) Stuttgart/Leipzig/Berlin/Vienna, Deutsche Verlags-Anstalt.

WIM PEETERS

Deconstructing 'Wasted Identities' in Contemporary German Literature

One of the most beautiful essays for the waste-nostalgic is Italo Calvino's text *La poubelle agréée*[1] (1977), reflecting on the communal waste disposal in Paris. In his essay Calvino asserts that placing household refuse in an approved container represents the core of the social contract. By putting the trash on the street the *pater familias* disciplines himself and takes on a social role. He (or she) accepts the convention of placing the garbage only in the state-approved dustbin with its uniform military colour. In return the state approves of the everyday domestic ritual of the *pater familias* who decides what enters into the production cycle of the *oikos*, the household, and what goes out as a leftover of this cycle, which is pleasing for the self-esteem of the head of the family. The waste-disposal monopoly of the state ensures the household remains orderly, and it prevents it from confusedly identifying with what is left over from production and consumer life. The smallest unit of social life only finds recognition if it respects the border between waste and useful product, between waste and potential recyclables. For Zygmunt Bauman the men who day in and day out 'refresh and make salient again the borderline between normality and pathology, [...] the accepted and the rejected, [...] the inside and the outside' are the garbage or rubbish collectors. They are the 'unsung heroes of modernity' (Bauman 2004: 28). Like immigration officers and quality controllers they are needed to prevent the borderline from blurring. This borderline is not given: on the contrary, it is the boundary itself that 'divines, literally conjures up, the

1 As part of the French expression for the state-provided dustbin, 'agréée' means
 agreeable in the sense of approved, acceptable or pleasing. Calvino plays with these
 connotations.

difference' between waste and non-waste (Bauman 2004: 28). Therefore, the rubbish collector can never work on his own account. He needs to be assigned the task and instructed on how to draw the boundary.

The Collector

In the 2006 novel *Der Sammler* ['The Collector'] by Evelyn Grill the main character Alfred Irgang ['Alfred Aberration'], an upper-class millionaire heir, turns the waste-traffic between his household and society on its head. Every day he acts as a rubbish collector by his own rules. He purloins waste of all kind from public containers to bring it into his luxury apartment and a number of basement rooms and garages. Alfred guards the rubbish, just as he takes care of the precious Biedermeier ensemble and the painting by the famous artist Beckmann that he inherited from his parents. He brings along special collector items to please the members of an upper-class group of academic and artist friends whom he meets once a week in a fancy Italian restaurant. Although the items do not fill them all with disgust and are very much suited to fit their special interests, his friends always reject his gifts for therapeutic reasons. They do not want to exacerbate his condition, they label him a compulsive hoarder. They discipline themselves and draw the border to protect their social environment from becoming contaminated by insanity. As a result of their anticipatory obedience to the environmental agency, they fail to acknowledge their friend as a heroic rubbish man. The girlfriend of a literature professor decides to write a novel about him, but complains that Alfred's life lacks the destiny of a literary hero. Although he is filthy and is always carrying plastic bags full of waste, he is not excluded from their exclusive circle. They legitimise this as an appropriate measure to save him from becoming completely isolated or at least to save his father's heritage from being wasted. Since he confronts them with the collective act of waste disposal every week, their usual cultivated conversation becomes more and more entangled in management discussions about their friend. When Dr Hugo Bosart ['Mal(icious)-Art'], a gallery owner, joins the group, the intellectual discourse about the meaning of collecting things becomes

irrevocably ambivalent. Dr Bosart exposes the self-satisfied attitude of the educated class towards the order of things as illusive:

> Es scheint, sagte Bosart sinnend, daß der Mensch der Moderne, der an keine meta-physische, vorgegebene Ordnung der Dinge mehr glaubt, dazu gezwungen ist, diese Ordnung durch das Sammeln künstlich herzustellen. (Grill 2006: 178)

> [It seems, Bosart said thoughtfully, that modern man, who doesn't believe in a meta-physical, predetermined order of things, is forced to artificially create this order by collecting things.][2]

Waste becomes an obsession for the group. For the sake of inner cohesion, they can no longer afford to not take action. When Alfred is bitten by a rat and finds himself severely ill in hospital, their time has come. In a heroic act they decide to ignore the law and to clean up his property without his consent. Now they act as unapproved rubbish collectors themselves. However, even they cannot conform fully to the work of the rubbish collector: part of their friend's collection is being recycled into an installation art work. The gallery owner even has the idea to place Alfred in the midst of his collection. If they fail to make him presentable to the educated elite they can always still recycle him or his collection as a work of art. They restore order by dividing his collection into two separate collections: the valuables remain in his apartment and the rubbish is moved into the gallery. Bringing waste into an art gallery or museum is art; bringing waste without further treatment into the household is asocial, because then nothing is wasted any more. When it comes to the design of human life, everybody is expected 'to plot more room for "the good" and less room, or no room, for "the bad"' (Bauman 2004: 29). Although Alfred's alleged friends do not change his collection much, they do so sufficiently to enable them to draw a distinction, 'that conjures up disorder together with order, dirt together with the project of purity' (Bauman 2004: 19).

2 Special thanks to Carolin Küll and Sibylle Vaut for the English translations. Unless otherwise stated, all translations in this chapter are by Küll and Vaut in conjunction with myself.

As expected, neither the clean-up nor the art project result in any thera-peutic effect. The waste collector dies in a fire, and his assistant, a woman he picked up on the street, inherits all his belongings, including his new, smaller, waste collection. Now the professor's girlfriend finally finds the authentic heroic ending she wanted for her novel. The discourse organising the border between waste and valuables, wasted life and approved exist-ence is wasted by title of inheritance to a person outside of the grasp of discourse. As a result of surgical treatment, Alfred's assistant can no longer speak. All she does is laugh at anyone who addresses her. The autonomy of the household is restored, but only wealth can protect the legacy of the rubbish collector.

Wasted life

Except perhaps among the Italian waste mafia, public rubbish collectors have a low status in society. For Calvino, the immigrant dustbin or gar-bage men from Paris represent the first step into social integration. The approved container stands for social recognition, not only for the head of family, but also for the garbage man. He or she embodies the transforma-tion of the pariah, the bad, into potential garbage producers, the good. This is according to Calvino the 'entry point into a system, that swallows up men and remakes them in its own likeness and image' (Calvino 1993: 111). In the same way as the household, the state, as a bigger economic entity, normally cannot afford to identify with or to coincide with its leftovers. It must have room to concentrate on the productive part played by its citi-zens. Therefore, it badly needs the distinction between 'good' and 'bad'. Zygmunt Bauman puts it this way:

> When it comes to designing the forms of human togetherness, the waste is human beings. Some human beings who do not fit into the designed form nor can be fitted into it. [...] Another name for the designation of the new and improved forms of human togetherness is order-building. (Bauman 2004: 30)

But what if the nation state does not have enough capacity to recycle its excluded? What if it produces more unemployed, excluded, more wasted life, than it can legally or bio-politically handle? This is the case in a number of Western welfare economies with traditionally strong public welfare systems, such as Belgium, France or Germany. In these countries, an increasing number of people find themselves excluded from the social mainstream because they have permanently lost their potential for social mobility. This applies to the increasing group of undereducated and long-term unemployed people, who have become quite literally redundant. Bauman defines them as a by-product of a society under pressure of neo-capitalist globalisation, as wasted lives:

> Where the prefix 'un' in unemployment used to suggest a departure from the norm – as in 'unhealthy' or 'unwell' – there is no such suggestion in the notion of 'Redundancy'. [...] 'Redundancy' whispers permanence and hints at the ordinariness of the condition. [...] 'Redundancy' shares its semantic space with 'rejects', 'wastrels', 'garbage', 'refuse' – with waste. (Bauman 2004: 11–12)

The 'production' of wasted life finds a resounding echo in contemporary German fiction. The novels for discussion here focus on the threshold between approved and wasted life and the fictional status of the discourses that protect this boundary.

The Case of Germany

After 1945, and then once again after the fall of the Berlin Wall in 1989, the German democracy made a strong claim to 'take care' of its people – this after two dictatorships that had pretended to take care, but had so terribly failed in doing so. In the wake of the reunification process, the self-confidence of the German welfare state was severely damaged once the extent of its social problems was uncovered, in particular the unemployment situation within the former GDR. The post-war West German nation had

been built on the assumption that the mass unemployment that had led to the Nazis taking power had been successfully and definitively overcome, and that nobody would ever again be excluded from society. Suddenly, the affective condition of the German nation, the 'formal and informal sense of social belonging' (Berlant 2007: 274) that structured the aspiration to realise social integration, was wasted.

Since the German welfare state sees no real solution for its current unemployment problem, control measures remain the only option for avoiding a potential threat to social stability. The welfare state forces unemployed people to accept surveillance in exchange for the appeasing guarantee of minimal integration into consumer life (Kloepfer 2008: 244–246). But this simulation of social integration conceals the gap between social life and mere existence reduced to a 'redundant life'.

Because of the German collective memory, contemporary German fiction tends to reflect the substantial ethical dilemma in the debate on social exclusion. A utopian agenda concerning the organisation of social life, as can be traced in Weimar 'unemployment literature', has been abandoned. In fact the narratives selected here show different aspects of the implicit dehumanising violence of the discourse that determines what is social life. In this discourse, the violence lies in the omission of redundant life. As Judith Butler points out 'there is less a dehumanizing discourse at work here than a refusal of discourse that produces dehumanization as a result' (Butler 2004: 36). Rather than offering accurate representations of unemployment, economic survival, or the demise of social safety nets in post-1989 Germany, the novels elaborate on the way we find ourselves caring about the problem of wasted identities. They depict the affective condition of being permanently exposed to the collective aspirations and memories of normal life, while being permanently excluded from it. In the first example, the reeducation programme of a social elite dealing with a so-called compulsive hoarder got out of hand. I shall now discuss two more examples in which contemporary German literature challenges the discourse on approved and wasted identities.

Herr Jensen

One literary strategy interrogating the experience of social redundancy consists in reducing the impact of the discourse on normal life to an absolute minimum. This is the case in *Herr Jensen steigt aus* by Jakob Hein ['Herr Jensen drops out', 2006]. In this novel, Herr Jensen contests the state monopoly on judging belonging and exclusion, usefulness and redundancy (Bauman 2004: 33). After being discharged as a postman, he starts looking for evidence that the state's claim to sovereignty over his productivity is legitimate. As he finds in himself a great talent for viewing public television programmes, he decides to appoint himself TV-researcher. With the help of several video recorders, he aims to uncover the hidden meaning of afternoon talk shows. Here are his results:

> Es ging um moralische Normen. Doch während man diese früher in Kursen erlernen und in Benimmbüchern nachschlagen konnte, wurden sie nun auf diese vollkommen andere Art vermittelt. [...] In den Sendungen, die Herr Jensen in den letzten Monaten studiert und analysiert hatte, konnte man [...] sehen, wie man nicht mehr leben durfte. Darum war es auch möglich, daß dieselben Menschen immer andere extreme Standpunkte vertraten. Sie dienten nur als Mensch gewordene schlechte Beispiele. [...] Das hatte Herr Jensen herausgefunden. Und er schrieb auf einen Zettel, was demzufolge normal sein sollte:
> Man sollte arbeiten gehen.
> Man sollte eine Frau oder zumindest häufig Sex haben.
> Man sollte viele Freunde haben.
> Man sollte die aktuelle Mode kennen.
> Man sollte Ahnung von Musik haben.
> Man sollte fröhlich sein.
> Man sollte Geld haben.
> Man sollte schön sein.
> Man sollte etwas mit sich anfangen.
> Man sollte Träume haben.
> Herr Jensen mußte feststellen, daß er nicht normal war. Er seufzte erschöpft. Herr Jensen konnte sich nicht erinnern, jemals etwas falsch gemacht zu haben. Stets hatte er getan, was ihm gesagt worden war, und niemals war er rebellisch geworden. Trotzdem mußte er erstaunt erkennen, dass er am Rand der Gesellschaft stand.
>
> (Hein 2006: 82–83)

[It was about moral norms. But whereas you used to be able to learn about these in courses or look them up in books on etiquette, they were now passed on in this utterly different way. [...] The programmes which Herr Jensen had been studying and analysing over the last months showed [...] how you ought not to live anymore. That is why it was possible that the same people represented an increasing variety of extreme positions. Their function was to embody the bad example in human form [...] This was what Herr Jensen had found out. And he wrote on a piece of paper what was accordingly considered normal: You ought to work.
You ought to have a wife or at least frequent sex.
You ought to have many friends.
You ought to be acquainted with the latest fashion.
You ought to know something about music.
You ought to be cheerful.
You ought to have money.
You ought to be beautiful.
You ought to make something of yourself.
You ought to have dreams.
Herr Jensen had to acknowledge that he was not normal. He sighed in exhaustion. Herr Jensen could not remember ever having done anything wrong. He had always done as he was told and never had rebelled against anything. Still he had to realise in amazement that he found himself at the margins of society.]

After this discovery, he acts as a *pater familias*. He throws his television set onto the street and disposes of his large collection of videos. It has become worthless junk to him. He refuses to accept that his way of life is not normal. After meticulously reconsidering his desires and everyday consumer rituals, he concludes that his way of adapting to society is to live in passivity. Productivity is reduced to a privilege that is guaranteed by the group of low-profile redundant people:

Es gibt viel zu wenig Leute, die nichts machen wollen. Die meisten wollen etwas machen, und davon gibt es zu viele. Es ist eine neue Art der Arbeitsteilung, bei der manche Arbeit bekommen, meistens sogar ziemlich viel. [...] Und andere bekommen weniger von der Arbeit ab. Zum Beispiel ich. Das ist praktisch meine gesellschaftliche Rolle. Es können nicht alle nur geben, manche müssen auch nehmen. [...] Die anderen arbeiten, ich verzichte darauf. Es wird zwar nicht so an die große Glocke gehängt, aber eigentlich ist das doch allen klar. Sieh mal, es gibt zum Beispiel ein ganzes riesiges Amt nur für uns. [...] Menschen wie ich sind der Beweis unseres

Wohlstands. Wir werden gebraucht. Kein Unternehmer überlegt sich, wie er neue Arbeitsplätze schaffen kann. Einen neuen Arbeitsplatz wird es nur dort geben, wo man zwei andere dafür abbauen kann. (Hein 2006: 93–94)

[There are far too few people who do not want to do anything. Most do want to do something and there are too many of them. It is a new kind of division of labour whereby some get work, mostly a lot. [...] And others get a lesser share of the work. Me for example. That's practically my role in society. Not everybody can just give, some people also have to take. [...] The others work, I go without. It may not be shouted from the rooftops but actually everyone knows it. Look, for example there is even a whole huge agency just for us. [...] People like me are the evidence of our prosperity. We are needed. No employer actually considers how to create more jobs. There will only be a new position where two other jobs can be cut.]

Fiction can turn the desires of social belonging around, thus reflecting on the elements that structure social identity. For Herr Jensen both the passive and active people are on the good side of life. At the end of the novel, all hope of this fact being recognised is dashed: people from social services invade Herr Jensen's private sphere and penetrate his house without his permission, as if he were a criminal. Once he has disposed of his mailbox and has decided that letters have become meaningless junk to him, the state breaches his domestic peace, to remove him not so much as a criminal citizen but as a wasted identity. His decision about what is junk and what is not is no longer accepted by the state. Herr Jensen finally convinces them to leave his house and then unscrews the name plate by his door and throws it away.

This intervention of social services is characteristic of modern biopolitics as Giorgio Agamben understands it. The room for life at the margins of what politics defines as 'good life' is more and more restricted and subjected to state surveillance. Once the state 'crosses over the walls of the *oikos* [...], the foundation of sovereignty – non-political life – is immediately transformed into a line that must be constantly redrawn' (Agamben 1998: 131). This insecure borderline is the main focus of the next novel presented here.

School for the Unemployed

In the novel *Schule der Arbeitslosen* ['School for the Unemployed', 2006]
Joachim Zelter imagines a near-future scenario of people 'voluntarily'
locked away in a job application training camp called SPHERICON.
The idea of bringing the unemployed together in a training camp already
existed at the eve of the Second World War. In fact it was proposed by the
Jewish legal historian and sociologist Eugen Rosenstock-Huessy in 1932.
The unemployed have to experience that they are:

> [...] Teile eines Ganzen, das zusammen gehört und in sich zusammenhängt auch ohne
> den Markt und vor jedem Markt. [...] Die Arbeitslosen [...] müssen praktisch erfahren,
> daß sie nur eine Funktion im Volksschicksal tragen. Die soziale Einheit zwischen
> wirkender und ruhender Kraft muß in Gruppen gelebt werden, die aus Arbeitslosen
> und Nichtarbeitslosen zusammengesetzt sind. (Rosenstock-Huessey 1932: 72)

> [[...] part of a whole that belongs together and forms a coherent unit in itself even
> without the market and prior to any market. [...] The unemployed [...] have to prac-
> tically experience that they only have a function in the context of the destiny of the
> people. The social unity between strength in action and at rest has to be lived in
> groups which are composed of the unemployed and the not-unemployed.]

Rosenstock-Huessy's utopian dream of a state that distances itself from the
free market to reconsider its foundations has lost its appeal. Nowadays the
unemployed are no longer glorified as a 'reserve army of labour' that can
be called back into active service any time. The job market itself is rather
imagined as a battle field for lone warriors.

Zelter uses his novel to reveal the hollowness of unemployment man-
agement slogans. The training camp slogans such as 'Deutschland bewegt
sich' ['Germany is on the move'], 'Work is freedom', 'A new life' or even
'Anything goes' are wasted: they lose their meaning. Zelter conjures up the
fear that this kind of empty rhetoric might get out of hand and become
part of a totalitarian system. This can be understood as a comment on the
current intellectual debate on social exclusion in Germany. In the novel,

the camp is the place where the state begins to dissolve from within, rather than under external pressure from globalisation.[3]

From the very beginning of the novel, the voluntary status of the detention in a camp seems doubtful. This suspicion is raised when at the last minute, two unemployed people decide not to join the training camp.

> Minuten später sind die beiden Vermissten erfasst, nicht leibhaftig, sie können gehen, wohin sie wollen, ohne gesucht zu werden – vielmehr in den Computern der Bundesagentur. Der Vorfall ist unumkehrbar vermerkt. Jeder weitere Anspruch gegenüber der Bundesagentur ist verwirkt. Ab jetzt stehen sie außerhalb jedweder Obhut. Ihre Namen und Daten werden zum Löschen freigegeben. Ihre Koffer werden entsorgt. (Zelter 2006: 16)

> [Minutes later both missing people are captured, not in person, they can go wherever they want to without being searched for – but rather in the computers of the federal agency. The incident is irrevocably noted. Every further claim against the federal agency is forfeited. From now on they are no longer taken care of. Their names and data are released to be deleted. Their luggage is disposed of.]

This scene reveals the basic issue of the novel in nuce: the novel elaborates on the problem that there is 'no compartment reserved for human "waste" (more to the point, wasted humans)' in modern society (Bauman 2004: 13). In a totalitarian coaching programme, the trainees are motivated to trash their real biography and to design a completely fictitious but combat-ready new identity, enabling them to be prepared for the battle they have to face on the current job market.

> Ein arbeitsloser Mensch ist nicht ein Mensch ohne Arbeit. [...] Ein Arbeitsloser leistet fortwährende Sucharbeit. [...] Dies ist die Arbeitsteilung unsere Zeit. [...] Eroberung von Arbeit gegenüber der Verteidigung von Arbeit. [...] Im Vergleich zur Sucharbeit ist die gefundene Arbeit nur noch eine milde Form der Nacharbeit. Reine Absicherung. Verteidigungsmaßnahmen, Befestigungsarbeiten. (Zelter 2006: 34)

3 Zelter's camp-imagination alludes to the strong appeal in German debates about Giorgio Agamben's conceptions of the state of exception and the concentration camp.

[An unemployed person is not a person without work. [...] An unemployed person carries out the relentless work of searching. [...] That is the division of work of our time. [...] The conquest of a job versus the defence of a job. [...] In comparison to the job of searching, the found job is nothing more than a mild form of follow-up work. Nothing but security measures. Defence strategies, fortification.]

With war rhetoric they are talked into a state of exception, in which they accept a restriction of their individual rights. Since the job market is at war, they have to give up their background and personal history and tolerate being transformed into legally unnamable and unclassifiable entities. The coaches in the camp take advantage of the fact that existence at the edge of social recognition makes it difficult for subjects to reconstruct their social identity, the part of our identity that is structured by the desire to belong to a group. As Pierre Bourdieu put it, people experience difficulties narrating their life when they lack access to the social mainstream (Bourdieu 1993: 68, 474).

Vocabulary plays a central role in this novel. It demarcates the camp situation, the non-place,[4] the trainees find themselves in. In Vincent Descombes's terms they are estranged from 'the rhetorical country' in which they are at home. Home, argues Descombes, is where a character is understood without too much difficulty, by 'the reasons he gives for his deeds and actions, the criticisms he makes or the enthusiasms he displays. A disturbance of rhetorical communication marks the crossing of a frontier, which should of course be envisaged as a border zone, a marchland, rather than a clearly drawn line' (Descombes 1987: 179, cit. in Augé 1995: 108). The trainees are deliberately being deterritorialised: they are reduced to a fictional job market existence. Zelter recycles here his work as a literary scholar: the language of research into (auto-)biographies is being exploited by the coaches to trash the real identity of the trainees. One coach puts it this way:

4 In his work *Non-Places. Introduction to an Anthropology of Supermodernity*, Marc Augé gives the following examples of non-places as opposed to familiar places: transit camp vs. residence; interchange vs. crossroads (where people meet); passenger (high speed train) vs. traveller (strolls along his route by train); housing estate (anonymous) vs. monument (where people share and commemorate); communication vs. spoken language etc. (Augé 1995: 107).

Lebensläufe sind Fiktionen. 'Der reine Erfolg, die äußere Wirkung eines Lebenslaufes, nichts anderes ist die Vorgabe. [...]' Und: 'Alles Autobiographische ist autofiktional, und umgekehrt.' Und: 'Eine gelungene Bewerbung ist wie ein Bestsellerroman: anziehend, mitreißend, hinreißend... Von der ersten bis zur letzten Zeile. Eine Vorwärtsbewegung... Eine durchgehende Trasse... eine Erfolgsspur... Eine epische Autobahn...'. (Zelter 2006: 66–67)

Bei einer anderen Gelegenheit sagt er: 'Würde man ein Buch über SPHERICON schreiben, es kämen darin keine wirklichen Menschen vor, auch keine Figuren von Menschen, sondern höchstens Fragmente oder Figmente wechselnder Lebensläufe... Funktionen und Produkte biographischer Entwürfe [...]!' Und: 'Die meisten Figuren bräuchten nicht einmal Namen. Und selbst wenn doch, dann nur, um sie jederzeit austauschen und wechseln zu können...'. (Zelter 2006, 68–69)

[Résumés are fictions. 'Pure success, the external impact of a résumé, is the only guideline. [...]' And: 'everything that is autobiographical is autofictional, and vice versa.' And: 'a successful application is like a bestselling novel: attractive, captivating, ravishing... From the first line to the last. A forward movement... A non-stop track... A road to success... An epic motorway...']

[On another occasion he says: 'if you wrote a book about SPHERICON, there would be no real people in it, not even characters of human beings but at best fragments or figments of changing résumés... functions and products of biographical drafts [...]!' And: 'most characters would not even need names. And even if they did, then only in order to be able to replace and exchange them at any time...']

However, in reality, the misuse of this academic discourse is fake: not only the trainees but also the coaches, who have been recruited from the group of trainees, are in a deportation camp facing disposal. They are in custody to secure deportation. Cynically enough, not even survival under a fake identity is guaranteed. The identities which have been created are deliberately obsolete. They are intended as disposable identities, not for life but to be trashed as soon as their short-lived usefulness expires.

Die Bundesagentur gibt bekannt: Sonderurlaub für alle Trainees. [...] Nicht Mallorca, nicht die Kanarischen Inseln, sondern Afrika... Freetown, Sierra Leone, Afrika. Abflug um 15 Uhr in Frankfurt... Alles bereits arrangiert: Flug, Transfers, Unterbringung... Beach Camps der Bundesagentur direkt am Atlantischen Ozean. (Zelter 2006: 199)

[The federal agency announces: special leave for all trainees. [...] Not Mallorca, not the Canary Islands, but Africa... Freetown, Sierra Leone, Africa. Departure at 3pm

from Frankfurt... Everything has already been arranged: flight, transfers, accommo-
dation... Federal agency beach camps right by the Atlantic ocean.]

Earlier in the novel, mysterious posters in the cafeteria reveal the true
nature of this journey:

[...] Strandposter mit Palmen, doch keine wirklich grünen, sondern halb vertrocknete
Palmen. Sie wirken angeschlagen, die Blätter zerrupft. Was das zu bedeuten habe?
Sierra Leone steht auf einem der Poster. Freetown, Sierra Leone. [...] Was wohl diese
Poster zu bedeuten haben? Gar nichts – reine Dekoration. [...] Warum überhaupt
das Logo der Bundesagentur auf jedem dieser Poster? (Zelter 2006: 74)

[[...] Posters of beaches with palm trees, not really lush green, but rather semi-dehy-
drated palm trees. They seem to be ailing, the leaves ragged. What significance does
this have? Sierra Leone is written on one of the posters. Freetown, Sierra Leone. [...]
What might these posters mean? Nothing at all – just decoration. [...] Why then
the logo of the federal agency on each of these posters?]

The trainees will be put on the plane, escorted by the police. Their mobile
telephones do not work anymore. Although the story is not fully consistent
– what will happen for instance when the deportation is noticed by their
relatives? – the message is clear. In this 1984-like future scenario the state
has given up. This large-scale state programme to help people re-integrate
into the employment market actually serves as a cover up. The state knows
that securing biological survival in a camp situation 'will not be sufficient
for a re-admission of the "redundant" to the society from which they have
been excluded – just as storing industrial waste in refrigerated containers
would hardly suffice to make it into a market commodity' (Bauman 2004:
12–13). The state abandons its own legal order and creates a parallel order
in which it cannot guarantee social survival any more. To this end it first
wastes the identities of the redundant, and then confronts them with an
unknown future in Africa. Ironically to us, this is the homeland of many
of the economic refugees of our times.

The meaninglessness of the trainee programme becomes obvious when
one female trainee does not want to co-operate any more. Because of man-
agement problems outside, they keep her in the camp. She is the one that
is excluded from camp life without being excluded from the camp.

Einen Monat zuvor hätte man sie von der Schule verwiesen [...] – mit allen Konse-
quenzen, die die Bundesagentur daraus gezogen hätte. Delete! Delete! Seit einiger
Zeit lag aber bei der Schulleitung die Weisung der Bundesagentur, bei disziplinar-
ischen Vergehen Trainees einstweilen auf dem Schulgelände zu halten. Es mehrten
sich die Fälle marodierender Arbeitsloser, die ziellos durch die Gegend zogen, ohne
Status und Plan. (Zelter 2006: 159)

[A month earlier they would have expelled her from the School [...] – with all the
consequences the federal agency would have drawn. Delete! Delete! But for some
time now the head of the School has been under instruction from the federal agency
to keep the trainees on the School grounds for the time being in case of disciplinary
offence. The number of cases of unemployed people marauding aimlessly around
without status or agenda had been multiplying.]

They even have to accommodate her in the weekend suite, which has
been designated as a place where successful trainees are rewarded with
sexual pleasure. It is for those trainees who have been very 'promiscuous'
['promiskuitiv'] (Zelter 2006: 68) in designing their fake identities and
career aspirations in various directions.

In the end, the female trainee is not punished, because she does not
exist any more. The disciplinary control restricts itself to dealing with
bare life and not with citizens, who have to be re-educated. To appease
her, she gets the camp-certificate with the bonus of the holiday camp in
Sierra Leone.

Sie hat ihr Zeugnis bei sich. Welch ein Zeugnis. Certificate of Professional Appli-
cation. Mit einem Vermerk. Aber sie hat keinen Ausweis oder sonstige Papiere bei
sich. Wo immer sie auch sein mögen. Noch im Bus bei den Begleiterinnen der Bun-
desagentur oder schon im Flugzeug. Sie könnte nicht einmal beweisen, wer sie ist
oder einmal war. (Zelter 2006: 205)

[She has her certificate with her. What a certificate. Certificate of Professional Appli-
cation. With a comment. But she does not have a passport or any other papers with
her. Wherever they may be. Still on the bus with the federal agency attendants or
already on the plane. She could not even prove who she is or once was.]

No law

The three rather thesis-like novels I have presented here call to mind a suppressed part of collective memory. Our social system is founded on an act of ostracism: it is only through the exclusion of a group of people, that the inclusiveness of the major productive part of the population can be defined and guaranteed. At the same time, the novels examine how the border between approved and rejected life is becoming increasingly nebulous. In fact, all three novels comment on the illegitimate and violent means used to conceal this blurred border. The protection of productive life gets out of hand once the excluded are made 'socially invisible' (Biehl 2001: 134). They are banned from the 'rhetorical territory' or literally dumped in non-places. They are no longer subject to the law, but are being subjected to state waste management control. When it comes to waste disposal, the state or its agents do not respect the social contract anymore: they deal with its redundant people as waste and not as rubbish producers. By recycling the various discourses on wasted life, literature, as a special epistemic source, shows the limits of the interventionist discourse. As early as 1932, Rosenstock-Huessy was formulating the ethical dilemma that retains all its sad quality today: 'now we have to remove the sting of redundancy from the redundant, the many all-too-many. This cannot be done by force, by the state, by law or by any legal rule' ['Nun gilt es, den Überflüssigen, den vielen Allzuvielen den Stachel ihrer Überflüssigkeit zu nehmen. Das kann kein Zwang, kein Staat, kein Gesetz und kein Rechtsatz'] (Rosenstock-Huessey 1932: 46).

Works Cited

Agamben, G. (1998), *Homo Sacer: Sovereign Power and Bare Life*. Heller-Roazen, D. (trans.). Stanford, CA, Stanford University Press.
Augé, M. (1995), *Non-Places: Introduction to an Anthropology of Supermodernity*. Howe, J. (trans.). London/New York, Verso.

Bauman, Z. (2004), *Wasted Lives: Modernity and its Outcasts*. Cambridge, Polity Press.

Berlant, L. (2007), Nearly Utopian, Nearly Normal: Post-Fordist Affect in La Promesse and Rosetta. *Public Culture* 19/2: 273–301.

Biehl, J. (2001), Vita: Life in a Zone of Social Abandonment. *Social Text* 19/3: 131–149.

Bourdieu, P. et al. (1993), *Misère du Monde*. Paris, Éditions du Seuil.

Butler, J. (2004), *Precarious Life: The Powers of Mourning and Violence*. London/New York, Verso.

Calvino, I. (1993), La Poubelle Agréée. In: *The Road to San Giovanni*. Parks, T. (trans.). London, Jonathan Cape Random House: 93–126.

Descombes, V. (1987), *Proust, philosophie du roman*. Paris, Éditions de Minuit.

Grill, E. (2006), *Der Sammler: Roman*. St. Pölten/Salzburg, Residenz Verlag.

Hein, J. (2006), *Herr Jensen steigt aus: Roman*. Munich/Zurich, Piper Verlag.

Rosenstock-Huessy, E. (1932), *Arbeitsdienst – Heeresdienst?* Jena, Eugen Diederichs Verlag.

Zelter, J. (2006), *Schule der Arbeitslosen: Ein Roman*. Tübingen, Klöpfer & Meyer.

CATHERINE BATES AND NASSER HUSSAIN

Talking Trash/Trashing Talk: Cliché in the Poetry of bpNichol and Christopher Dewdney

> The minute you start paying attention to waste a different relation with it is enacted.
>
> — HAWKINS 2006: 13

> To this very day civilization's ambivalence toward shit continues to be marked, on the one hand, by a will to wash those places where garbage collects (i.e., in city and speech) and, on the other, by a belief in the purifying nature of waste – so long as it is human.
>
> — LAPORTE 2000: 38

> I always said that I was part of the oral tradition. I always said poetry was an oral art. When I went into therapy my therapist always said I had an oral personality […] And here I've been for years running after me, trying to catch up, shouting 'it's the oral', 'it all depends on the oral', everybody looking at my bibliography, the too many books & pamphlets, saying with painful accuracy: 'that bp – he really runs off at the mouth'.
>
> — BPNICHOL 1988: 15

Running Off at the Mouth

We propose in the space of this essay to consider a singular entity in the oral tradition: the cliché. The cliché is the thing that appears to have 'always' been said (note above how bpNichol insists on the ubiquitous and omnipresent nature of his convictions regarding orality). That which is 'always' said' ultimately finds its way into print, and from there, is reflected back into the sonic sphere through our mouths. In this way, the cliché is a portrait of language moving from mouth to hand to mouth again. In spite of

Nichol's public pre-occupation with orality, his readers only have recourse
to his printed output, his many performances 'disintegrating into history'[1]
as soon as the event has passed. Our speculations on the cliché, rubbish
and orality are based on our readings of two Canadian poets, Christopher
Dewdney and bpNichol – artists whose poetry explicitly works to find an
aesthetic value in the most commonplace language. Our foray into the
matter of trash talk, and specifically the devalued entity we call cliché,
takes on several dimensions simultaneously. We do not wish to form clear
layerings, consistent and separable topologies, or clean discursive breaks
so much as form a heap of overlapping tensions, a provisional and shifting
mass of associations that either whirl off on their own trajectory or plug
neatly into cyclical economies of desire, use, refuse and re-fusion.

Again, the mode of trash talk that we have isolated here (and we have
dispensed with more than we have retained in our search) takes cliché as
its starting point. The cliché is, as novelist Ali Smith puts it, 'truth misted
by overexpression [...] like a structure waiting to be re-felt, re-seen'. Smith
goes on to hypothesise that the cliché is so true it 'actually protect[s] you
from its own truth by being what it was, nothing but cliché' (Smith 2005:
59). We would extend Smith's conceit: clichés approach the status of the
phatic in speech, those murmurs of assent that ensure our conversational
partner not only that 'I'm here and listening', but also that 'you are over
there, talking'. In this manner, the phatic holds us in the world, ties us to
our places and offers a guarantee of reality. This is a remarkable property
of the cliché: in spite of its semantic poverty, in these most commonplace
utterances we harden our grasp on the present and the real through our
very social presence.

We might have focused on other utterances which, deviating from
perceived appropriate, crafted use, potentially fall by the wayside, invisible
to the critical eye. We might have concentrated on Spoonerisms, writing
under erasure, or we could have mixed our metaphors. But, as Opus the

1 This is a phrase taken from bpNichol and Steve McCaffery in their collaborative
 guise as the Toronto Research Group. In the introduction to their performance
 entitled The Language of Performance of Language, they allude to their belief that
 the 'performing being is a human hieroglyph, an instance of writing disintegrating
 in history' (McCaffery 1992: 228).

penguin says, 'You can lead a yak to water, but you can't teach an old dog to make a silk purse out of a pig in a poke' (Breathed 1988: 51). Here, our focus is on the cliché; retrieving it from the gutter, we hope to renew and rework it.

When Sheridan's marvellous creation Mrs Malaprop is asked how a woman's knowledge base should be built, her reply is that she would

> send her, at nine years old, to a boarding school, in order to learn a little ingenuity and artifice. Then sir, she should have a supercilious knowledge in accounts: and as she grew up, I would have her instructed in geometry, that she might know something of the contagious countries. But above all, Sir Anthony, she should be mistress of orthodoxy, that she might not misspell, and mispronounce words so shamefully as girls usually do, and likewise that she might reprehend the true meaning of what she is saying. (Sheridan 2004: 240–241)

We cannot even begin to imagine the curriculum at Malaprop's school. But we are pleased by the conflation of geometry and geography in this passage. Geography (at least political geography) calcifies into borders, nations, identities, fact from fiction, Selves and Others. Perhaps geometry (a root science in the art of cartography) does bring us some knowledge of those hinterlands at our borders, seething with disease. Malaprop's perfectly pronounced 'misuses' of words surprise and reveal far more than a simple truth or falsehood. Thus is meaning violently 'reprehended' (not apprehended, nor comprehended) from linear, one-to-one signification – but reprehended from order and pressed into a much messier state of affairs. What Malaprop does to words, Dewdney and Nichol do to cliché.

A cliché is a performative – it is neither true nor false in itself, but it enacts. Unlike J.L. Austin's examples, however, it does not perform an instrumental task (naming a ship, binding a couple in matrimony), but instead enacts a moment of shared experience.[2] Faced with the unknowable depths and infinite regress of a fellow human being's joy or despair or boredom, we nod our assent with a phrase. When it pours, it rains cats

2 Austin 1971: 13–22. Here, Austin differentiates from constative statements, which can be broadly said to have the property of either truth or falsity and isolates a different class: the performative utterance 'can never be either [true or false]: it has its own special job, it is used to perform an action' (13).

and dogs. The cliché emerges from our mouths fully formed, pre-digested nuggets of a social memory that express (in a remarkably and appropriately condensed manner) far more than they denote. It's not actually raining at all, is it? These utterances are so 'happy' that they transcend the strictures of immediate context. They are democratised, decentralised performatives, transferable from one mouth to another, and always carrying precisely the same authority – the authority of a Subject, one among many, stripped of the hierarchy of citing a single source, and invested instead with the weight of an entire history and culture. Cliché is Wordsworth's 'selection of language really used by men', and Eliot's objective correlative, pinning a universal truth down in language.[3] Truly, how many phrases dance on the ends of our tongues?

Perhaps bpNichol (Canada's most 'oral poet') might have an answer for us. We may run off at the mouth, but where do we (or it) run to? Jean Starobinski writes that 'holding one's breath, not letting it escape once and for all the barrier of one's teeth represents an elementary but fundamental form of self control exercised at that verge where a personal inside and out-side take shape' (Starobinski 1975: 341). We do not intend to underscore the individuation Starobinski advertises here, but rather, we choose to invert his statement. The mouth is the verge where the inside and the outside meet, a permeable membrane that not only renders the inside dependably interior, but also lets the outside in, too. It comes in through breath, certainly, but also in the form of food. In his essay, 'Edible Ecriture' Terry Eagleton tells us that '[F]ood looks like an object but is actually a relationship, and the same is true of literary works' (Eagleton 1998: 204). This is to say that we consume the literary and the linguistic, we digest and atomise it, read and are read, consume and are eaten in what Charles Bernstein has called the 'communal meal of language' (Bernstein 1992: 143).

If we take this angle, then Eagleton's next assertion takes on signifi-cant resonances. 'Fast food,' he writes, 'is like cliché or computerese, an emotionless exchange or purely instrumental form of discourse' (Eagleton

3 For their original discussions of poetic vernaculars and objective correlatives, respec-tively, see Mason 1992: 59, and Eliot 1967: 95–103, 101.

1998: 205). We hope that Eagleton's sentiment here jars with our earlier remarks about the phatic and cliché and the assertion of the Subject into the sphere of presence. Eagleton is perhaps correct in his characterisation of cliché as junk food, but the mistake he makes is in assuming that junk food is somehow morally or emotionally bankrupt. There's a snobbery afoot, here. Three-star Michelin or Big Mac, Heston Blumenthal or Delia Smith (and it is interesting to note that they have publicly declared their common interest in food chemistry)⁴ – food is purely sustenance when stripped of the distinctions of style, class and if not flavour, then 'taste'. If the Chicken Nugget is the homespun limerick and *morelles farcies au ris d'agneau*⁵ an epic, we must keep in mind that these are both still poems. By this we mean to underscore that cliché is not as trashy as one might assume. When we 'pay attention' to this wasted language, art emerges – and in this pressurised container, this tin of alphabet soup, we can find sustenance, warmth and comfort. But, like bp, now we're just running off at the mouth.

You, on the other hand, you put your foot in your mouth and bit off more than you could chew

Hand in Glove with an Old Hat
When it's raining cats and dogs you've got to cut corners because you could get your eyes peeled. You must come to grips with yourself until you fly off the handle & then if you're not as fit as a fiddle you'll spill the beans. That's hitting below the belt with the short end of the stick, if i can bring the point home, ladies.

4 See Rayner 2008 for more on how chef Heston Blumenthal, renowned for his 'molecular gastronomy', aligns his avant-garde techniques with Delia Smith's reliance on processed food, especially in 'junk' food's ability to stimulate emotional and cognitive responses from the diner.
5 Morel mushrooms stuffed with the testicles of a lamb. From *The Concise Larousse Gastronomique* 1999: 1254.

[...]
You, on the other hand, put your foot in your mouth and bit off more than you could chew. Now with what's left you put your foot in the door and then accuse me of changing my tune? I had to change my tune in order to face the music.

—DEWDNEY 1980: 94

To obsess with the obsolete on a job application, to rave about rubbish at the supper table, to sing about shit at a party – all could constitute 'putting your foot in your mouth'. It makes people uncomfortable to discuss waste; it disrupts the system of polite society. We treat rubbish worse than children – it should be neither seen nor heard. When we take notice of the waste we produce, we might choke on what is revealed; we are surrounded by our own trash. And we cannot stop producing it; as Gay Hawkins says:

> In the commodity relations that touch every aspect of life, waste, as conspicuous consumption, is an invitation most find difficult to refuse. Not because they lack moral fiber but because this particular habit is embedded in the character of social life. (Hawkins 2006: viii)

Our constitution as social subjects and our survival rely on our production of waste; whether we acknowledge it or not, we have a particular relationship with it: we are compelled to accept the invitation. But we hide it away and ignore it; we attempt to deny this connection. Similarly, whilst as social beings we are continually utilising clichéd language to communicate, the nature of the cliché is that which becomes practically invisible, undervalued: used but not heard. As we have begun to argue, Dewdney's *The Dialectic Criminal* and Nichols's *Selected Organs* ask us to hear the cliché, to conspicuously consume it, by piling cliché upon cliché they show us it is hard work to pay attention to this category of language act, as it is to *really* pay attention to waste. In our continual production, we have bitten off more than we can chew.

We have begun to argue that clichés are, in some respect, considered part of language's junk heap. Rather than desired well-wrought objects, they are the putty, the interstitial, they fill in the gaps and 'grease the wheels' of our limited communion through language, but we are not required to focus upon them, not really. Dewdney says of these colloquial phrases

that 'they are composed of words whose literal meaning is other than the context in which they are used [...].These units can almost be regarded as single words' (Dewdney 1980: 93–94). Others also consider the cliché to be a digestible unit, in which the individual words merge into an easily swallowed whole. Amossy and Lyons define clichés as 'stylistic features frozen by usage, lexically full figures felt to be shopworn or hackneyed' (Amossy and Lyons 1982: 34). Anton C. Zijderveld, in his seminal work *On Clichés: The Supersedure of Meaning by Function in Modernity*, argues we could view them as 'containers of old experience' (Zijderfeld 1979: 11). In the shop windows of our discourse, then, we have these peculiar products that are perceived as both their wrapper and the thing wrapped simultaneously. These are items that we safely judge by their covers: they do what they say on the tin every time because they *are* what they say on the tin. There seems to be no gap between the package and the content: the product is used, its package becomes invisible. The baby is thrown out with the bathwater. Expressed linguistically, the effect of an unquestioningly used cliché is that there is no referent at play in the economy of this sign. We only register a seamless match between the signifier and the signified (assuming we treat the phrase as a single morpheme), a circumstance that inaugurates a totally closed system. In this most trashy of verbal economies, nothing *seems* wasted.

Zijderveld argues that clichés are functional products rather than ones of reflective meaning; they become disposable once we have received the meaning: we take the meaning out and leave the container behind. The cats and dogs do not signify, they only evoke the rain. Just as rubbish can be defined as matter out of place – we only really notice it when we have not successfully hidden it away and it comes intruding on our everyday lives – if we *do* hear the individual words in a cliché, we begin to think about it, and note it as a cliché.[6] This, we hope, emphasises the precariousness of notic-

6 Michael Thompson, building upon Mary Douglas's idea that dirt and rubbish are socially produced categories, defined as 'matter out of place', points out that 'we only notice [rubbish] when it is in the wrong place. Something which has been discarded [and] threatens to intrude' (Thompson 1979: 4).

ing rubbish or cliché, they are only noticed when not functioning quite as rubbish and cliché, when they are being disruptive by being disrupted. This rupture enables the packaging to be noticed and recycled rather than just thrown away in the (vain) hope that it will disappear.

Much of the contemporary anxiety about waste focuses on the durability of what we dispense; the most useful packaging becomes rubbish very quickly – and then it lingers, reminding us of our consumption. This accounts for the same dynamic in language – our homilies and commonplaces tend to outlast their immediate contexts even as they drag outdated sediments and sentiments into the present conversation. But we need to notice; Hawkins and Muecke, two key rubbish thinkers, begin to suggest ways we can understand a more productive relation with the left-behind. Both focus on wasted containers: Hawkins infuses the plastic bag with affect, unveiling a biography which moves from container, to rubbish, to object of guilt but always in relation to a 'thinking, feeling, acting, becoming' subject-in-process (Hawkins 2001: 7). Muecke reveals the empty coke can about to be discarded as absolutely an extension of the discarder's body, and at the same time already the necessary wastage of this embodied subjectivity.

> In the interval between finishing a drink and throwing the can out of the car window there is a fundamental decision to be made about purity, about what is connected with our body and what is not. Waste has that magical liminal space of both being and not being in a relationship with our bodies. [...] That bit of waste has no connection with me, [we] might say, but, by this same logic, other highly significant things are connected with me. (Hawkins and Muecke 2003: 122)

By the same token, rather than refusing the cliché, this package of language, Dewdney and Nichol re-fuse it, making us hear the words, by putting something out of place. When it is in our way we take note. Take Dewdney's conjoining of 'foot in your mouth' with 'bit off more than you could chew'. Rarely would we visualise an actual foot in an actual mouth when we hear this term; it indicates saying the wrong thing at the wrong time, words out of place. But, being a cliché, the words become displaced, taken over by a common understanding of the overriding meaning. Juxtaposed with another cliché, the reader/listener bites off more than they can chew – the

meaning of the individual words, or perhaps the visual, physical meaning, rather than the clichéd meaning has to be processed – the cliché is displaced, put out of place. The feet are chewed, and we choke a bit.

We labour this point to, hopefully, emphasise the connection between cliché and rubbish; cliché is a kind of trash talk – it is devalued, dismissed and degraded language. It is the verbal equivalent to rubbish, trash, garbage, junk – material which, in the hands of Dewdney and Nichol, becomes disruptive, poetically sub-versive in its re-fusal of meaning. Nichol reminds us of society's privileging of the visual, 'it was better to be seen than heard' (1988: 9); rubbish is stuff we expressly do not want to see, or hear. But we only notice it when we do see it – just as kids will be heard, traces of ourselves will remain, and what's swept under the rug will be seen.

In *Of Grammatology* Derrida insists on the continual presence of trace: '[T]he trace is in fact the absolute origin of sense in general. Which amounts to saying that there is no absolute origin of sense in general. The trace is difference which opens appearance and signification' (Derrida 1976: 65). The chewing gum we find under the seat signifies a presence prior to us, and in the moment that we find it (however unsavoury an experience it may be) and acknowledge the Other any potential sense of a self-sufficient Cartesian ego is fundamentally disrupted. Our status as individuals is threatened; our trajectory intersects with the gum-chewer's, the gum's story mingles with our own. Like gum we won't chew, the cliché is undervalued because it is somehow used up, its original flavour wrung from it – we prefer 'fresh' language, novel flavours, something to savour. But, as Amossy points out 'the notion of the cliché implies a conception of reception as parroting and must necessarily be based on a dichotomy between Creation and Imitation, Originality and Banality, the Individual and the Collective' (Amossy 1982: 35). The cliché is the language act which reminds us that language is necessarily something re-used and imitative, not original, but communal. There is more of the Other in our mouths than we might otherwise be comfortable with, it seems.

In other words, clichés are the traces of previous conversations, reminding us, as Derrida does when discussing Austin's performative, that to be understood every language act is a citation, an iteration, haunted by former dialogues:

> For, finally, is not what Austin excludes as anomalous, exceptional, 'nonserious', that is citation (on the stage, in a poem, or in a soliloquy), the determined modification of a general citationality – or rather, a general iterability – without which there would not even be a 'successful performative.' In other words, all language utterances are quotation, some more clearly so, than others. (Derrida 1982: 35)

Dewdney and Nichol highlight this recycling of language, injecting the clichés with more meaning with every re-iteration; we think of how they have become throwaway remarks just at the point where the poet infuses them with value by juxtaposing them with other discard and making something of re-gard. As Hawkins says 'The value we perceive in things, is not a feature or quality of them, but a residue deposited in them by our act of valuing them' (Hawkins: 6). Designating certain items as rubbish is a performative act, we bring the idea of rubbish categories into being through the process of rejection; to highlight this process disrupts the system, demolishing even the category of 'rubbish' itself, and by extension, opens a space in which the material we once considered trash can be recycled into something with purpose.

Your mom is so phatic. Or: if you haven't got anything nice to say, write it down

Anecessity
There is no oral tradition.
There is amoral tradition
Instinct. A sense
of concentric liqueurs
mutually arriving at their
respective levels.
That's a moral. A thorn
breaking off just under the skin.
Barbs relying on
your movement
to work their way in.

— DEWDNEY 1980: 24

Dewdney proffers music and problems with *Anecessity*. If the presence of the poem itself beckons its performance (as bp might proclaim – 'it's all oral!'), implicating a reader/listener loop, then how are we meant to hear the difference between 'amoral' and a simply moral tradition? The poem seems to argue that morality (line 7, above) is a function of quiddity – of things behaving as they do. Or better, morality is a function of things behaving as they will (to power), 'work[ing] their way' in the world symbiotically with our bodies' motion. The equivalent of such inanimate 'will' in the conscious being is 'Instinct' (line 3). And it is instinct that will determine, say, in the moment of performance whether 'a' moral or 'amoral' is the appropriate context in which to hear/read/understand these lines. Amoral. Not as in 'bad', or irredeemable, but stripped of judgement. Stripped, or suspended – as liqueurs with differing specific gravities settle to their preferred levels in a heterogeneous solution.

A cliché is a labour-saving device. From the sound of a stereotype block of text shifted into place by a French typesetter in the 1860s: cliquer. The onomatopoeia of it all – the sound of the moveable typist who 'clicks' language into place before imprinting it on the page, armed with a library of commonplaces close to hand: phrases for all occasions. What clicks into place in a conversation when a cliché is uttered is an entire conceptual matrix, (re)enacted in order to assure one another that we understand just how bad the weather is today. Exchanges of clichés are not devoid of sense: rather, there is so much meaning, it starts raining cats and dogs.

This is the dialectic at play – the tension between and the resolution of the literal and the meaning-full. There aren't piles of pets on the streets, but somehow, I will 'know what you mean'. The cost of an oral tradition is to sacrifice quiddity, the present and the literal. In our communal effort to make ourselves understood as understanding beings, we lie a little. We cheat and cut corners, because the work of intersubjectivity is so great that we need to save some labour, somewhere. It is in this fashion that we can understand Dewdney and Nichol's approach to rubbish language. Clichés are not born out of an oral tradition: they are the product of a necessary amorality. They are baroquely embroidered grunts of assent, instinctual and instinctively known tokens of exchange in a discursive and cultural economy. And in this economy, we have a surplus of staggering proportions. Simply put, clichés do not just highlight the gap between the literal

and the figurative – they transcend it – they mean more than they say, never less.

Repurposing this surplus, 'upcycling' this agglomeration of meanings that float about in the realm of the possibilities suggested by the cliché, then, is a very moral position to take. The dialectic criminal is stealing his cake and eating it too. So, now, Dewdney can write his opening line to the poem: 'When it's raining cats and dogs you've got to cut corners because you could get your eyes peeled' (Dewdney 1980: 94). When the stuff of the world becomes overwhelming, you need to cheat a bit, because the result of trying to encompass it all means getting 'your eyes peeled'. When we keep our eyes peeled, we are looking for some lost thing. Having them peeled not only sounds ominous and painful (though we must be careful not to let the literal intrude), it implies that we might be forced to observe *everything* without letting the minutiae escape our attention: looking, with a fine-toothed comb.

But such a level of attention is inhuman – so we cut out corners when expediency requires it. We absolutely require our filters in order to manage the superfluities of the norm, the merely average amount of phenomeno-logical data that subtends 'everyday' life. Including the man in the corner of the room I am typing this part of this essay in, his hairline receding, cream shirt with mauve threads shot through it. Large, thick black-rimmed spectacles that wouldn't be out of place on a b-boy. He is fully dressed, there is dirt on the soles of his brown leather shoes from the street that carried him to work. And I haven't even gotten to the desk he sits at. Shall I describe, sheet by sheet, the piles of paper that partially obscure him from my view when he swivels around on his seat roughly 60 degrees of where I sit in Special Collections at the University Library because this is the only place I can guarantee myself a quiet and solitary place to write?[7] If this paragraph is leading you astray, then my point about getting one's

7 This is, admittedly, a feeble attempt to 'record' my entire surroundings in the moment of writing – but it is my hope that in spite of my lack of talent, and the pragmat-ics of publication in print, a charitable reader might imagine a much, much longer paragraph (and a much, much longer footnote, for that matter), and thus register my point about a totalising, exhaustive point-of-view.

'eyes peeled' (ironically) comes into sharp focus. The best way to find the baby in the bathwater is to put a hole in the bucket.

Talking Dirty

As important as it is for us to keep our eyes peeled, we still need to keep our blinders on. We have a responsibility to witness, but we can only do so with a buffer to protect us from a too-sharp encounter with bare reality. The body serves as just such a protective layer. Nichol's list of clichés asks us to consider language formulas which figure a potentially disruptive relationship between our bodies and the world. The body becomes dangerous if it intrudes on the other; it should remain clean and distinct, according to the commonplace regulations of the norm:

> You were never supposed to talk when it was full. It was better to keep it shut if you had nothing to say. You were never supposed to shoot it off. It was better to be seen than heard. It got washed out with soap if you talked dirty. You were never supposed to mouth-off, give them any of your lip, turn your nose up at them, give them a dirty look, and evil eye or a baleful stare. So your mouth just sat there, in the middle of your still face, one more set of muscles trying not to give too much away. 'HEY! Smile! What's the matter with you anyway?' (bpNichol 1988: 9)

Nichol re-hearses the known set of rules for the mouth, indicating a culture-wide awareness of the potential danger and dirtiness of orality (and aurality) in the eyes of our first regulators: parents. It speaks to a prevailing desire to systematise, create order and ultimately sanitise behaviour. This need to 'keep up appearances' involves developing a particular relationship with language, our bodies, and our living spaces. Dominique Laporte's *The History of Shit* is useful in the way it shows a connection between language and shit, and so language and the body. He notes the parallel cleansing of the French language and the French streets, and points out the moves to ultimately privatise excrement: '[T]he Edict of 1539 ordered private citizens to build latrines in their homes thereby establishing a rigorous equivalence between the terms "retreat" and "privy" to designate where, from then on

out, nature obeys its call' (Laporte 2000: 44). This regulation, driven by an ideology linking 'propriety to property', involved, Laporte tells us – infusing two more clichés with meaning – citizens 'minding their own business' and not airing 'their dirty laundry'. It is significant we now associate these clichés ostensibly about waste, with language.

Airing your dirty laundry is mouthing off – not 'pruning language and transmuting it [from] "a savage place to a domesticated one", ridding it of waste, saving it from rot, giving it its weight in gold', as we might think a poet should.[8] Nichol and Dewdney do not subscribe to this ruthless purification of language. One man's trash talk is a poet's pleasure; Nichol and Dewdney find gold in running off at the mouth, they delight in playing with the endlessly re-used cliché. Moreover, Nichol's ode to the mouth testifies further to his search for the personal and so the necessarily contingent beauty in the messy, the tactile, the bodily:

> It all begins with the mouth. I shouted waaa when I was born, maaa when I could name her, took her nipple in, the rubber nipple of the bottle later, the silver spoon, mashed peas, dirt, ants, anything with flavour I could shove there, took the tongue & flung it 'round the mouth making sounds, words, sentences, tried to say the things that made it possible to reach him, kiss her, get my tongue from my mouth into some other. [...] so many things began there – words did, meals, sex – & tho later you travelled down the body, below the belt, up there you could belt out a duet, share a belt of whiskey, undo your belts & put your mouths together. (bpNichol 1988: 10)

Clichés are already considered trashy language. Nichol breaks them apart, turns them into rubble, and with the remains makes something new to try and touch the Other. Rather than trying to remain in a capsule, spouting original language, he uses language to mingle with the Other, he gives them his lip, whilst wanting to take theirs. And he emphasises the everyday-ness of this instinct. Here, it is helpful to consider Ronald Carter's discussion of the use of formulaic phrases in his defence of 'common talk'. He argues that rather than dismiss the cliché as used up, worn, without meaning, we should acknowledge the poetry it brings to everyday speech. He argues that whilst fixed expressions, like cliché, 'are routinely used for conventional and

8 Laporte 2000: 9 citing Goethe.

formulaic speech function [...] some of them are also sufficiently flexible in form that they can be made open to freshly reconfigured and creative patternings' (Carter 2004: 129). He then cites McCarthy who comments on such idioms in a way particularly productive for our discussion:

> Another noteworthy feature of idioms in everyday talk is the way speakers use them creatively by a process of 'unpacking' them into their literal elements and exploiting these; even in opaque idioms, literal meanings of component words are in some sense activated, or are at least potentially available. (McCarthy 1998: 117)

Examples of these in the data Carter draws upon are abundant and interesting; to share an edible example might convince that the cliché brings the relationship between 'ordinary' and 'poetic' language closer, showing these definitions to be performative rather than reflective; the packaging, like Hawkins's subject can remain in a process of becoming if approached creatively, rather than with stultifying disdain. Carter makes the point that 'idioms are not simply comprehended without some kind of metalingual analysis of component parts by speakers and listeners' and gives as an example part of a conversation between two retired schoolteachers:

> The second year I had, I started off with 37 in the class I know that, of what you call dead wood the real dregs has been taken off the bottom and the cream the sour cream in our case up there had been creamed off the top and I just had this dead wood. I mean it really was and he was so impressed with the job that I did with them. (Carter 2004: 129)

The milk metaphor is played with creatively here to emphasise the 'woodiness' of the remaining pupils. We return to Dewdney's attention to fluid dynamics, but this time liquid is manipulated, transformed by skimming and turning to indicate a process of thought; language indicating the messiness of thought, the continual cycle of distillation, outpouring and imbibing (in this schoolteacher's case) all the sour milk we can squeeze from dead wood.

Lynette Hunter says of Nichol that he is:

> [...] someone who reaches into the body of language, its heart, mouth and musculature, in rather literal ways. He breaks apart words, letters, sounds and syntax, and restructures them so that they may release different feelings. [...] in *Selected Organs* he plays oral storytelling devices against the written to loosen the ties of grammar and narrative. (Hunter 2001: 145)

The cliché is at the nexus of the spoken and the written; indeed it shows the two to be inextricably intertwined, much as the body and language are. They are both mutually dependent relationships. Loosening the ties of grammar and narrative involves paying great attention to cliché. And it is this attention which helps us revalue – and re-story this often-rejected speech container to show it to be a meaning-full(y) embodied transformer. To conclude this article – this picking over of trash talk – we can productively return to Gay Hawkins and the potential ethical relationship we can all form with waste. Hawkins, like Dewdney and Nichol, wants to disrupt our habitual relationship with the formerly disposable, or undervalued, arguing that:

> To throw things away is to subordinate objects to human action, it is to construct a world in which we think we have dominion. This doesn't just deny the persistent force of objects as material presence, it also denies the ways in which we stay enmeshed with rubbishy things. So, for rubbish to be framed differently it needs first of all to be noticed, it has to become conspicuous. Before other possibilities and potential emerge [...] the phenomenological reality of rubbish has to be acknowledged. We have to recognize discarded objects not as the passive redundant context for our lives but as mobile, vital matter open to reconstitution. (Hawkins 2006: 80)

We stay enmeshed with rubbishy things, nothing is disposable, and we must re-fuse the refuse, by perceiving the packaging as valuable and malleable in itself. Clichés have this persistent force, too, which remind us how much our speech carries the trace of others, this recycling being necessary to the constitution of social relationships. But more, these relationships are continually in process, becoming more embodied, tangible and ethically vital once the phenomenological reality of the language within the cliché is experienced and heard, the Other being invited to the continual re-fusing of the self.

Works Cited

Amossy, R./Lyons, T. (1982), The Cliché in the Reading Process. *SubStance* 11/35: 34–45.

Austin, J.L. (1971), Performative Constative. In: Searle, J.R. (ed.), *The Philosophy of Language*. Oxford, Oxford University Press.

Bernstein, C. (1992), Professing Stein/Stein Professing. In: *A Poetics*. London, Harvard University Press: 142–149.

bpNichol (1988), *Selected Organs*. Windsor, Ont., Black Moss Press.

Breathed, B. (1988), *Billy and the Boingers Bootleg*. New York, Little, Brown and Co.

Carter, R. (2004), *Language and Creativity*. London/New York, Routledge.

Derrida, J. (1976), *Of Grammatology*. Spivak, G.C. (trans.). Baltimore, Johns Hopkins University Press.

——— (1982), Signature, Event, Context. In: *Margins of Philosophy*. Bass, A. (trans.). Sussex, Harvester Press: 307–330.

Dewdney, C. (1980), *Alter Sublime*. Toronto, Coach House Press.

Eagleton, T. (1998), Edible Ecriture. In: Griffiths, S./Wallace, J. (eds), *Consuming Passions: Food in the Age of Anxiety*. Manchester, Mandolin/Manchester University Press: 203–208.

Eliot, T.S. (1920), Hamlet and his Problems. In: *The Sacred Wood* (1960). London, Methuen and Co.

Hawkins, G. (2001), Plastic Bags: Living with Rubbish. *International Journal of Cultural Studies* 4/1: 5–23

——— (2006), *The Ethics of Waste*. Lanham, MD/Oxford, Rowman and Littlefield.

Hunter, L. (2001), *Literary Value/Cultural Power*. Manchester, Manchester University Press.

Laporte, D. (2000), *The History of Shit*. Cambridge, MA/London, MIT Press.

McCaffery, S./bpNichol (1992), *Rational Geomancy: The Kids of The Book Machine*. Vancouver, Talonbooks.

McCarthy, M. (1998), *Spoken Language and Applied Linguistics*. Cambridge, Cambridge University Press.

Montagne, P. (ed.) (1999), *The Concise Larousse Gastronomique*. London, Hamlyn Press.

Muecke, S. (2003), Devastation. In: Hawkins, G./Muecke, S. (2003), *Culture and Waste: The Creation and Destruction of Value*. Lanham, MD, Rowman and Littlefield, 117–128.

Rayner, J., *Deconstructed Delia, Word of Mouth Blog* http://www.guardian.co.uk/
 lifeandstyle/wordofmouth/2008/apr/01/deconstructeddelia (accessed on 16
 August 2008).
Sheridan, R.B., *The Rivals* (1775), Stern, T. (ed.) (2004). London, A. & C. Black.
Smith, A. (2005), *The Accidental*. London, Hamish Hamilton.
Starobinski, J. (1975), The Inside and the Outside. *The Hudson Review* 28: 333–351.
Thompson, M. (1979), *Rubbish Theory: The Creation and Destruction of Value*. Oxford,
 Oxford University Press.
Wordsworth, W. (1798), *Lyrical Ballads*, Mason, M. (ed.) (1992). London/New York,
 Longman.
Zijderveld, A.C. (1979), *On Clichés: The Supersedure of Meaning by Function in Moder-
 nity*. London/Boston, Routledge and Kegan Paul.

RANDALL K. VAN SCHEPEN

The Heroic 'Garbage Man': Trash in Ilya Kabakov's *The Man Who Never Threw Anything Away*

Introduction

The contemporary Russian artist Ilya Kabakov, known for his challenging installations that address social and political realities in Soviet and post-Soviet culture, once created a work created entirely out of the trash that he accumulated in his studio. Part of a series of works called *Ten Characters* (1972–1975), the piece was entitled *The Man Who Never Threw Anything Away*. Formed by simply letting the paper garbage that arrived at his studio amass into an overwhelming pile and then taking these objects and labelling and installing them, Kabakov's lack of choice and discrimination were the work's ironic modes of creation. Despite this seemingly cavalier creative process, *The Man Who Never Threw Anything Away* challenges much more than the traditional notions of conscious artistic programme and choice. In fact, in the light of the repressive atmosphere in which it was created, its humble materials and construction method disguise its larger purpose, which is to use its accumulated trash as a site of resistance to the Soviet state's desire to control memory and history.

The Man Who Never Threw Anything Away (see Figure 7) draws on a long tradition of using cast-off materials in modern art. In 1912, Georges Braque pasted pieces of what Clement Greenberg later called 'extraneous material' onto the surface of a canvas (Greenberg 1961: 70). First using oilcloth with illusionistically printed images, then incorporating sand into paint, Braque finally adhered pieces of newspapers and journals to their pictorial surfaces. Braque and Picasso were the first to incorporate such bits of 'reality' into works of modern art. Greenberg's 1959 description of

these elements as 'extraneous material' is telling because it inadvertently points to how the disjunctive nature of these bits of matter create a tension between depth and surface, illusion and material facticity, and tradition and the new in what was a formerly coherent painted surface. Equally jarring is the fact that collage introduces heterodox, 'junky', contemporary materials onto a painted surface that participates in a centuries-old form of cultural discourse.

Greenberg's justifiably famous 'The Pasted Paper Revolution' essay (also published with the title 'Collage'), suggests that the sole reason for the introduction of material flotsam onto the cubist surface was to articulate the distinction between literal and simulated flatness:

> The process of flattening seemed inexorable, and it became necessary to emphasize the surface still further in order to prevent it from fusing with the illusion. It was for this reason, and no other that I can see, that in September 1912, Braque took the radical and revolutionary step of pasting actual pieces of imitation-woodgrain wallpaper to a drawing on paper, instead of trying to simulate its texture in paint. (Greenberg 1961: 74)

Greenberg suggests that any shock effect found in cubist collage as a result of the strangeness of collage material is entirely 'accidental' (Greenberg 1961: 74). Of course, Greenberg's modernist argument about the pieces of 'reality' that Picasso and Braque employed is that they have nothing whatever to do with a shocking intrusion of material detritus onto the sacrosanct picture surface. Any such residual effects are described as 'accidental' and fugitive. Rather, Greenberg argues that Picasso and Braque triumph over the collage's raw materiality and pictorial illusion through modernist formalistic integration. Greenberg's explanation, pasting over collage's radical challenge as it does, is blind to its everydayness, especially of works that conspicuously court such 'low' associations.[1]

The use of trash to create modern and contemporary art thus has a history going back at least a century by now. Whether in a *papier collé* by Braque or in a *Merz* picture by Schwitters, the ephemeral detritus of

1 See the first version of Greenberg's essay in Greenberg/O'Brian (ed.) 1993: 61–66.

the tabletop and the gutter was woven by early modernist artists into the aesthetic fabric of an abstract compositional whole. If some resonances of the trash's former life as tossed-aside daily newspapers or ticket stubs were retained, it was the artist's transformative power to turn worthless daily dross into meaningful, timeless aesthetic gold, that most fascinated critics and viewers. Perhaps the thing that most strikes twenty-first-century eyes about early collage is its sheer aesthetic beauty. Formerly pedestrian associations have been transformed, by time and nostalgia, into a picturesque vision of the studio and street life of early twentieth-century Paris and Berlin. But, whether through Greenberg's formalistic desire to ignore trash's more visceral characteristics in favour of its aestheticisation, or by its temporal conversion into poignant signs of early modern avant-garde life, trash is consistently subject to conflicting interpretations.

A history of the use of trash in modern art might move from collage to Dada, to Johns/Rauschenberg, to Pop to assemblage to its seeming apotheosis in contemporary installation. A variety of possible motivations for employing trash present themselves in the twentieth century along this trajectory. Does an artist's use of throwaway materials destined for the trash bin valorise them, as in Richard Hamilton's Pop Art photo-collages? Does it revel in them as a forbidden and guilty pleasure, as in Bruce Conner's seedy assemblages? Does it use them to reveal the structure of municipal authority, as in Mierle Laderman Ukeles's performances with the New York City Sanitation Department? Does it aestheticise them for their hidden beauty like in the accumulation of cast-off objects by Arman, or present them, like Daniel Spoerri's preserved meal leftovers, as a diary of experience? Do these scraps function, as did Walter Benjamin's literary fragments, as eruptions of the redemptive and utopian potential hidden behind the machinations of capital? Or does trash merely become a linguistic signifier of the semiotic role of the artist as the provider of the definition of art, as is the case in Marcel Duchamp's readymades?

More fundamental than the problem of determining the purpose to which artistic trash is put, is the issue of determining what is trash, dirt or vile in relation to art. Or, as Mary Douglas asks in her classic study, *Purity and Danger*, 'what counts as dirt?' Interestingly, Douglas problematises an objective definition of the impure by describing an artist's studio whose

characteristics seem to bear a striking resemblance to Ilya Kabakov's work, with one crucial difference: Douglas juxtaposes the disorder of a studio filled with 'dirt' with the clarity of art:

> Should I not allow for the obsessional artist whose tolerance of disorder is practically complete? His studio is chaotic, he sleeps there, eats there, urinates in the hand basin or out of the window when his passion for his work gives him no time to go to the W.C. Everything looks wildly disordered, except on his canvas: there alone do calm and order reign. For him the canvas is the only sacred space, where repleteness is compulsory and where the least sign of disorder would send him into fits of anxiety. (Douglas 2002: xviii)

Douglas employs this test case to suggest that objective and dogmatic definitions of cleanliness and dirtiness should be tempered by an awareness of the relationship of the artist's disordered and profusely sensual studio environment and the relative ascetic and controlled surface of his finished canvas. Here, dirt is redeemed through art.

Both Douglas and Greenberg tend to read art as an oasis of coherence and aesthetic triumph in a world filled mostly with trash. In Greenberg's case, the avant-garde becomes the positive term in binary relationship with the negative 'kitsch', which is cultural trash (Greenberg, 1939). But, beginning in the second half of the twentieth century, a wide range of artists began to question whether such a dichotomous relationship between the rich and abundant disorder of their lives and purified aesthetic expression was productive or desirable. Ilya Kabakov's *The Man Who Never Threw Anything Away* seems to directly confront Douglas's binary characterisation of the impure, 'dirty' studio leading to an Apollonian and pure art. Kabakov even develops a character/alter ego to assist him with these installations, called *The Garbage Man* – someone who magically transforms pieces of daily, accumulated trash 'into artistic objects that form strange sets of things and installations' (Wallach 1996: 171). Kabakov's *The Man Who Never Threw Anything Away* addresses the failure of systems of value in the then-Soviet Union by aesthetically redeeming trash. Kabakov's redemption of the quotidian trash of Soviet life is a symbol of resistance to the Soviet politicisation of personal and collective memory.

Here I will explicate two, binary, stages of Kabakov's early artistic production, one characterised by emptiness and abstraction and the other, the main focus here, by fullness and filth. Kabakov's use of trash came after a period of producing works of great ascetic reduction and purification. Kabakov admits that his turn to trash as a source for his art is riddled with conflicting feelings of attraction and repulsion. Even as he comes to see the validity and even honesty of working with trash, he nevertheless finds it disturbing to do so. Ultimately, in the fictional character of *The Garbage Man*, and in *The Man Who Never Threw Anything Away*, Kabakov's redemption of trash is a poignant demonstration of how the simplest of materials and means take on heroic character in totalitarian circumstances.

Emptiness/Cleanness

Hygiene, efficiency, reduction, abstraction, form, clarity, composition, and purity are all modernist values that champion conscious aesthetic decision-making and sweeping clean the past to stage the potential future. The history of the modernist clean, 'well-lit space' has been carefully surveyed, but perhaps nowhere more effectively than in Brian O'Doherty's classic 1976 text, *Inside the White Cube: The Ideology of the Gallery Space*. O'Doherty notes how the art situation had reached a point in the late 1970s, just before Kabakov begins his garbage works, where 'we see not the art but the space first' (1986: 14). This space took the form of a 'white, ideal space that, more than any single picture, may be the archetypal image of 20th century art'. When the strength of the modernist white cube's 'perceptual fields of force' is missing, it allows art to slip into a 'secular' status (1986: 14); conversely, when this white cube is present, it has the ability to transform the commonplace into art.

> Some of the sanctity of the church, the formality of the courtroom, the mystique of the experimental laboratory joins with chic design to produce a unique chamber of esthetics. So powerful are the perceptual fields of force within this chamber that

once outside it, art can lapse into secular status – and conversely, things become art in a space where powerful ideas about art focus on them. (O'Doherty 1986: 14)

Almost entirely bereft of images, Kabakov painted a series of white, abstract paintings that align him with the trajectory of modernism O'Doherty articulates – along an axis of 'emptiness' and iconoclastic impulses (see Figure 8). Modernism, as Soviet art critic and historian Boris Groys writes, is a more thoroughly iconoclastic approach than that of religious zealots – who still wish to manipulate the image's power even if they fear its contagion in relation to a deity.[2] Modernists, on the other hand, take the iconoclastic suspicion of imagery further by troubling the very process of making images, putting their existence and efficacy into question through internal and deconstructive critique.

In 1983, Kabakov wrote the text 'On Emptiness' in which he articulated the state of profound blankness that he felt had become his field of creative endeavour. Well aware of the early modern expressions of emptiness in the Russian avant-garde, Kabakov made specific reference in 'On Emptiness' to 'Malevich white' as a purely 'radiant light' that does 'not tolerate nature.' 'Malevich white', so ethereal and idealistic, expressed the 'absolute antipode of any living existence.' But Kabakov's emptiness also relates to his experience of late Soviet life – a messy, dysfunctional existence that could not handle its own waste. Ironically, the detritus piling up in empty city lots was a sign to Kabakov of a 'staggeringly active' emptiness. Kabakov's emptiness was thereby in utter opposition to Malevich's clean slate. Instead, it was something that transformed 'being into its antithesis, destroying construction, mystifying reality, turning all to dust and emptiness [...]. It is a special ... hole ... in the fabric of being' (Ross 1989: 103).[3] The flipside of 'Malevich white', a visually empty white that was ironically

2 Speaking especially with regard to Islamic fundamentalist terrorists, Groys notes that they, unlike modernists, actually still give the image an incredible surplus of power. They are as much technologically sophisticated image-makers as they are primitive iconoclasts (Groys 2008).

3 The kind of amnesia active in modernism is different than that actively fostered by totalitarian states, although Boris Groys would argue otherwise. Groy's breakthrough 1988 study, *Gesamtkunstwerk Stalin* (published in translation in 1992 as *The Total*

full of potential meaning, Kabakov's emptiness was born of the stultifying and overwhelming visual homogeneity of scattered trash, embodying 'ephemerality, absurdity, and fragility' (Ross 1989: 103) (see Figure 9).

Made in the mid- to late 1970s, Kabakov's series of mostly white paintings were large blank expanses with small anecdotal details around their perimeters and across their surfaces, seemingly designed to evoke the state articulated in his later 'On Emptiness'. Kabakov's painted forms were an early attempt to express how emptiness contained 'no history, no sedimented deposits, no continuity'. In order to demonstrate how, 'nothing results from anything, nothing is connected to anything, nothing means anything', Kabakov painted virtually nothing (Kabakov 1996: 68).

Fullness/Filth

But when Kabakov extended the idea behind this catatonic series of paintings of nothing even further, he discovered a wellspring of creative possibilities by 'doing' almost nothing. 'Doing nothing' became a more powerful artistic force than 'painting nothing' because through it Kabakov could more effectively express the manner in which all of Soviet life was emptiness, how 'everything incarnates emptiness' (Ross 1989: 103). Kabakov expressed this in two ways: firstly, he moved away from the limitations of the modernist vocabulary of paint; and, secondly, he established a new relationship to the contemporary material reality surrounding him (see Figure 10). Kabakov's role became diagnostic and descriptive rather than idealistic and prophetic. He explained this new approach as that of a doctor describing 'the history of an illness with which he is terminally afflicted' (Ross 1989: 103). Trash was no longer dialectically at odds with the clean, well-lit canvas, but instead became the unique 'genius' of his existence.

Art of Stalinism: Avant-Garde, Aesthetic Dictatorship, and Beyond) expounds his unorthodox point of view that Stalin was the ultimate modernist.

Only when Kabakov was able to recognise the expressive potential of his 'cluttered, dusty, half-abandoned, ownerless existence', was he able to see nothingness instead as fullness. Only then was Kabakov able to find his own particular artistic language to express it (Kabakov 1996: 171):

> The image of a cluttered, dusty, half-abandoned, ownerless existence is firmly connected for me with the feeling of my Homeland and with the hopeless feeling that it is impossible to get rid of the situation, that it is here forever, and that garbage and dirt are the very unique 'genius' of our place. (Ross 1989: 103)

Kabakov's choice to artistically express himself using the fullness/filth of his studio was thus not primarily an aesthetic decision to find poetic resonance in the gutters, nor was it to confront high culture taste. Rather, Kabakov's choice to consciously turn toward life, toward the disturbing aspects of a deadening existence that had become second nature to Soviet citizens, held potential moral importance. The printed tickets, papers, cast-off building materials, and broken-down appliances that littered the Soviet urban landscape were a tragic expression of a Soviet spiritual and economic vacuum. Kabakov began to revel in trash's arbitrariness, to expose it for its numbingly ugly reality, and to use it as a diagnostic tool (see Figure 11).

In conjunction with his use of trash in the 1980s, a period when he recalled never 'regularly taking out paper garbage', Kabakov develops a comprehensive enveloping aesthetic he calls the 'Total Installation' (Kabakov 1996: 171). Kabakov discovered/created meaning out of these disparate paper scraps by sewing them together into booklets, weaving elements together, tying them to ropes, installing them in vitrines and boxes, and providing narrative fragments. In the process he produced an image of an individual who might have collected such an accumulation of detritus. Kabakov says, I 'gradually began to see in this an image of a unique psychological personage who cherishes each paper, not discarding any paper trash from the past; that's how the hero *The Garbage Man* came to be' (Kabakov 1996: 173).

Kabakov recognises himself in these scraps (he talks fondly of picking them up in his studio when creating the installations and rediscovering his past), deploys them as a diagnosis of Soviet life, and creates a portrait of

the almost mythically redemptive figure of *The Garbage Man*. The *Garbage Man* heroically protects trash from the ravages of time and rescues it from entombment in the dump, bringing to consciousness the hidden, forgotten, yet meaningful details of the past. In Kabakov's admixture of the personal and the fictive, of the psychological and the sociological we recognise a technique frequently employed by contemporary Communist-Bloc novelists of the 1970s. Czeslaw Milosz, for example, notes that the preservation of personal memory focuses 'attention on the background, looking upon oneself as a sociological phenomenon' – and it is through the employment of the 'self-as-sociological-specimen' that a diagnosis of painful social realities can take place (Milosz 1981: 5–6). Kabakov's theory of the 'Total Installation', a group of objects and forms that so overwhelms the space and viewer as to be comprehensive, similarly engulfs any potential distinctions between personal, aesthetic and political space.

Political Redemption

Turning his back on an idealistic desire for clean modern emptiness and instead turning toward a personal and sociological identification with trash, Kabakov began to recognise that 'precisely this garbage – this trash, in which everything is all mixed up and the important papers are not separated from the scraps – represents the truly genuine and only real material of my life, even if from the outside it may appear as some sort of nonsense and stupid stuff' (Kabakov 1996: 68). One hears in Kabakov's statement his inner conflict about garbage. It is truth and it is stupid. It is creative and it is stultifying. Kabakov's struggle with the damned/redeemed character of trash, of the ultimate 'dirt' or 'garbage', human waste, might be understood against Milan Kundera's juxtaposition of shit with kitsch. Where Greenberg defends the avant-garde as the last bastion of high culture left in modern life, the only cultural expression capable of opposing the debasement of middlebrow kitsch, Kundera instead suggests that kitsch's binary opposite

is that which threatens its seamless sameness and denial of contingency: '[K]itsch is the absolute denial of shit, in both the literal and figurative senses of the word; kitsch excludes everything from its purview which is essentially unacceptable in human existence' (Kundera 1999: 248). If shit is the ultimate symbol and manifestation of basic human existence, of bodily frailty and mortality, kitsch is a denial of embodiedness and of disgust and death. Kabakov signals disgust as a feature of his trash works when he asks, for example, 'But if you don't do these sortings, these purges [of the mail], and you allow the flow of paper to engulf you, considering it impossible to separate the important from the unimportant – wouldn't that be insanity?' (Kabakov 1977: 33).

It was necessary for Kabakov to admit to the disgusting character of his artistic expression, to dwell in its insanity, in order to represent the madness of Soviet life, a life that was 'suffocating amidst' a 'dump with no ends or borders, an inexhaustible, diverse sea of garbage' (Kabakov 1977: 35), and in which people were so disillusioned as to not care that trash piled up around them. Kabakov begins to be strangely compelled by garbage even as he is disturbed by its soul-deadening ugliness. Just as Duchamp's hygienic and controlled dust accumulation seems to but can never really avoid association with dirt and with death, Kabakov's 'dry' trash works can be said to employ what Auriel Kolnai calls a disgustingly 'indecent surplus of life' (Kolnai 2004: 54–55). Mario Perniola, in a phrase from *Art and Its Shadow* that sounds like a description of Kabakov, says, 'disgust consists in a life surplus, in an exaggerated and abnormal organic vitality that swells and spreads beyond any boundary and any form' (Perniola 2004: 7). He goes on to suggest, following Kolnai, that the disgusting is the vital 'swelling' and 'polluting', 'immoderate' and 'rebellious' – 'a life impregnated with death'.[4]

How is it that trash became a symbol of the authentic for Kabakov and what is the efficacy of this authenticity? Kabakov's trash is a sociological

4 For Perniola, 'decomposition mingles everything with everything else and, in making everything indistinct and indifferent, homogenises all that it contaminates'. And this is why he believes that contemporary art 'cannot be characterized by disgust and abjection alone' (2004: 7–8).

metaphor for how to survive Soviet life. This is his description: 'every-
one who was in the "middle", in the "light" or near it ... was swept away
by a terrible broom ... whereas those who sat it out in a corner remained
unswept [...].' (Kabakov 1996: 68). People survived ruthless Soviet ideologi-
cal cleansing by becoming marginalised trash themselves, as if they were
dust accumulating in a corner. Many were not so lucky and were subject to
being swept away by the Soviet obsession with intellectual and ideological
purity. The 'enormous littered space' (Kabakov 1996: 171) of Soviet life is
made particular in Kabakov's studio. Kabakov's metaphysical moves were
simultaneously inward, toward the particular psychology of the *Garbage
Man*, and outward, toward a general sociology (see Figure 12).

Trash was the material evidence of the life Kabakov lived, the residue
left behind from connections to people, events and institutions: 'What
ties you to the world is rubbish/A midnight key to someone's flat/A silver
coin in your pocket/And the celluloid of a detective film' (Kabakov 1996:
68). But the list of these clearly personal objects in this quote differs from
the more arbitrary materials of the trash installations. Kabakov notes how
Westerners imbue their well- and purposefully-made individual objects
with inherent/designed meanings. Western objects are thereby more easily
internalised as ideal self-images – reflections of a perfectible, discrete,
hypostatised individual. In contrast, Kabakov says that in Soviet society
objects have arbitrary meanings that easily push them into the category
of meaningless garbage. Soviet objects lack a purposiveness even before
they are used. Soviet objects are so poorly made that they are immediately
useless – they are garbage from the beginning. In an inversion of Western
tendencies, in Soviet culture context and space were highly particularised
and individual, whereas objects were arbitrary and purposeless. Because of
this, Amei Wallach argues that Kabakov's objects cannot be assigned the
kinds of metaphorical meanings found in the objects of Joseph Beuys and
Mario Merz. Kabakov's objects are therefore only meaningful in a system or
a space that defines them as semes in a syntactical environment, part of what
Kabakov calls 'a mysterious, but powerful and pervasive whole' (Wallach
1996: 85). Kabakov tempers the arbitrariness of his installation objects by
the use of labels and booklets as supplements to them – this happens in *The
Garbage Man*, for example, where he strings up items gathered from his

studio on sixteen ropes and affixes paper labels to them with string ('each item had a five- or six-digit number glued on it and a label attached to it from below' (Kabakov 1977: 32)).

For Duchamp and Kabakov, the arbitrary visual expression resulting from their inactive artistic creative process compelled them to provide a set of verbal cues for the viewer. In Duchamp's case, this took the unrealised form of a bound booklet that was to be attached to *The Large Glass* as a diagrammatic key to its cryptic story of the bride and bachelor; for Kabakov, verbal cues come in the form of the linguistic labels he attaches to the trash objects. It is as if Kabakov, realising how long it took him to recognise the artistic potential of his studio contents, provides a narrative prompt to the viewer through these linguistic appurtenances. Kabakov redeems trash, finds in it the identity that was lacking when it was part of the field of sameness and monotony that characterised Soviet life. In this, he is quite distinct from his American contemporary Robert Morris, who never brings the history of thread waste as a material, for example, into the gallery for his scatter pieces. Morris treats thread waste as raw, undifferentiated matter. Morris's redemption of such materials comes when, as he says, 'ends and means are brought together [in some recent work] in a way that never existed before in art' (Morris in Taylor 2006: 222). Material is not transformed according to a predetermined artistic purpose, transmuting it into something else, leaving behind its material nature, but remains raw, unrefined, untransmuted, thereby embodying a unity of material means, expression and artistic ends. For Kabakov, the offense of his objects comes not from everydayness, lack of material value, or raw materiality; rather, they trouble the viewer by 'waiting' to be reactivated into new, potentially meaningful relations. Their cast-off status points to their former usefulness and their present degradation.

As Mary Douglas explains, the attitude toward trash, toward the tossed-aside object, undergoes two stages. Upon their initial designation as trash, trash objects maintain something of their previous functional identity. Objects are still recognisably what they were designed to be but have been placed in an evironment that indicates that this identity and function are increasingly threatened and waning. Identity stubbornly clings to them and they are clearly 'out of place, a threat to good order, and so are

regarded as objectionable and vigorously brushed away' (Douglas 2002: 197). In this stage, trash still dangerously threatens our desire for control and must be cast out of sight in order to maintain the appearance of good order. The white paintings in Kabakov's 'emptiness' phase, his aesthetic clean sweep, indicate that he operated under this fear.

As the identities of things pile up on top of one another, as time creates distance from the object's original purpose, bits and pieces lose their individual identity to become 'the mass of common rubbish' (Douglas 2002: 197). Kabakov's redemptive project becomes, to use Douglas's words, a 'reviv[al of] identity' (Douglas 2002: 197). The content of Kabakov's object labels also indicates the level of conflict that such a redemption of identity provokes. Labels include vulgar expressions about sex and violent insults; the painful and sometimes hostile responses result from the wresting of cultural meaning from trash. Remembrances of forgotten dreams, embarrassing impulses, delayed gratifications, and the broken utopian promises of fulfilment through material means have the potential to be more bitter than sweet. Brandon Taylor quotes the vulgarities on Kabakov's verbal tags, which are attached to the trash bits:

> Not only do the fragments of the new installations have verbal tags, but these tags now answer back abusively – 'Take a hike, go fuck yourself!', or 'You cunt, put it down or I'll kill you' – as if their power to contaminate had turned personal with a vengeance: not only bad objects from a bad culture, but also bad objects projected from the personal to the outer world. 'Anything that I touch suddenly belches out a stream of abuse, insults, curses [...] that's how I experience inside me the world that surrounds me'. (Taylor 2006: 228)

But the deepest political sense in which Kabakov redeems trash in his installations is in their evocation of memory and history. In the face of the Soviet system, whose linguistic and imagistic utterances could never be trusted to convey historical realities, memory itself has political implications. Duchamp's dust harvesting on the surface of his *Large Glass* captured the passing of time, but not of experience. Kabakov's trash, on the other hand, is his trash, like and unlike any other – filled with things that many others might possess but with a combination of objects unique to himself. It is the systemic arrangement or un-arrangement of these fragments of life

that constitutes an archive of sorts. Memory, whether personal and fugitive or public and encoded, had a loaded political status in the Soviet Union, as it always will for any totalitarian state. George Orwell understood well the desire of twentieth-century totalitarian systems to control memory for expedient ideological use, when he wrote in *1984*: 'Day by day and almost minute by minute, the past was brought up to date' (Orwell in Marcus 2008: n.p.).[5] The attempt to retain memory, even of seemingly meaningless details, thereby becomes an act of resistance.

Novelists working under Soviet rule richly mined the subject of the politicisation of memory. Creating a personal fiction out of semi-autobiographical details arranged in a non-linear fashion, such as *The Book of Laughter and Forgetting* or *A Guest in My Own Country*, these novelists employed a technique that could have provided a model for Kabakov's free-form installations. The use of memory and daily mundane experience for what appears to be non-political purposes became known as 'anti-politics' (Marcus 2008: n.p.), in the words of George Konrad. Konrad's seemingly arbitrary non-linear novelistic approach and embrace of a vast variety of literary forms, for example, mirrors Kabakov's dystopically profuse piles of trash. The impulses of self, the arbitrariness of content, and the un-hierarchical arrangement of forms were all attempts to wrest memory from the pit of organised forgetfulness that supported the totalitarian machine. By turning away from explicit political engagement, Kabakov and the anti-politics writers carved out an arena in which their personal freedom, even if expressed in debased terms, was affirmed.

Konrad's *A Feast in the Garden* contains the following moving meditation on the hidden political power of memory:

> Reliving the past, that is the most fantastic adventure of all. The event, relived, grows more and more enigmatic, and richer and richer in meaning. Turning to the past, I

5 David Marcus, from whom I have borrowed in the following section, quotes Orwell in his excellent review of two of George Konrad's novels, 'Memory as Homeland'. The review was prompted by the 2007 publication/translation of Konrad's *A Guest in My Own Country and The City Builder*, both of which are literary explorations of the connection of personal memory to politics (Marcus 2008).

reach the future, I recall people I never knew. In the time/space continuum of consciousness, *Was* and *Will Be* occupy the same point. The mind, too, is fortified because we have dared the watchtowers and watchdogs. Coming back from that journey we find the police less terrifying. (Konrad in Marcus 2008: n.p.)

Kabakov's diary-in-trash, *The Man Who Never Threw Anything Away*, is such a creative reconstruction of the past – the past experienced and the past that might have been. In the process, it fortifies Kabakov to create a future.

For the rootless West and the memory-less Soviet Union, Kabakov's 'Total Installations' provide a sense of continuity, one filled with potential meanings, with latent connections, with the promise of the redemption of the ordinariness of mundane existence, filled with trash. It is here, in the dustbin of history, where chance encounters between disparate fragments meet to be formed into meaningful syntactical units. For Foucault, what was remarkable about the modern archive was not the impossibility of the 'propinquity of the things [...] but the very site on which their propinquity would be possible' (Foucault 1994: xvi). *The Man Who Never Threw Anything Away* becomes a site on which such propinquity is possible. Boris Groys provocatively suggests that perhaps garbage is the only truly sacred thing left in the West because it is the only thing that is thrown away without expecting anything back. As a Soviet museum director, responding to Kabakov's *The Red Wagon,* observed, garbage's complete lack of 'return' becomes an 'eternal return' as its nothingness is an ultimate and not relative value (cit. in Wallach 1996: 68).

But Kabakov's redemption of trash also came with a social cost, as Soviets often had little understanding of, or appreciation for, being represented by garbage or a toilet. Some invoked the Russian proverbial phrase, 'Do not take your trash out of your hut' ['ne vynosi sor iz izby'], meaning do not criticise your own people in front of strangers and foreigners (Wallach 1996: 11–12). It is because of this kind of cultural prohibition against handling or displaying trash that archaeology, in its desire to become a respected intellectual discipline, has traditionally denied that it creates a concept of culture out of the trash people leave behind. The archaeologists Michael Shanks, David Platt and William Rathje recently suggested as much by

saying that the 'real stuff of archaeology and history' is 'what gets thrown away – garbage'. Further, they note that though garbage levels in modern cultures have increased exponentially, it is 'hugely misunderstood and popularly ignored (other than as an environmental issue)' (Shanks/Platt/ Rathje 2008: 64).

Kabakov's recognition of the value of trash is just such an archaeological exercise. As Carol Steedman writes in *Dust: The Archive and Cultural History*, the modern archive, on which so much of history depends, is only a slightly more organised reservoir of cultural remains than the dust and detritus of our lives (Steedman 2002). In *The Man Who Never Threw Anything Away* Kabakov recognised how a symbol of degradation can be transformed into a symbol of desperate human achievement.

Works Cited

Douglas, M. (2002), *Purity and Danger: An Analysis of Concepts of Pollution and Taboo*. London/New York, Routledge Classics.

Foucault, M. (1994), *The Order of Things*. New York, Vintage.

Greenberg, C. (1988), Avant-Garde and Kitsch. In: *Clement Greenberg: The Collected Essays and Criticism* 1 (1939–1944). Chicago, University of Chicago Press: 5–22.

—— (1961), Collage. In: *Art and Culture: Critical Essays*. New York, Beacon Press: 70–83.

——/O'Brian, J. (1993), The Pasted Paper Revolution. In: *Clement Greenberg: The Collected Essays and Criticism* 4 (1957–1969). Chicago, University of Chicago Press: 61–6.

Groys, B., (n.d.), The Fate of Art in the Age of Terror, http://www.unitednationsplaza. org/readingroom/ (accessed on 20 July 2008).

—— (2008), Boris Groys questions how art is presented to its audience: A review of *Art Power* by Matthew Jesse Jackson. See http://www.bookforum.com/ inprint/015_02/2496 (accessed on 8 July 2008).

—— (1992), *The Total Art of Stalinism: Avant-Garde, Aesthetic Dictatorship, and Beyond*. Princeton, NJ, Princeton University Press.

Kabakov, I. (1983), On Emptiness. In: Ross, D. (ed.) (1990), *Between Spring and Summer: Soviet Conceptualism*. Boston, MIT Press: 53–59.

—— (1977), The Man Who Never Threw Anything Away. In: Merewether, C. (ed.) (2006), *The Archive*. Boston, MIT Press: 32–37.

Kolnai, A. (2004), *On Disgust*. Smith, B./Korsemeyer C. (eds). Chicago/La Salle, IL, Open Court.

Konrad, G. (1992), *A Feast in the Garden*. New York, Harcourt.

Kundera, M. (1999), *The Unbearable Lightness of Being*. New York, Harper Perennial Modern Classics.

Marcus, D. (2008), Memory as Homeland, *Dissent*, Winter 2008. See http://www.dissentmagazine.org/article/?article=1000 (accessed on 8 July 2008).

Milosz, C. (1981), *A Native Realm*. Berkeley, CA, University of California Press.

O'Doherty, B. (1986), *Inside the White Cube: The Ideology of the Gallery Space*. Santa Monica/San Francisco, Lapis Press.

Perniola, M. (2004), *Art and Its Shadow*. London, Continuum.

Shanks, M. et al. (2004), The Perfume of Garbage: Modernity and the Archeological. *Modernism/Modernity* 11/1: 61–83.

Steedman, C. (2002), *Dust: The Archive and Cultural History*. New Brunswick, NJ, Rutgers University Press.

Taylor, B. (2006), Revulsion/Matter's Limits. *Sculpture and Psychoanalysis*: 213–231.

Wallach, A. (1996), *Ilya Kabakov: The Man Who Never Threw Anything Away*. New York, Harry N. Abrams.

JOEL BURGES

The Television and the Teapot: Obsolescence, *All that Heaven Allows*, and a Sense of Historical Time in Contemporary Life

Progress has a dark twin. Commonly understood as an unstoppable force of historical change that forever launches us into the modern, progress is shadowed by obsolescence. Every time we advance historically, things, structures, and people are rendered obsolete, as are the cultural values, social relations, political hopes, and personal desires they embody. This does not mean that any of these vanishes. Whatever is rendered obsolete does not disappear. It accumulates, piling up both in public sites such as landfills, flea markets, secondhand stores, and collectors' markets, and in private locations such as trashcans, attics, basements, and closets. It endures as the rubble of a bygone modernity in the form of abandoned industrial infrastructure and as the ruins of an ancient culture now transformed into a venerable tourist destination. The obsolete persists as a reminder that life was once different, even that life might have turned out differently.

On the most massive scale, obsolescence produces reminders of entirely foreign orders of things, traces of bygone modes of production that long ago organised economics, politics, and aesthetics. Such traces – prehistoric ruins, structures of antiquity – can be signals from the past that communicate little more than that the past was other than the present, unless those signals have been decoded across time by archaeologists unearthing their lost meanings. On a much more modest scale, obsolescence is the source of the now clunky technologies of yesteryear and unfashionable clothes from a decade (or five decades) ago. These evoke tastes that feel either embarrassingly outdated or comfortably cool, while the return of those tastes as 'retro' preferences or historically derivative styles suggests that yesterday may not actually be so different than today. But whatever its

scale, obsolescence reveals that historical change is never simply a matter of progress; transformations in and over time have a mnemonic night-side that darkens the prism of enlightenment through which we tend to see history progressing teleologically forward.

But just how mnemonic that night-side is has been subject to debate, especially as discussions of contemporary life as shaped by capitalist modernity have unfolded over the last century. In 2002, for example, Hal Foster evoked Walter Benjamin's 1929 argument that the Surrealists mobilised obsolete machinery, outmoded structures, and passé fashions symbolically in their art and writings as 'mnemonic signals [...] that might not otherwise have reached the present. This deployment of the outmoded can remind [capitalist modernity] of its own wish symbols, and its own forfeited dreams of liberty, equality, and fraternity' (Foster 2002: 196). For Benjamin, the Surrealists accomplished this end by prompting us, in a gesture of 'profane illumination' (Benjamin 1999: 216), to remember how the innovations and inventions we once celebrated as embodying the democratic promises of capitalist modernity – 'the first iron constructions, the first factory buildings, the earliest photos, objects that have begun to be extinct' (Benjamin 1999: 210) – have been demolished and abandoned under the pressures of obsolescence. Those pressures supplant old things with new things, their promises overcome in the name of profit. But those new things also repeat the very promises of easier lives for everyone that the old ones once said they would keep. As a result, the obsolete and the outmoded possess a critical, even 'revolutionary' (Benjamin 1999: 210), potential for Benjamin. Together they expose a cycle of endlessly repeated and forever broken promises from the past in capitalist modernity, the recollection of which makes us politically unhappy, or so Benjamin hopes, with how things have turned out (Buck-Morss 1989: 285–286).

In recalling this 1929 argument in 2002, however, Foster was tacitly reminding us that Benjamin wrote in the modernist moment of the European avant-garde, not in our own later and 'postmodern' moment of capitalist modernity. This later moment is a time, for instance, in which especially since World War II the business philosophy and practice of planned obsolescence has made the outmoded a fact of life, one we simply accept in the heady rush to buy the next generation of a good, technology,

or medium designed to revolutionise life much as the previous generation claimed it would. And for many critics, this rush to buy is part and parcel of 'an ever-increasing time-space compression' in our era, in which 'the relationship among past, present, and future is being transformed beyond recognition' (Huyssen 2003: 28). Here 'commodification equals forgetting' (Huyssen 2003: 21), meaning that our mnemonic ability to perceive 'the constitutive tension between past and present' (Huyssen 2003: 10), our sense of historical time, looks more and more vestigial today; as a result, 'the imagined past is sucked into the timeless present of the all-pervasive virtual space of consumer culture' (Huyssen 2003: 10). In that space, critics have suggested, obsolescence is a force of atrophy that works against our sense of historical time, one of the central 'detemporalizing processes' that fuels 'late capitalist amnesia' (Huyssen 2003: 10, 21).

Given this critique of obsolescence, can the outmoded mean much at all anymore, even when it is symbolically deployed as Benjamin understood the Surrealists to be doing in an earlier phase of capitalist modernity? As Foster puts it, '[C]an [the] mnemonic dimension of the outmoded still be mined today, or is the outmoded now outmoded too – another device of fashion?' (Foster 2002: 196). Although it sounds as if we cannot answer yes to both parts of this question, this chapter does just that. It argues that, despite our distance from Benjamin, the outmoded still engenders a critical relation to capitalist modernity. However much it has been bent to the demands of the market in the last half-century or so, obsolescence remains a powerful process of historical change that works on a number of intercalated scales both massive and modest. Such a process inevitably generates a set of relations between past and present even when it is tangled up in, indeed, arguably even when it is an engine of, the late capitalist transformation of our sense of historical time within the culture of consumption that has spread far and wide in the period extending from World War II to the present (what I have been referring to as contemporary life).

I make my case for this claim through a reading of Douglas Sirk's 1955 film *All that Heaven Allows*. Scholars traditionally argue that this film ironically and reflexively subverts the melodramatic genre to which it belongs. But a story of obsolescence also structures *All that Heaven Allows*, and this story repeatedly circles back to what I call 'figurations of

the outmoded'. In Sirk's film, figurations of the outmoded project histori-
cal change on screen, so to speak, by concretely figuring obsolescence as a
relation between past and present marked paradoxically by both repetitions
and breaks. These add up to so many unpaid debts and so much unfinished
business, becoming the very stuff of a sense of historical time in the film.
Although finally nostalgic more than revolutionary, this sense is arguably
critical in something like a Benjaminian fashion, providing a mnemonic
medium for imagining historical alternatives to contemporary life under
late capitalism.

Critics often turn to the obsolete and the outmoded when they are
discussing what has variously been called the 'time-space compression' and
the 'end of temporality' in contemporary life, especially as that period is
shaped by the pressures of capitalist modernity (Harvey 1990; Jameson
2003). In *The Seeds of Time*, for instance, Fredric Jameson speaks of 'the
[dawning] realization that no society has ever been so standardized as
[ours], and that the stream of human, social, and historical temporality
has never flowed quite so homogeneously' (1994: 17). This is a society from
which, Jameson posits, 'the residual, in the forms of habits and practices of
older modes of production, has been tendentially eliminated' (1994: 13).
This is a society for which demolition of 'outmoded mentalities' aims 'to
prepare a purely *fungible* present in which space and psyches alike can be
processed and remade at will, with a "flexibility" with which the creativ-
ity of the ideologues busy coining glowing new adjectives to describe the
potentialities of "post-Fordism" can scarcely keep up' (1994: 14). And if
they can't keep up on that front, then obsolete and outmoded – not to
mention old, backwards, behind-the-times, and out-of-date – supply less-
than-glowing adjectives that rationalise the effort to level people, places,
and things in the name of a fungible and flexible present fully ceded to
capitalism in a way no other time ever has been.

These adjectives also spring to mind when reading Andreas Huyssen's
account of obsolescence in *Present Pasts*. Focused less on residual modes
of production, Huyssen discusses instead consumer culture's 'fast-paced
mechanism of declaring obsolescence' (2003: 3). Although Huyssen tracks
some of the mnemonic possibilities still available to us today in *Present
Pasts*, he nonetheless understands this mechanism as a rhetorical and a

material force of amnesia, a marketing lingo that cajoles us to buy the next good, technology, or medium and, at the same time, to forget the last good, technology, or medium. This mechanism so saturates contemporary life, suggests Huyssen, that obsolescence transforms it into a 'timeless present' (2003: 10) in which even the recent past is, at best, 'museal' (2003: 23). To use Jameson's idiom, contemporary life emerges as a standardised and homogeneous period that puts an end to temporality as such. In Jameson and Huyssen, then, obsolescence is not only a material force of demolition and a rhetorical ploy of consumer culture. It also figures in their arguments as a motif for the late capitalist forces that give rise to an amnesiac rather than a mnemonic sense of historical time.

But we would be moving too quickly were we to think of obsolescence as solely an anti-historical force in a present that wholly eliminates outmoded mentalities, making the residual unreadable in its historicity. The structures of a more distant past may be historically illegible because they have been demolished in some cases; in others, objects that have begun to be extinct, as with certain fashions and technologies, may so closely approximate the next rising forms of stylistic life that there is nothing historical to grasp about their predecessors' extinctions. But many structures and objects nonetheless remain, visible evidence of another time. On their own, of course, they may not do much but sit there, gathering dust as so many artefacts of an age that, even if that 'age' was only five years ago, we have putatively left behind in contemporary life. In contemporary culture, however, they frequently assume a figural form that performs mnemonic work, that invites us both to imagine historical change and to think the tensions between past and present within capitalist modernity.

All that Heaven Allows invests in such thinking. At first glance, however, it seems like pure melodrama, as evidenced by the love plot. The film tells the story of Cary Scott (Jane Wyman), an ageing and beautiful widow who falls in love with Ron Kirby (Rock Hudson), a handsome and younger man who also happens to be the son of her recently deceased gardener. The romance between Cary and Ron causes a scandal in Cary's upper-middle-class community. Cary's love for Ron turns her into Hester Prynne in Eisenhower America. Her friends shun her, as do her children. Her son accuses her of bucking 'tradition' for the selfish and lustful reason

of a 'good-looking set of muscles'. Her daughter weeps that her life will
be ruined because her boyfriend refuses to date a woman with a mother
like Cary. In light of her children's accusations and crises, Cary gives Ron
up for them only to discover they are abandoning her to a life alone, one
in which they are preparing to force her to move from the house which
they claimed to venerate when Cary originally told them she planned to
marry Ron. But in the end, when Ron falls from a cliff and almost dies,
a final reversal occurs: Cary returns to him, bringing the emotional ups
and downs of the film to a close. As this love plot shows, *All that Heaven
Allows* is narrated according to the sentimental conventions of melodra-
matic storytelling (which many critics who have worked on Sirk – from
Charles Affron and Paul Willeman to Laura Mulvey and Lauren Berlant
– insist he ironises and undercuts).

Intertwined with the melodramatic narrative is a story of obsolescence
in which the outmoded constitutes a character in its own right. Take Ron:
if Cary is Hester Prynne in Eisenhower America, then Ron is Henry David
Thoreau in a Consumer's Republic (Cohen 2003).[1] In fact, the film explicitly
alludes to Thoreau's 1851 *Walden* to oppose Ron as a historical outsider to
the consumerist and corporate values of the postwar period, evoking, for
instance, the ad men of Madison Avenue as his late-capitalist doppelgang-
ers. As an arborist who refurbishes and resides in a nineteenth-century mill,
Ron recalls in addition the outmoded figure of the classic craftsman and
independent artisan described by C. Wright Mills. Around the very time
of *All that Heaven Allows'* release in movie theaters, Mills was celebrating
and mourning this figure as he disappeared in post-World War II America,

1 I borrow the phrase 'a Consumer's Republic' from the title of Lizabeth Cohen's study
 of mass consumption in postwar America from the 1950s to the 1970s. Her title refers,
 she writes, to 'an economy, culture, and politics built around the promises of mass
 consumption, both in terms of material life and the more idealistic goals of greater
 freedom, democracy, and equality'; in a Consumer's Republic, '[r]ather than isolated
 ideal types, citizen and consumer were ever-shifting categories that sometimes over-
 lapped, often were in tension, but always reflected the permeability of the political
 and economic spheres' (Cohen 2003: 7, 8). While Cohen, as far as I know, does not
 mention Thoreau (though the film, as we shall see, does), her notion of a Consumer's
 Republic in part captures the world that *All that Heaven Allows* describes.

a victim of 'the pervasive mechanisms of the market [that] have penetrated every feature of life – including art, science and learning – and made them subject to the pecuniary evaluation' (Mills 1963: 377–378). Or take Cary: as a widow, she is a gendered figure for obsolescence. Cynically put, she is a woman whose wifely uses have been exhausted, and whose motherly uses are waning as her children grow up. The film insists upon this quality of gendered obsolescence when characters strikingly compare this middle-class mommy to an Egyptian mummy entombed in her home now that her husband has died. Such a comparison not only stresses that widowhood can mean the death of the wife as much as the husband; it also emphasises the archaic position women occupy in a contemporary mode of production that has ostensibly progressed far beyond ancient life.

The protagonists, then, are obsolete people. In Marshall Berman's words, Cary and Ron belong to 'a category of people that is [...] very large in modern history: people who are in the way – in the way of history, of progress, of development; people who are classified, and disposed of, as obsolete' (1988: 67). What such character choices tell us is that, while *All that Heaven Allows* is undoubtedly melodrama, it is more precisely a melodramatic story of obsolescence. That Cary in particular is caught up in this story is nowhere more evident than in a climactic scene in which her children effectively try to dispose of her as an obsolete person. The scene takes place on Christmas Day, after Cary has forsaken Ron because of her children's appeals to tradition, especially her son Ned's filial objections to his mother moving out of their family home into a new house with Ron. But it turns out that these objections were an alibi to keep his mother in line. After exchanging gifts, Ned announces to his mother that he plans to sell the Scott home because it is too expensive to maintain, what with him going abroad to work for the Dayton Company in the Middle East and his sister, Kay, preparing to marry the man who threatened to leave her because of Cary's affair with Ron. Cary's sacrifice of Ron turns out to be, as she puts it, 'pointless'. The melodramatic reversal here leads her to realise that her children are disposing of her. As they move forward, she is left behind. In this Cary is not unlike Berman's prototypes for the obsolete person, the elderly couple Philemon and Baucis in Goethe's 1831 *Faust*. Faust wants to get rid of them because they occupy a small area of

land he wishes to develop in the name of progress and profit (Berman 1988: 66–68), much as Ned wants to sell a house it is unprofitable to maintain solely for his mother while he prepares to advance the cause of late capitalism in the Middle East.

In telling this story of obsolescence, *All that Heaven Allows* makes a larger point about historical change, turning to a contemporary medium of the postwar period to do so. At the end of the Christmas scene, Ned and Kay present a gift to their mother: a television set. This gift, however, is ironic through and through. When a salesman delivers the set on Christmas Day, he tells Cary that it will provide her with 'all the company you want' and 'life's parade at your fingertips'. But in giving this gift to their mother, her children are actually substituting familial immediacy with mass media, real with phantom company (Anders 1957: 360). In fact, the comparison of Cary to an Egyptian mummy resonates at this moment, which closes with a shot of her reflection in the screen of the set; in that reflection she looks phantasmatic, as if she she's been buried alive rather than given access to life's parade. This is a function of how she is framed: reflected by the set, she appears enclosed, even trapped, within a television screen that drably mirrors her back to herself in browns and yellows. And the look on Cary's face, masterfully performed by Wyman, embodies a sense of doom at finding herself confined to a loneliness that the television is ironically meant to combat (if we are to believe her son and the salesman). The television's technoeconomic status in the 1950s only thickens this irony. Cary is being consigned to the dustbin of history with the help of a mass medium that was perhaps *the* technological innovation and novel consumer good of the postwar period. Through its ironies, this scene exemplifies the idea about historical change with which I began this chapter: movement into the future is always coupled with mummification of the past, advancement is always shadowed by obsolescence.

But what does the story of obsolescence in *All that Heaven Allows* have to do with the question of late capitalist amnesia, with whether or not obsolescence atrophies our sense of historical time in contemporary life? The story has a bearing on this question in part because it stresses the night-side of historical change, showing that obsolescence is a process of negative change over time that leaves, in the above at least, a person in its

wake. But that story also contains media, commodities, and structures that have been left behind as the wreckage of that very same process. This obsolete stuff is the raw material for figurations of the outmoded in *All that Heaven Allows*, and those figurations are the stuff out of which a sense of historical time materialises in the film.

I use the term *figuration* intentionally here, drawing on Erich Auerbach's essay on the word *figura* to define my usage. While the film both allegorises the process of obsolescence and represents obsolete objects, neither allegory nor representation captures the meaning of figuration. Following Auerbach, a figuration has a specifically temporal dimension; 'it differs', Auerbach writes, 'from most of the allegorical forms known to us by the historicity of both the sign and what it signifies' (1984: 54). It refers simultaneously to a concrete historical object or person from the past in addition to the promises that object or person embodies in the present (Auerbach 1984: 53) – promises of, at least in the case of *All that Heaven Allows*, an alternative and hopefully better modernity. Figurations of the outmoded thus constellate then and now, with the former becoming a resource – one that has been abandoned as obsolete – that can be fulfilled in the latter. As such, they reveal how obsolescence, at least when it assumes this figural form, possesses mnemonic possibilities in contemporary culture.

Among the most significant figurations of the outmoded in *All that Heaven Allows* is the one that grows out of the scene in which Cary's children give her a television set. It is the visual language, and specifically the idiom of camera movement, surrounding the set that articulates this figuration. After the salesman delivers the television, the camera shows us the set flanked by salesman and son. It then cuts to a shot of Cary gazing bleakly at the gift. After this shot-reverse-shot, the camera cuts back to the set and dollies in on it. As the camera moves towards it, the screen of the television set slowly, ominously engulfs the frame, steadily overtaking the screen of the movie theater. The image is now two media, old and new, all at once.

What this dual image in part reflects, even allegorises, is the historical transition from a cinematic to a televisual culture in the 1950s. Since *All that Heaven Allows* was released in 1955, it comes as no surprise that this transition expresses itself allegorically through the visual language around the television. Starting in the late 1940s, television sales expanded exponentially

in the United States: 8,000 in 1946, 172,000 in 1948, 940,000 in 1949 (Belton 1992: 73). In these years moviegoing was still popular (Belton 1993: 70). 1946, for instance, had been a signal year for Hollywood, with 82 million admissions at movie theatres per week (Kindem 2000: 322). But '[a]ttendance dropped sharply to 60 million per week in 1950 and continued to fall steadily through the decade, reaching 40 million in 1960' (Belton 1992: 70). In the same ten years, television ownership exploded in the US, dramatically increasing from 12 percent of households owning one or more sets in 1950 to 87 percent owning one or more sets in 1960 – a staggering 46.3 million households by the end of the 1950s (US Bureau of Census). According to one film historian, these numbers added up, especially for Hollywood studios, to an 'obvious and imminent danger, that free home entertainment on television would render theater movies obsolescent' (Sklar 1994: 276).

This danger obviously looms large in the Christmas scene, so large that we might see the television screen engulfing the movie screen as an instance of anxious remediation (Bolter/Grusin 1999). It shows how, as Marshall McLuhan put it in 1964, a 'new medium is never an addition to an old one, nor does it leave the old one in peace. It never ceases to oppress the older media until it finds new shapes and positions for them' (1994: 174). Following McLuhan, the dual image of old and new media in *All that Heaven Allows*, a product of Universal Studios, allegorically reflects the threat of obsolescence Hollywood was feeling in the 1950s as it, and arguably the cinematic medium itself, found themselves no longer certain of their place in both the US and the global 'mediascapes' of the postwar period (Sklar 1994: 275–276; Appadurai 1996: 35–40).

But the dual image of old and new media also expresses a technoeco-nomically-charged relation between past and present. The dual image is, in other words, a figuration of the outmoded in which historical change is a function of one medium outmoding another. The transformation of then into now is determined by the temporal relationship between the out-of-date and the state-of-the-art. Put more strongly, the obsolescence of an earlier mass medium of capitalist reproducibility by a later one is the very condition for the representability of historical change in Sirk's film. To return to Foster's question at the outset of this essay, historical change has

become a 'device of fashion' in *All that Heaven Allows*, part of the machine that makes modernity run on technoeconomic cycles of obsolescence and innovation. But it does not follow, as Jameson and Huyssen imply when they figure the outmoded as amnesiac, that the obsolete no longer has any mnemonic or historicist function as a result. By all means, the dual image of television and cinema in Sirk's film shows how our sense of historical time is now bound up with obsolescence as an instrument of the market, especially in the contemporary period that begins to unfold after World War II. But being an instrument of the market does not necessarily mean that obsolescence is therefore a process of forgetting in late capitalist culture, even if it sometimes is in late capitalist life.

To clarify, we need to return for one final time to the dual image of television and cinema. 'The culture industry', write Theodor Adorno and Max Horkheimer in *Dialectic of Enlightenment*, 'endlessly cheats its consumers out of what it endlessly promises' (2002: 111). This is a point the dual image makes historically. For this figuration constellates a relationship between past and present that provides a historical reminder of how capitalist modernity breaks promises. This reminder emerges when, in the Christmas scene, both children and salesman pitch the television as a form of collective experience ('company'), a pitch that the film ironically undermines. But despite the irony, the film does not counter by advertising itself as a version of collective experience that is better than television. Instead, the dual image of old and new media suggests that film itself once made this promise, but that its successor is simply repeating it. For as the television screen overtakes the movie screen, it also comes to resemble it.[2] This conjunction of obsolete and innovative media aims to remind us that

2 This point hinges on the assumption that the film intends a correspondence instead of a contrast in this scene; the former seems probable because of the parallels that the camera work engenders between movie and television screens. But more broadly it is worth acknowledging that cinema can essentially guarantee the company of other spectators, no matter how alienated they may be from one another in the darkness of the movie theatre. It is more difficult for television to make this promise, though in its early days, it often did. As Lynn Spigel has shown, 'television promises to increase social contacts' in advertising for the medium during the 1950s, and in the same

capitalist modernity repeats its promises over and over again through time; though it is stressing a cycle of repetition, this figuration of the outmoded actually implies a break between past and present in which the former promised something – collective experience – that did not come to pass in the latter. Ultimately, then, obsolescence is not only a condition for the representability of historical change in this figuration of the outmoded, but the outmoded is itself the site of a critically mnemonic sense of historical time in that figuration as well.

This sense is more fully developed in two other figurations – a Wedgwood teapot and an old mill – in which it assumes a counterhistorical form. More specifically, these figurations mine the obsolete as a site of unfinished historical business worth completing. Teapot and mill appear early in the film when Cary visits Ron's property outside of town in the countryside. Cary is pleased to discover an old mill on the property, a structure, however, that Ron explains he plans to tear down so that he can expand his business as an arborist. But Cary loves to poke around old buildings, so he takes her on a tour of the old mill, which is in a state of total disrepair. Once inside, Cary is excited to find a large piece of a broken Wedgwood teapot because, as she explains to Ron, she is a lover of the tableware. Her love of old stuff prompts Cary to advise Ron to renovate the mill as a home for himself and his future wife. And as the love plot progresses, he not only refurbishes the structure for him and Cary as a couple; he also painstakingly reassembles the teapot as a gift for her. At the manifest level of melodramatic storyline, teapot and mill provide an object medium for the love plot of *All that Heaven Allows*.

At another level, a more historical one, teapot and mill represent obsolete objects. They are the wreckage of bygone eras, born of the vicissitudes of obsolescence in capitalist modernity; or as Marx might put it, they are born of the commitment to 'constantly revolutionizing the instruments of production, and thereby the relations of production, and with them the whole relations of society' (1988: 58). Not unlike Cary earlier, teapot and

period '[t]elevision producers and executives devised schemes by which to merge public and private worlds into a new electrical neighborhood' (2001: 45, 46).

mill show *All that Heaven Allows* once again figuring historical change as obsolescence as much as progress. But more significantly, the film mobilises these objects as figurations of the outmoded in order to imagine modernity otherwise, to articulate a sense of historical time that runs counter to the present.

This sense emerges out of these figurations to the degree that they refer to an earlier moment in capitalist modernity. Both teapot and mill are material fragments of an outmoded instant in economic time: the end of the eighteenth and the beginning of the nineteenth centuries. This period represents a transitional moment when artisanal culture and industrial capitalism mixed, when craft economies and capitalist markets interpenetrated. The Wedgwood teapot points to one area in which such interpenetration occurred: the pottery industry. This industry emerged during the eighteenth century out of a craft tradition of domestic pottery manufacture in the largely agrarian provinces of England (Baker 1991: 6–9). Josiah Wedgwood is the most famous case of this shift. His neoclassical tableware was a runaway hit and regular novelty in the consumer society born in eighteenth-century England (Baker 1991: 10–35; McKendrick/Brewer/ Plumb 1982: 100–145). Crucial to Wedgwood's success was his reliance in his factories on techniques of mass production that looked forward to the assembly line as both Taylor and Ford would codify it more than a century later (Baker 1991: 22–26). However:

> pottery-making was still largely a hand-craft industry, operated by human power [in the later eighteenth century]. The 'making' shops [...] accommodated hand-operated wheels, the actual throwing wheel being worked by a rope pulley leading to a second, vertical wheel turned by an assistant. The other methods of pot-making, slip-casting and press-moulding were by hand, as were the decorating processes. (Baker 1991: 26)

The Wedgwood teapot in Sirk's film, then, is a figuration of the outmoded in that in the postwar period it looks backwards to an obsolete mode of production in which the industrial machine did not yet dominate the human body, in which capital had not yet overwhelmed craft.

The old mill similarly figures this transitional moment in capitalist modernity. Like the pottery industry, mills of all types innovated in the

late eighteenth and early nineteenth centuries. This period of innovation involved a dynamic interchange of craft and capital. Grain and textile mills in the rural regions of the United States form a case in point. The mill village was developing as a unit of capitalist production in the US countryside during this period, with advanced knowledge about new industrial inventions flowing into the American economy as a result of transatlantic artisans migrating from England (Licht 1995: 22–23). The developing village did not instantaneously displace an older model rooted in agrarian and artisanal culture with strictly capitalist modes of production linked to impersonal and trans-Atlantic routes of exchange. Instead, the early mill village 'perpetuated and intensified the economy's existing characteristics: reliance on family and local labor and embeddedness in networks of local exchange' (Clark 1993: 22–23). Thus the mill in *All that Heaven Allows* evokes not only an obsolete mode of production in which craft and capital were wedded to one another, as in the case of the teapot, but also an earlier modernity in which the familial and the local were intimately bound to labour and exchange.

All that Heaven Allows does not rehearse the histories I have just sketched. Teapot and mill clearly refer to a prior instant in historical time, but the film's relationship to that instant is nostalgically evocative at best. However, it tends to bring that instant back to life through characters that fulfil its potential in the postwar present of the story-world. More specifically, that story-world calls to mind an economy embedded in local and familial forms of labour through the various obsolete people that populate the diegesis. In addition to Cary and Ron, there are Alida and Mick, who have abandoned a life in New York City and a job on Madison Avenue to run a nursery in the country; when during the holidays they sell Christmas trees, Ron works with them, recalling the intimate collectivity and communal locality of an earlier moment of capitalist modernity. There are also Manuel, the 'lobster king', and his wife Rozanne and daughter Marguerite, not to mention Grandpa Adams, a bee-keeper. And once upon a time, in the most direct allusion to that earlier modernity we get, Ron's grandfather processed grain in the now defunct mill. All of these obsolete people run (or ran) cottage industries motored by both the filial and communal networks that characterised the early-capitalist mill village, and the mix of craft and capital that typified the late eighteenth and early nineteenth centuries.

Ron himself embodies that mix. This is suggested by way of the arboreal business he is starting. But it is most explicitly figured through the labour he devotes to reconstructing teapot and mill. We watch Ron work as a carpenter when he remodels the mill as a home for him and Cary, and we learn of the time he spends patiently reassembling the Wedgwood teapot by hand for his beloved. Ron yokes together artisanal activity and an industrial context in a manner nostalgically reminiscent of the late eighteenth- and early nineteenth-century phase of capitalist modernity.

Given this nostalgia in the film, how do the teapot and mill contribute to a sense of historical time as figurations of the outmoded? And in what ways are they counterhistorical figurations, especially vis-à-vis the late capitalist present that is beginning to flower in the postwar period? In the dual image of old and new media we examined earlier, historical change achieves representability through a figuration that visualises a technoeconomically-charged relationship between past (cinema) and present (television) in which the latter is rendering the former obsolete. This figuration aims to remind us that what the past promised has not materialised in the present, revealing through the outmoded that capitalist modernity seems frequently to repeat – and therefore often to break – its promises. In contrast to the dual image, teapot and mill are figurations that seek to redeem those broken promises by mining the obsolete for historical alternatives to the present.

It is in this sense that teapot and mill are counterhistorical. We need only think here of what they represent in the film as gifts for Cary, especially in contrast to the gift Ned and Kay give their mother. Where Cary's children give her an up-to-date consumer good, Ron presents her with the out-of-date stuff of the past. This stuff, the teapot and the mill, figures a life of intimate collectivity – one rooted in, so to speak, 'outmodes' of production from a now obsolete modernity that Mick and Alida, Manuel, Grandpa Adams, and Ron collectively embody as well. This is in stark contrast to the life alone that the television foreshadows. This is a life that the film tacitly associates with what we now call late capitalism when it suggests, as it does in the Christmas scene, that Ned – about to leave the US for a corporate position in the Middle East – is the main proponent of its value in Cary's daily existence. Obsolescence in *All that Heaven Allows* becomes, then, a past resource for alternative ways of organising the present; in Cary's case,

it turns into a resource for a better – or at least a good enough – modernity. And while there may be little in the way of revolution and much in the way of nostalgia in the film's relationship to this resource, figurations of the outmoded from the television to the teapot in *All that Heaven Allows* are ultimately the architectonic material for a sense of historical time both contoured by and challenging to the tempos of contemporary life under capitalist modernity.

All that Heaven Allows is not the only story of obsolescence to contour a sense of historical time in contemporary culture. Were it so, then this chapter's focus on it would be little more than a blurry account of the mnemonic possibilities of the obsolete in our time. Films throughout the 'postmodern' period of contemporary life have moulded a sense of historical time through such stories and the figurations of the outmoded they often contain. Akira Kurosawa's 1963 thriller, *High and Low*, narrates the demise of a wealthy industrialist (Toshiro Mifune) who refuses to embrace profitable business strategies – most notably, planned obsolescence – that his competitive business partners encourage him to. His refusal ends up outmoding him. Nora Ephron's 1998 romantic comedy *You've Got Mail* similarly depicts the obsolescence of an entrepeneur, in this case the female owner of a small bookstore (Meg Ryan), at the hands of a corporate book giant, Fox Books. In fact, *You've Got Mail* tells the story of *All that Heaven Allows*, only in reverse: as in Sirk's film a woman faces obsolescence, but rather than finding a similarly obsolete person to love, she falls for the head of the Fox Books chain (Tom Hanks). And then most recently there is Pixar's *Wall-E* (2008), a film which also tells a love story, but between an obsolete and a cutting-edge robot. Most interesting in *Wall-E*, however, are the credits. In them Pixar declares the end of art history as it digitally animates and digitally outperforms the entire tradition of visual representation ranging from cave paintings to impressionism to video games. The credits are in effect a figuration of the outmoded not unlike the dual image in *All that Heaven Allows*, for they capture the relationship between past and present by dramatising a newer medium overtaking and rendering obsolete not just *an* older, but *all* older visual media.

From Sirk to Ephron, from Kurosawa to Pixar, we progress further and further into the contemporary period, closing in on our own moment,

that moment that Jameson, Huyssen, and Foster all worry has no historical sense left. And while obsolescence does not percolate with the revolutionary energies Benjamin attributed to it in 1929 in these films, they nonetheless track how much contemporary culture circles back to the outmoded to imagine historical change, to narrate and to figure the night-side of progress through people, structures, and things rendered obsolete by a faith in development, innovation, and advancement. As such, these stories and figurations teach us that obsolescence is hardly a detemporalising process that stands for late capitalist amnesia. Instead, it is the outmoded horizon out of which a mnemonic sense of historical time emerges again and again in the culture of contemporary life.

Acknowledgements

This essay is dedicated with love to Dirk Dixon, whose heart, spirit, and soul have indelibly touched my life.

Works Cited

Affron, C. (1991), Performing Performing: Irony and Affect. In: *Imitation of Life*, Fischer, L. (ed.), New Brunswick, NJ, Rutgers University Press: 207–215.

Anders, G. (1957), The Phantom World of TV. In: Rosenberg, B./Manning White, D. (eds), *Mass Culture: The Popular Arts in America*, Glencoe, IL, The Free Press: 358–367.

Appadurai, A. (1996), *Modernity at Large: Cultural Dimensions of Globalization*. London, University of Minnesota Press.

Auerbach, E. (1984), Figura. In: *Scenes from the Drama of European Literature*. Minneapolis, MN, University of Minnesota Press: 11–76.

Baker, D. (1991), *Potworks: The Industrial Architecture of the Staffordshire Potteries.* London, Royal Commission of the Historical Monuments of England.

Belton, J. (1992), *Widescreen Cinema.* Cambridge, MA, Harvard University Press.

Benjamin, W. (1999), Surrealism: The Last Snapshot of the European Intelligentsia. In: Jennings, M.W. et al. (eds), *Selected Writings, Volume 2, 1927–1934.* Cambridge, MA, Harvard University Press, 207–221.

Berlant, L. (1991), National Brands/National Body: Imitation of Life. In: Spillers, H.J. (ed.), *Comparative American Identities: Race, Sex, and Nationality in the Modern Text.* London, Routledge, 110–140.

Berman, M. (1988), *All That Is Solid Melts Into Air: The Experience of Modernity.* New York, Penguin Books.

Bolter, J. David/Grusin, R. (1999), *Remediation: Understanding New Media.* Cambridge, MA, MIT Press.

Buck-Morss, S. (1989), *The Dialectics of Seeing: Walter Benjamin and the Arcades Project.* Cambridge, MA, MIT Press.

Clark, C. (1993), Social Structure and Manufacturing before the Factory: Rural New England, 1750–1830. In: Safley, T.M./Rosenband, L.N. (eds), *The Workplace before the Factory: Artisans and Proletarians, 1500–1800.* Ithaca, NY, Cornell University Press, 11–36.

Cohen, L. (2003), *A Consumer's Republic: The Politics of Mass Consumption in Postwar America.* New York, Knopf.

Foster, H. (2002), The ABCs of Contemporary Design, *OCTOBER* 100: 191–199.

Harvey, D. (1990), *The Condition of Postmodernity: An Enquiry into the Origins of Cultural Change.* Cambridge, MA, Blackwell Publishing.

Horkheimer M./Adorno, T.W. (2002), *Dialectic of Enlightenment: Philosophical Fragments.* Noerr, G.S. (ed.), Jephcott, E. (trans.). Stanford, CA, Stanford University Press.

Huyssen, A. (2003), *Present Pasts: Urban Palimpsests and the Politics of Memory.* Stanford, CA, Stanford University Press.

Jameson, F. (2003), The End of Temporality, *Critical Inquiry* 29/4: 695–718.

—— (1994), *The Seeds of Time.* New York: Columbia University Press.

Kindem, G. (ed.) (2000), *The International Movie Industry.* Carbondale, IL, Southern Illinois University Press.

Licht, W. (1995), *Industrializing America: The Nineteenth Century.* Baltimore, MD, Johns Hopkins University Press.

Marx, K. (1988), *The Communist Manifesto.* Bender, F.L. (ed.). New York: W.W. Norton and Company.

McKendrick, N. et al. (1982), *The Birth of a Consumer Society: The Commercialization of Eighteenth-century England.* London, Europa Publications Limited.

McLuhan, M. (1994), *Understanding Media: The Extensions of Man*. Cambridge, MA, MIT Press.

Mills, C. Wright (1963), *Power, Politics and People: The Collected Essays of C. Wright Mills*. Horowitz I.L. (ed.). New York, Oxford University Press.

Mulvey, L. (1996), *Fetishism and Curiosity*. London, British Film Institute/Bloomington, IN, Indiana University Press.

Sklar, R. (1994), *Movie-Made America: A Cultural History of American Movies*. New York, Vintage Books.

Spigel, L. (2001), *Welcome to the Dreamhouse: Popular Media and Postwar Suburbs*. Durham, NC, Duke University Press.

US Bureau of Census (1963), *US Census of Housing, 1960, Volume 1: States and Small Areas, Part 1: United States Summary*. Washington, DC, US Government Printing Office.

Willeman, P. (1991), Distanciation and Douglas Sirk. In: Fischer, L. (ed.), *Imitation of Life*. New Brunswick, NJ, Rutgers University Press: 268–272.

——(1991), Toward an Analysis of the Sirkian System. In: Fischer, L. (ed.), *Imitation of Life*. New Brunswick, NJ, Rutgers University Press: 273–278.

Films

All that Heaven Allows (2001), Sirk, D. (dir.), Universal Pictures Company, Inc./The Criterion Collection, DVD.

High and Low (1998), Tanaka, T./Kikushima, R. (prods), Kurosawa, K. (dir.), Toho Co., Ltd/The Criterion Collection, DVD.

Wall-E (2008), Stanton, A. (dir.), Walt Disney Pictures/Pixar Animation Studios, DVD.

You've Got Mail (2008), N. Ephron (dir.), Warner Bros. Entertainment, Inc., DVD.

HARVEY O'BRIEN

'Really? Worst film you ever saw. Well, my next one will be better': Edward D. Wood Jr, Tim Burton and the Apotheosis of the Forsaken

The title of this chapter comes from a scene in Tim Burton's *Ed Wood* (1994) where film director Edward D. Wood Jr, played by Johnny Depp, is trying to hustle work with a major studio on the basis of his first feature film, *Glen or Glenda?* (1954). The response of the producer to whom he has just shown the film can be inferred from the dialogue. Wood's retort encapsulates the irrepressible optimism that the real Edward D. Wood Jr apparently genuinely demonstrated throughout his disastrous filmmaking career. 'My next one will be better,' he says, and we cannot but believe that he believes it. Wood's life and work has been comparatively well documented for a filmmaker of his calibre, not just in Burton's fanciful film, but in the book upon which Scott Alexander and Larry Karaszewski's screenplay was based, namely Rudolph Grey's *The Nightmare of Ecstasy* (1992), and in two documentary films, *Ed Wood: Look Back in Angora* (Newsom 1994) and *The Haunted World of Edward D. Wood Jr* (Thompson 1996). These sources attest to the passion, determination and self-belief demonstrated by the real Edward D. Wood Jr, attributes all the more endearing and perhaps surprising when you realise that his films were trash.

In a collection of this nature, one cannot use the word 'trash' very lightly, and I don't. Wood's films are trash on many levels. On the most basic – that of the level of the production of the object – they are badly made: statically filmed, badly lit, poorly acted, narratively and stylistically incoherent (partly due to the frequent incorporation of stock footage), woefully pretentious, painfully derivative, and simply dull. They have achieved cult status because of late night television screenings in the 1970s and the indulgence of cinephiles who rate them among the category of 'so

bad they're good'. In fact, Wood's 1959 science-fiction/horror *Plan 9 From Outer Space* is usually recognised as the worst film ever made, with the result that it is also among the most widely seen.

Wood's films are also trash on another level, in the broader sense of the term marking the objects themselves as part of the cultural residue of the 1950s – trash culture, so to speak. The subjects are lowbrow, the approach unsophisticated, and the results were intended to be relatively disposable – exploitation pictures for the youth market. Wood's novels, mostly written after his film career had ground more or less to a halt, are pure pulp fiction: cheap and multitudinous paperbacks with lurid titles and covers promising sex and violence without pretension to social value, including *Side-Show Siren* (1966), *Devil Girls* (1967), *To Make a Homo* (1971) and *Death of a Transvestite Hooker* (1974).

In all of this, Wood's films lend themselves to analysis in terms of an understanding of the aesthetics of trash. That forty years after Wood's heyday a young Hollywood wunderkind with five successive hit films under his belt would come along to enshrine the man as an exemplar of creative energy, addresses the paradigm at the heart of the study of trash – the notion of what use we make or what value we find in the detritus of cultural production. Tim Burton's *Ed Wood* is a monument to creative individuality at the fringes of accepted norms, a theme Burton has consistently explored as a director since his own feature debut in 1985. That Wood had no skill and no talent is, to Burton, an irrelevance. He was, in Burton's eyes, a legitimate creative energy. The unasked but perhaps implied question here is what value we attach to the creative act, to cultural production, if the product itself is not deemed to have value. In this context, to what extent is Tim Burton's *Ed Wood* a paradigm for Hollywood's vision of its own past?

Paul Watson (1997) has argued that exploitation cinema may, in fact, represent a fundamental alignment between the preoccupations of what, on the surface, would appear to be a kind of para-cinema existing outside the demesne of legitimate cinematic endeavour, and the mainstream itself. He argues that a mode of exploitation has defined production and exhibition practices from the beginning of cinema, which can be located within the sensational entertainment culture of the late nineteenth century (see also Charney/Schwartz 1995). Watson's focus is more historically wide-ranging

however, suggesting that cinema has never outlived that moment of its creation as a technical spectacle that became a success based on an experience of shock and awe and on the economic establishment of a logistical system through which to deliver that experience to an audience. Though exploitation cinema can be located historically within the period during which the notorious Production Code defined the boundaries of what was permissible and tasteful, the mode of production and means of address to the audience established in sensational cinema came to define mainstream industrial practices with the decline of the Studios. As he says:

> The issue, then, becomes the extent to which histories of the cinema are also histories of exploitation, how far it is possible to disintricate the two sets of structures associated with them at particular moments in history. The schema according to which exploitation cinema is distinguished from the institution and history of cinema should be abandoned, and attention turned to the historiographic, aesthetic and economic discursive structures through which all cinema operates. (Watson 1997: 81–82)

By the 1950s, when Wood became active as a filmmaker, the cultural hegemony of old Hollywood was already dissipating. The increasing freedom of actors and producers to pursue projects of their own choosing over those assigned to them by the Studios gradually broke the stranglehold of the centrist production system. One effect of this was to create variant streams of film making with differing production methodologies and aims. The market for film consumption had also begun to fragment at this time, shifting from an assumed homogenous whole representing the middle ground of popular culture into various types of audiences demanding various types of film. This was particularly evident as young people with independent income began to respond to a kind of cinema considered beneath the standards of quality and intellect expected by the preceding generation. In his classic analysis of Hollywood Cinema, Richard Maltby explicitly makes the connection between these types of films and what he identifies more generally as a trend in American economics of the era towards the production of 'cheap, consumable goods that identified teenagers as a subculture' (2003: 168), raising the point that in many ways it was in fact the cheapness and consumability of these goods (including their filmed entertainments) that actually served to define that culture: one that valued

low cost disposable goods over any suggestion of investment or permanence that might be associated with a 'grown-up' lifestyle. It is here that we find the proverbial detritus of American film culture – the exploitation market – and it is here we find the films of Edward D. Wood Jr.

To give some credit to Wood, though he made low-budget films that he hoped would make money by tapping the youth market, he also did seem to have a genuine love of movies. Born in 1924 in Poughkeepsie, New York to a postal employee and a thrift store buyer, he spent a great deal of time in the cinema as a child, according to his mother and childhood friends (see Grey 1992). In this Wood represented a generation born into a world where the very existence of cinema was taken for granted. He first experienced film as a child and grew to love movies so much as a consumer that he wanted to become a producer of the objects of his own fascination. After the usual initial experiences with home movies, Wood moved on to play and television scriptwriting after serving as a Marine during World War II. Wood's self-conscious indulgence in genre (western, sci-fi, horror, crime thriller) was therefore born partly out of sheer familiarity, but it can also be seen as a wilful act of nostalgia and reclamation, an attempt to re-create for himself as an adult the experiences he had as a child: a cinema that comes from cinema, to paraphrase Umberto Eco.[1]

This act of attempted reconstruction of course also corresponds to Frederic Jameson's reading of nostalgia in postmodern cinema, which, as Vera Dika puts it, 'is not so much a re-presentation of a particular historical period as it is a re-creation of its cultural artifacts,' (Dika 2003: 10). As Dika points out in her book *Recycled Culture in Contemporary Art and Film*, many genre films, especially in the later New Hollywood period, revisited popular genres from the past for the purpose of revision, finding in familiar patterns points of disjuncture through which to rupture the sense of ideological continuity in society on the whole. These provide what she labels 'discontinuous movement' (Dika 2003: 56) that distinguishes later genre films from their forebears. Edward D. Wood Jr was neither able nor motivated to engage with discontinuity. Wood's films tend to sincerely and

1 Eco was here referring to *Casablanca* (Curtiz, 1942). See Eco 1985.

uncritically re-present the programme low-budget genre features of twenty or thirty years previous, recycling their stock situations and dialogue with a straight face as if filmmaking or the sensibilities of the audience had not moved on. In this sense, all he could do was re-create artefacts, or even just shells of them, and in so doing he figuratively sifted through the trash of Hollywood's Golden Age in search of materials to work with.

Actor Gregory Walcott, the leading man of *Plan 9 From Outer Space*, had this to say about Wood:

> Ed Wood was a very effusive, charming, lovable chap, but he was also a con artist... To me, Ed Wood was kind of like a junk collector who would walk along the street and pick up things that were discarded, like a bumper that had fallen off or a rusty fender or a transmission that had fallen out of the car – he would get all this junk together and the he would put it on a pile, stick it in a pile, and would not even bother to torch it together with a torch, he would just kind of hang there with spit and a dream and then he would declare – this is my work. (*The Haunted World of Edward D. Wood Jr*)

While this description of Wood's aesthetic or mode of practice perhaps has resonance with trends in postmodern art, or outsider and found art, and might not, in itself suggest a lack of value, interviewed in the same documentary as Walcott, Bela Lugosi Jr was even less kind and more direct when he said: 'Ed Wood was a loser and a user' (*The Haunted World of Edward D. Wood Jr*).

It is easy to understand why Lugosi would say that. In his search for artefacts with which to reconstruct his genre past, Wood found a very precious genuine treasure in befriending the elderly, drug-addled Bela Lugosi Sr. Wood gave Lugosi several of his last film roles in *Glen or Glenda?* (1954), *Bride of the Monster* (1956), and *Plan 9 From Outer Space* (1959), before the production of which Lugosi famously died and was replaced by an amateur performer who draped a black cape over his lower face to disguise the substitution. Lugosi, almost literally sitting on the scrap heap of Hollywood, found himself recycled not just as an icon, but as a used-up shell of himself. Regardless of what camp or nostalgia value may be attached to them in retrospect, or how Burton chose to frame this relationship in his film (which we will examine later), Wood's Lugosi films present a sad

spectacle of an elderly actor grasping for skills in performance that were now beyond his reach from behind a veil of old age and addiction. This was almost literally what was left over of Bela Lugosi – residue: of a creative personality and of a working life.

Lugosi Jr sees Wood's films as a sad denigration of the legacy of his father, and while this is in many ways true, it is also true to say that by this time in his career Lugosi Sr had nothing left and he needed the money. In his film Burton would make much of the personal and professional relationship between Wood and Lugosi, and this is a point to which we will return later. For now though, the important thing is to acknowledge that Wood did indeed use people, and things – whatever he could find – to make his movies, from stock footage to amateur actors to cardboard for coffins and hubcaps for flying saucers, and did assemble these materials into cineastic objects. But this was residual endeavour, inessential to the performance of American culture as defined by the division between mainstream and exploitation cinema (if we are even to accept this as an historical construct, bearing in mind Watson's position) and, even at the time, barely acknowledged. Wood's films were not popular with teenagers in the 1950s (when they were seen at all) and no more tapped the youth subculture than they did impress the mainstream industry. They were trash, and always were thought of as trash. After *Plan 9 From Outer Space* Wood's professional career was a slow, sad spiral into increasing obscurity – writing scripts and novels for a pittance, making films with and without supernatural or fantastical elements that became increasingly pornographic, including some hard core 'instructional' films, until all he had left were wild dreams and phantom projects that never saw realisation.[2] His personal life, meanwhile, was a painful, fatal decline into alcoholism and an unglamorous death at the age of fifty-four.

But in the hands of Tim Burton, Wood achieves apotheosis: in myth, he gains access to the pantheon of the Hollywood Gods that he never did, or could, in life. He does so as a paragon of creative energy – a producer of cultural objects that assume value because of their association with

2 Although one of his scripts was filmed twenty years after his death – *I Woke Up Early the Day I Died* (Iliopulos, 1998).

that energy rather than any inherent value they might have as objects in themselves. In making this happen, Tim Burton does two things: first, he mythologises the fringes of 1950s Hollywood as a legitimate producer of meaningful cultural output, and second, he allegorises his own story as an emergent American auteur, which is highly ironic given that *Ed Wood* was the first of Burton's films not to turn a profit. The key to Burton's strategy in achieving this is not just to emphasise the (apparently genuine) lovable aspects of Wood's character, but to metonymise elements of his life; specifically: his love of Orson Welles, his transvestism, and his friendship with Bela Lugosi.

Let's start with Welles: Wood, apparently, being a movie buff, was a big fan of Welles and did find inspiration in the fact that Welles, like himself, often assumed multiple roles in the production of his films including direction, writing, editing, and acting. In the documentary *The Haunted World of Edward D. Wood Jr*, Wood's early career collaborator and former girlfriend Dolores Fuller describes him as 'the Orson Welles of low-budget films', a phrase also used by then well-known United Press correspondent Aline Mosby reporting from the set of *Glen or Glenda?* in 1954.[3] While this is fair enough as far as it goes, it fails to recognise that the vast majority of Orson Welles's own films were very low-budget and in many ways as cobbled together from disparate elements as Wood's were, only they were a great deal more accomplished.

Burton takes this fanciful descriptive apposition and metonymises it. A key scene occurs near the end of the film when Wood, in production on *Plan 9 From Outer Space*, is frustrated by what he sees as undue interference from his producers, a religious consortium that had hoped to use the profits from a successful exploitation film to fund a series of religious films (this is true). As the scene begins, Wood has tried to make himself comfortable by changing into women's clothes (this is not true: Wood was a transvestite, but according to people who worked on the film he did not dress in drag while directing *Plan 9*).

3 See Grey 1992: 222. Mosby, in fact, was a journalist of some repute, and would later interview Lee Harvey Oswald in 1959.

This scene essentially summarises Burton's film, and is ample demonstration of the ability that he brought to the project in contrast to that which Wood himself had brought to his own. The point of the first part of the scene is the presence of Orson Welles, played by Vincent d'Onofrio although voiced by Maurice LaMarche, best known for his vocal acting in the popular cartoon *Pinky and the Brain* (1995–1998). Welles, here depicted as in preproduction on *Touch of Evil* (Welles, 1958), is both contrasted with and compared to Wood. The dialogue gives us the direct explanation: they speak of the value of having vision and the importance of artistic integrity. 'Visions are worth fighting for,' says Welles, 'Why spend your life making someone else's dreams?' This poignant observation is both comic and ironic given the audience's contextual awareness of the difference between what Wood is doing and what Welles had done, but Burton's film does not allow the dialogue alone to carry the meaning, something that Wood was very much guilty of and which partly accounts for the static nature of most of his films.

The contrast in dress between the two characters, though humorous, encodes their separation. Welles wears a tuxedo (unlikely in that setting), and Wood is in drag (which Welles seems not to notice or care about) – one classy, one trashy. Welles is also seated and Wood standing at first, creating a visual opposition between their points of view as represented by the line of sight of the camera as it cuts between them. Interestingly, though filmed at first from a lower angle, Wood does not dominate the frame. Welles dominates the frame, as he did as an actor in life, whereas Wood seems all-too-overtly framed against the bar surroundings (a narratively insignificant but biographically extremely significant reference to his alcoholism, equally true of Welles, here depicted as drinking also). Wood's wide-eyed fanboy response to Welles's presence gives way to an enthusiasm for his own work, and this, again, presents us with the paradigm that defines Wood in Burton's terms as a creative energy, sharing kinship with Welles as a creator of art. But it also defines him as a postmodern nostalgist, basking in reflected glory encoded in cinematic terms by lighting and editing: Welles, though his own face is lit quite darkly by cinematographer Stefan Czapsky, is the light by which Wood's face (and cineaste's soul) is illuminated. The light on Wood's face is therefore a reflected light, and yet seems to come from within him: the proverbial 'inner glow' generated by his enthusiasm.

Interestingly though, Welles himself is also shown to be in the grip of romantic nostalgia here. He speaks wistfully of *Citizen Kane* (Welles, 1941) as 'the only film where I had complete control,' and this he holds up as the exemplar of creative achievement. Though few would deny that this is fair enough in general terms, in the context of this fictive, symbolic conversation it should be remembered that *Citizen Kane* was actually a box office failure for the most part on its first release. Largely well-reviewed and well-received in American urban centres, the film floundered in the American heartland, and this, together with sustained pressure from newspaper magnate William Randolph Hearst (the focus of satire in Kane), left the film unable to find an audience in 1941. This was precisely what landed Welles in a subsequent career based on compromise. His later troubles on *Touch of Evil*,[4] dramatised in this scene by Burton and his writers, suggest that Welles is here aware of the passing of his own 'golden age', or a time of genuine creative output, in the face of the forces of economic repression – he too now works at the fringes. Again though, this is clearly a thematic interpretation, as *Touch of Evil* was and is widely regarded as one of Welles's best films and marked a brief return to the mainstream centre.[5]

Nevertheless, in this scene from Burton's film, the conversation between Welles and Wood gives Wood renewed conviction to pursue his vision in making *Plan 9 From Outer Space*, and this mythic moment gives way to a montage sequence in which Burton re-creates several of the key moments from *Plan 9 From Outer Space*. The montage is loaded with in-jokes, revealing the behind-the-scenes vignettes that inherently deconstruct the action in front of the camera: but it is not dismissive of the endeavour itself. In fact, Burton draws further attention to its value by showing Wood's con-

4 Actually, this is historically inaccurate. Though Welles here speaks of Universal pressuring him to use Charlton Heston as a Mexican, it was in fact Heston, who was a major star, who insisted on Welles being hired for the film against the wishes of the Studio, who considered Welles too much of a risk.

5 Famously, Welles was unhappy with the release version of the film and penned a fifty eight-page memo suggesting corrections. Whether this was what he would actually have done with the film had he been given final cut or if it was simply a grand, excessive gesture of protest is hard to say. Nonetheless this memo formed the basis of a re-edit of the film distributed in 1998 as a director's cut.

tinued passion and commitment to what everyone around him can see is trash. The humour derived from recognising the famous scenes and the comedy of their creation is firmly rooted in the audience's recognition of the ironic distance between Wood and Orson Welles, who has evidently inspired it, Wood and Burton, who is now giving us Dika's 'discontinuous movement' (Dika 2003: 56) by breaking ideologically with the original context of the scenes, and Wood and the audience, who stand a quarter of a century distant from the moment in time being presented to them. The audience also recognises the aesthetic gap between signifier and signified. Burton and Czapsky bring considerable aesthetic gloss to what is, in the original, utterly flat. Some of the images from the sequence, such as that silhouetting Wood and crew with projected light behind them, are even resonant with *Citizen Kane*. *Plan 9 From Outer Space* has been called the *Citizen Kane* of bad movies, and Burton well knows this.

There is such an evident distance between *Ed Wood* as a film, and the films of Ed Wood themselves that it might be worthwhile at this point to turn to Wood's actual films for a moment before coming back to Burton. Though *Plan 9 From Outer Space* tends to attract the most attention in Wood's oeuvre, and is the lynchpin moment in Burton's film ('This is the one I'll be remembered for,' says Wood, eyes wide and teary in self-induced ecstasy), his most deeply personal film is unquestionably his first feature, *Glen or Glenda?*, where his real-life transvestitism found its most direct cinematic expression.

Glen or Glenda? began as a proposed sensational biography of Christine Jorgensen, a real life ex-US soldier whose actual case of gender reassignment surgery became a piquant public scandal in Eisenhower America.[6] Producer George Weiss, known at the time for a few lurid exploitation pictures on topical subjects, including teenage drug use, test tube babies, and women wrestlers, had intended to make a film based on Jorgensen's case. Weiss had no pretensions about himself as a producer, and was chasing down sensational material to generate sales – a classic example of the 'cheap

6 Jorgensen's story was published as a five-part serial across five issues of *American Weekly* in 1953, which can be accessed online at http://www.christinejorgensen.org (accessed on 9 September 2009).

and consumable' ethos of film-making referred to by Maltby (2003: 68). In a key scene in Burton's film, Weiss, played by actor Mike Starr, responds to Wood's idea that they hire a movie star to appear in the film with the wonderful line: 'You must have me confused with David Selznick. I don't make major motion pictures: I make crap'. This is not a direct quote, but in Aline Mosby's United Press article from the set of the film, he was happy enough to say 'we do exploitation pictures' (Grey 1992: 122) without evident concern.

Wood was hired to direct *Glen or Glenda?* not primarily because of his transvestitism, but mainly on the basis of his experience working on stage and in television. He had a legitimate career at this point as a low-level gopher and jack-of-all-trades, and had directed one short film, a western called *Crossroads of Laredo.*[7] He offered to write, direct, edit and star in the Jorgensen film, which, in purely economic terms, made him a viable proposition for a film that had to be shot quickly and cheaply. Wood was neither the first nor the last director to get a break this way.

In Burton's film Wood reveals his transvestitism to Weiss as proof that he is the right man for the job. Though this is not an accurate depiction of what happened, it is a symbolic representation of the deeper commitment to the project Wood demonstrated when the film hit a major roadblock in development. *Glen or Glenda?* went into production under the title *I Changed My Sex* and was intended to be a docudrama on the Jorgensen case; however a legal dispute with Jorgensen herself, who had not agreed to any deal with Weiss, meant that the film had to be something more generally about transgender issues: enter the personal dimension of the work for Wood, who readily supplied a quasi-autobiographical script about transvestitism.

Wood's transvestitism was certainly not in the closet even then. When he was seventeen, Wood had joined the army, and served as a US Marine from 1942 to 1946. He fought in several major engagements in the Pacific during the World War II and would later tell fellow ex-Marine and fellow

7 Unreleased at the time, this even more avowedly amateurish film than usual was 'restored' for a special screening in 1995 with music by Dolores Fuller and the financial backing of several Wood veterans, all of whom attended the premiere.

low budget filmmaker Joe Robertson that he wore ladies' underwear under his uniform during several battles and had a mortal fear of being wounded in case he would have to explain it to an army doctor (Grey 1992: 20). This particular aspect of his personal life is heavily foregrounded in Burton's film and also in the two feature-length documentaries on his life. It is also chronicled by Grey, who provides several photographic images of Wood in drag, including one of a comfortable, casual Ed wearing an angora sweater over his everyday clothes. If any further proof were needed that trans-vestitism was genuinely part of Edward D. Wood Jr's life, several of his many pulp novels are about transvestites or feature transvestite characters, including *Drag Trade* (1967), *It Takes One to Know One* (1967), *Death of a Transvestite* (1967) and *Killer in Drag* (1965). Not least of all, we have the film *Glen or Glenda?* which, though absolutely indefensible in craft terms, has the merit of clearly being heartfelt.

Wood casts this story of a man who likes to wear women's clothes in terms of a metaphysical battle between forces of good and evil; the fates who tamper with and torment this poor unfortunate character, Glen, played in the film by Wood himself. Bela Lugosi appears in the role of the Creator of the Universe, a shattered-looking old man seated in a chair spouting inelegant, aphoristic nonsense that suggests he is in control of all that unfolds. In the particular segment I wish to discuss here, Glen, who is grappling with transvestitism, tries to have a casually loaded conversation with his fiancée about something like the Jorgensen case, which they are reading about in the paper.

We are first introduced to the Creator of the Universe, who makes his famous 'pull the strings' speech over bizarrely interpolated stock footage of buffalo on the run. This sets up the fact that Glen has a dilemma, seemingly initiated by forces beyond his control. We are then presented with a short scene of Glen ruminating over his female clothes (a single mid-shot with no close-ups or edits), wondering if he should tell his fiancée, Barbara, about his alter-ego. We know this is what he is thinking because the ponderous voice-over tells us so, a typical level of communicative redundancy built into every Wood film.

In dramatic terms, the scene between Glen and Barbara which follows should work, not least of all because of its autobiographical dimension, but Wood photographs his actors (himself and then girlfriend Dolores Fuller)

mainly in a dull side-on two-shot which shows too much of the sparse set, and holds the flat image for far too long (again, there are no edits). The characters speak the clumsy dialogue with awkward emphases and then repeat the few key points – Glen thinks that individuals should be free to make choices which make them happy, Barbara thinks it is sad and tragic that a man can't be a man. An awkward scene change follows, again to the inclusion of stock footage, featuring cars on the LA freeway. This shot, which is seen several times throughout the film, provides far too little visual interest as the voice-over intones generalities about the many lives of many people with many problems that make up this crazy old world: 'The world is a strange place to live in. All those cars. All going someplace. All carrying humans, which are carrying out their lives'.

The mechanistic construction of this sequence is matched by the rudimentary level of craft with which it has been filmed. The stunning lack of visual interest throughout (other than being confused by the stock footage) leaves the audience only with Wood's leaden dialogue and the frankly amateurish performances to carry his message. Where there should be irony, Wood gives us only pathos. Where there should be drama, Wood gives only exposition. Where there should be tension, Wood leaves us laughing.

It is not difficult to see that Edward D. Wood Jr was a very poor filmmaker. What is difficult, and arguably runs the risk of missing the point, is evaluating his oeuvre in purely qualitative terms. If what you value in films is the voice of an artist, or even just a person, trying to express themselves through their art, then we can assign value to the art of Edward D. Wood Jr, even if that art is, in qualitative terms, trash. Nowhere is this more pronounced in effect than in *Glen or Glenda?* which is in so many ways an act of tormented autobiography. Though often spoken of as being ahead of its time, the film is not so much making a plea for difference as calling for that difference to be accepted within the homogenous norm. Glen's transvestitism is actually a source of torment and a locus of anxiety. His difference is a social and personal disequilibrium. The film's resolution has 'Glenda' explained away as a psychological malady resolved by therapy and by finding true love with Barbara. In this, Wood fails to follow through on his own plea for acceptance, making the film an abject failure on an ideological level. This can be seen, of course, in the context of the 1950s, where such potentially transgressive material, even in the hands of an exploitation

producer, was not deployed for the purposes of social critique, but the reassurance of the continuity of a unitary vision of American society.

In *The Cult Film Experience: Beyond All Reason* (1991), Graham identifies such failures as the core of the appeal of bad 1950s movies. She observes that the retro-active viewers' perception of a culture of repression which has now passed, facilitates audiences in establishing their sense of superiority to the material. It allows them to 'love' these films for their failure and to find in the failure of the cinematic imagination a mechanism to examine the social schisms that mainstream culture sought to deny. As she remarks, 'Wood, it seems, is worshipped by cult audiences precisely for his failings and especially for displaying his own and his materials' limitations so very clearly' (1991: 109). *Glen or Glenda?* cannot but be considered such a failure, and its limitations (aesthetic, technical, ideological) are all too clearly evident.

In Burton's film, Wood's transvestitism is a progressive syntagm that is central to the film. Throughout the film it is literally a costume that the character wears to signify his difference, and it is this notion of difference – and the status of outsider – upon which Burton centres his film thematically, as he had *Pee Wee's Big Adventure* (1985), *Beetlejuice* (1988), *Batman* (1989), *Edward Scissorhands* (1990) and *Batman Returns* (1992). Transvestitism also serves to acknowledge the inherent value of Wood's work as an act of creative self-expression, as if this performance of character through overt physical transformation of his appearance metonymises the act of creative transformation that is turning trash into art (or artistic activity). In narrative terms, transvestitism is shown to be central to the failure of his relationship with Dolores Fuller, played by Sarah Jessica Parker, and to the success of that with his eventual life partner Kathy Wood, played by Patricia Arquette. Kathy's casual acceptance of his admission to this fetish as they journey through a fun park (a familiar Burton motif) is represented as an open-minded understanding with which the audience is predispositioned to empathise. In reality, Kathy Wood was also an alcoholic, like Wood, and this fact certainly intertwined their fates and their lifestyle as much as anything else. But for Burton this theme of acceptance and kinship goes beyond biography and enters the realm of the symbolic, where it operates as a critique of the 1950s (and of mainstream culture in general)

as a culture of repression, reversing Wood's own deployment of the trash culture figure of the transvestite and turning torment into triumph.

Burton makes similar use of another of Wood's tragedies – his addiction to alcohol, by again shifting from the realm of the real to that of metaphor. In reality, alcohol destroyed Edward D. Wood Jr, but in Burton's film, his alcoholism is not addressed directly. Burton does devote a great deal of time to Wood's relationship with drug-addicted Bela Lugosi, however, and uses Lugosi's addiction as a mirror of what would later befall Wood. It is also used to provide Wood with a genuinely heroic character. The relationship between these two men, both artists, both residual to mainstream aesthetic endeavour, is central in allowing the aggrandisement of cultural and cinematic recycling, and invests the film with spiritual value.

On screen, this relationship is shown to be centrally concerned with Wood supporting Lugosi through the last stages of his addiction to morphine, which is at least partly historically accurate. Lugosi did suffer from addiction to painkillers including morphine and did, as the film depicts, check himself into rehab, one of the first major Hollywood actors to do so. Burton's film delves deeply into Lugosi's addiction and his sense of loss and failure, and Burton again returns to the theme of recycling and nostalgia in having Lugosi reflect on his faded glory at several points. Though it may seem like a cinematic conceit, the scenes of Lugosi sitting in his home framed by a giant painting of himself as Dracula are actually based on fact, proving that sometimes life provides apt metaphors without much need for invention. Burton's Lugosi is an irascible grump: envious of Boris Karloff, contemptuous of Hollywood, resentful of attempts to water down his Hungarian ethnicity or interfere with his craft as he sees it. But in Ed Wood he finds an uncritical admirer and avid supporter, an initial relationship which deepens as the film progresses and Lugosi's health fails. Wood here becomes an anchor for Lugosi to the glory of his past, but also he represents the reality of a present and the possibility of a future. Wood is recycling Lugosi – perhaps using him – but he is also engaging with his life in fundamental ways, crossing over from the professional to the personal in a most dramatic manner at times, most startlingly in the scene where Lugosi threatens to kill himself and wants to take Wood with him.

Again, some of this is true, but there certainly seems to be an indication that sometimes it was Lugosi who made the phone calls in the middle of the night to Wood's family for someone to come and fetch Wood when he, not Lugosi, was dead drunk. Reading Rudolph Grey's book into the years beyond *Plan 9 From Outer Space* through the nudie films and outright porn is very depressing. It paints a portrait of a damaged individual careering from low-paying writing gig to low-paying writing gig, full of grandiose dreams, selling possessions (including his typewriter) for booze money, fighting with his wife, paranoid about his racially different neighbours, hitting up friends for money at every opportunity – a sad if never broken character who still ran on dreams.

This is worth marking for what I hope is an obvious reason. This real-life Edward D. Wood Jr is Bela Lugosi in Burton's *Ed Wood*. Tim Burton allegorises Wood's own addiction and decline in his portrayal of Lugosi, and the irony here is that there was no Ed Wood to rescue Edward D. Wood Jr in real life. Instead there is Tim Burton, in 1994, sixteen years after Wood's death. Perhaps Burton's most potent act of reconstruction is to retroactively step in to help Edward D. Wood Jr the way he saw him stepping in to help Bela Lugosi – redeeming a faded past with hope of a future through the act of cinema. Tim Burton's *Ed Wood* is a wonderful, vibrant, funny film, a moving and entertaining homage to a man who made truly awful films. Burton's act of apotheosis conveys value on the life and art of Edward D. Wood Jr, and, by inference, on any film director who believes him- or herself to be an artist. And here, again, we find Tim Burton, literal artist (with a background in graphic art), film artist, and, at the time, Hollywood wunderkind, telling us that one person's trash is another person's apotheosis. This is a remarkably defensive stance for Burton to assume in the light of his own reputation at the time following five hit films with strong critical reputations. It is as if Burton projects his anxieties about mainstream filmmaking practice into his reading of the art of Edward D. Wood Jr, unconsciously, or perhaps consciously, anticipating a time at which his own work might be deemed a failure. As it happened, he didn't have long to wait. His very next project was the expensive, critically panned and commercially underperforming *Mars Attacks!* (1996), a film Wood would no doubt have very much enjoyed and which has become a favourite among admirers of trash.

Works Cited

Charney, L./Schwartz, V.R. (eds) (1995), *Cinema and the Invention of Modern Life*. Berkeley/Los Angeles/London, University of California Press.

Dika, V. (2003), *Recycled Culture in Contemporary Art and Film: The Uses of Nostalgia*. Cambridge, Cambridge University Press.

Eco, U. (1985), *Casablanca*: Cult Movies and Intertextual Collage. *SubStance* 47/2: 3–12.

Graham, A. (1991), Journey to the Center of the Fifties: The Cult of Banality. In: Telotte, J.P. (ed.), *The Cult Film Experience: Beyond All Reason*. Austin, Texas, University of Texas Press: 107–121.

Grey, R. (1992), *The Nightmare of Ecstasy: The Life and Art of Edward D. Wood Jr*. Los Angeles, CA, Feral House.

Maltby, R. (2003), *Hollywood Cinema* (second edition). Malden, MA, Blackwell.

Watson, P. (1997), There's No Accounting for Taste: Exploitation Cinema and the Limits of Film Theory. In: Cartmell, D. et al. (eds), *Trash Aesthetics: Popular Culture and its Audience*. London/Chicago, Pluto Press: 66–83.

Wood, E.D. Jr. (1974), *Death of a Transvestite Hooker*. Wilmington, DE, Eros Goldstripe.

—— (1971), *To Make a Homo*. Los Angeles, Little Library Press.

—— (1967), *Death of a Transvestite*. Padlibrary.com, Pad Library.

—— (1967), *Devil Girls*. Padlibrary.com, Pad Library.

—— (1967), *Drag Trade*. Van Nuys, CA, Triumph News.

—— (1967), *It Takes One to Know One*. Padlibrary.com, Pad Library.

—— (1966), *Side-Show Siren*. Sundown Reader, Taos, NM, Cameron-Wolfe.

—— (1965), *Killer in Drag*. Burnaby, BC, Imperial Books.

Films

Bride of the Monster (1956), Wood Jr., E.D. (dir.), Rolling M./Banner Productions.

Casablanca (1942), Curtiz, M. (dir.), Warner Bros.

Citizen Kane (1941), Welles, O. (dir.), RKO.

Ed Wood (1994), Burton, T. (dir.), Touchstone/Buena Vista.

Glen or Glenda? (1954), Wood Jr., E.D. (dir.), Screen Classics.

I Woke Up Early the Day I Died (1998), Iliopulos, A. (dir.), Paramount.

Look Back in Angora (1994), Newsom, T. (dir.), Rhino Home Video.

Pinky and the Brain (1995–98), Amblin Entertainment.

Plan 9 From Outer Space (1959), Wood Jr., E.D. (dir.), ADCA.

The Haunted World of Edward D. Wood Jr (1996), Thompson, B. (dir), Wood-Thompson Pictures.

Touch of Evil (1958), Welles, O. (dir.), Universal Pictures.

Notes on Contributors

CATHERINE BATES is a Lecturer in English Literature. She researches life-writing, radical poetries, fictocriticism and rubbish, within North American and postcolonial contexts. She is currently working on a book about Robert Kroetsch and planning a book-length study on rubbish provisionally entitled *Regarding Discard: Figurations of Rubbish in Contemporary Literature.*

JOEL BURGES teaches Literature at the Massachusetts Institute of Technology, where he is currently a Mellon Postdoctoral Fellow in the Humanities. He is working on two books about late twentieth-century culture, especially literature, film and television since 1945: *The Uses of Obsolescence*, from which the essay in this volume is drawn, and *Fiction after TV*.

KEVIN HETHERINGTON is Professor of Geography at the Open University. He researches on issues of consumption and disposal, museums and materiality. Recent books include *Capitalism's Eye: Cultural Spaces of the Commodity* (Routledge, 2007) and the co-edited *Consuming the Entrepreneurial City* (Routledge, 2008).

NASSER HUSSAIN obtained his doctorate from the University of York in 2008. His many interests include embodiment in literature, contemporary performance poetry, eco-criticism and Conceptual writing. He is currently at work on a book about the iconic value of cross-country travel in American literature.

KATHLEEN JAMES-CHAKRABORTY is Professor of Art History at University College Dublin. She is the author of *Erich Mendelsohn and the Architecture of German Modernism* (Cambridge, 1997), *German Architecture for a Mass Audience* (Routledge, 2000), and *Bauhaus Culture from Weimar to the Cold War* (Minnesota, 2006).

TAHL KAMINER is currently teaching at the Faculty of Architecture, TU Delft, where in 2008 he completed his doctoral research. He received an MSc in Architecture History and Theory at the Bartlett, UCL (2002–3), and is an architect and a founding member of the academic journal *Footprint* and of the Amsterdam-based organisation 66 East.

HARVEY O'BRIEN teaches film studies at University College Dublin. He is co-editor of the journal *Film and Film Culture* and a member of the Board of Directors of the Irish Film Institute. His books include *The Real Ireland* (Manchester, 2004) and *Keeping it Real* (Wallflower, 2004).

WIM PEETERS is a literary scholar, currently working as postdoctoral researcher at the German Department of Leiden University. He is the author of a dissertation on chatter (*Recht auf Geschwätz. Geltung und Darstellung von Rede in der Moderne*). His other publications include work on Robert Walser, the Sacrifice of Abraham and 9/11.

GILLIAN PYE is Lecturer in German at University College Dublin. She studied at the University of Sheffield, England where she completed her PhD thesis on contemporary German-language drama in 1998. Her research and teaching focus on twentieth- and twenty-first-century German and Austrian literature and culture. Recent publications include the monograph *Approaches to Comedy in German Drama* (2002) and articles and book chapters on pop-literature of the nineties, Elfriede Jelinek and music, Marlene Streeruwitz, German architecture and Wolfgang Hilbig.

DOUGLAS SMITH teaches literature, cinema and theory in the French and Francophone Section of the UCD School of Languages and Literatures. He has published a monograph on the French reception of Nietzsche and two translations of Nietzsche, as well as articles on a variety of topics in twentieth-century French studies.

UWE STEINER is Lecturer in Contemporary Literature, Culture and Media at the University of Mannheim. He studied in Düsseldorf, Bochum, Mannheim und Heidelberg. In 1999 he was Visiting Lecturer at the University of Virginia, Charlottesville. He has published and lectured widely

on literature from the Baroque to the present day. His latest work focuses on the role of the thing in literature. Recent publications include the edited volume *Edmund Husserl* (1997) and the monographs *Die Zeit der Schrift. Die Vergänglichkeit der Gleichnisse und die Krisen von Zeit, Schrift und Subjektivität bei Hofmannsthal und Rilke* (1996) and *Verhüllungsgeschichten. Die Dichtung des Schleiers* (2006).

LEE STICKELLS teaches architecture and urban design in the Faculty of Architecture, Design and Planning at the University of Sydney. He is also an editorial committee member of *Architectural Theory Review*. His research activities are linked by an interest in the shifting conceptions of architecture's urban role, meaning and affect.

NICOLE SULLY lectures in Architectural History in the School of Architecture at the University of Queensland, and is a member of the ATCH research group. Her research focuses on architecture and memory. In 2008, with Andrew Leach and Antony Moulis, she co-edited *Shifting Views: Selected Essays on the Architectural History of Australia and New Zealand*.

RANDALL K. VAN SCHEPEN is Associate Professor of Modern and Contemporary Art and Architectural History in the School of Architecture, Art and Historic Preservation at Roger Williams University, Bristol, Rhode Island. His areas of research and publication include modernist theories of art and art criticism, as well as artists ranging from Marcel Duchamp to Gerhard Richter.

SONJA WINDMÜLLER is Lecturer in Cultural Anthropology at the University of Hamburg. She received her PhD in 2002 from Philipps University Marburg, Germany. Her dissertation *Die Kehrseite der Dinge. Müll, Abfall, Wegwerfen als kulturwissenschaftliches Problem* (published 2004) explores rubbish as a cultural phenomenon. Current research interests include material culture and modernity, rubbish, standardisation and classification processes, bodily movement analysis, concepts and practice of rhythm. Recent publications include *Normieren, Standardisieren, Vereinheitlichen* (co-edited with Saskia Frank, 2006) and *Tanz! Rhythmus und Leidenschaft* (co-edited with Kathrin Bonacker, 2007).

Index

1. 'Müllmuseum' in the Cologne waste sorting plant, Germany (1929).

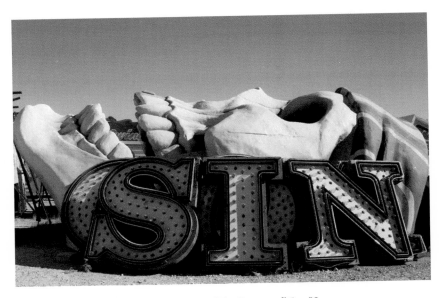

2. Fragments of memory in 'The Boneyard', Las Vegas, 2007.

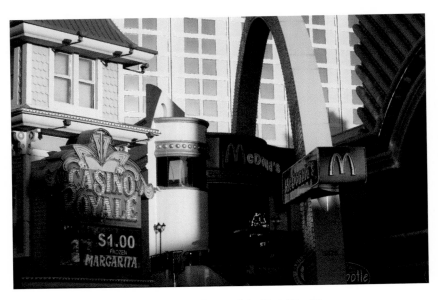

3. The new immersive condition of the 'Strip', Las Vegas, 2007.

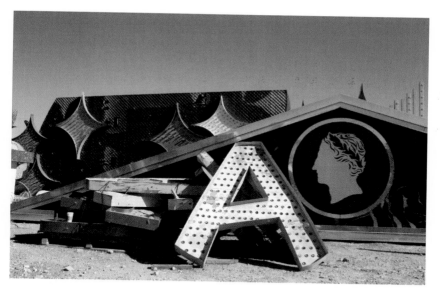

4. Ghosts, 'The Boneyard', Las Vegas, 2007.

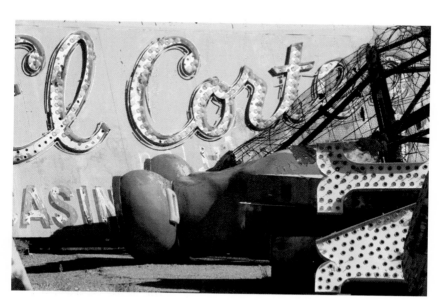

5. Ensembles of dereliction, 'The Boneyard', Las Vegas, 2007.

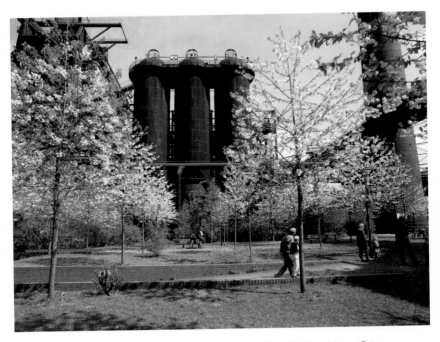

6. Landschaftspark Duisburg Nord, Cowperplatz; Design Latz + Partner.

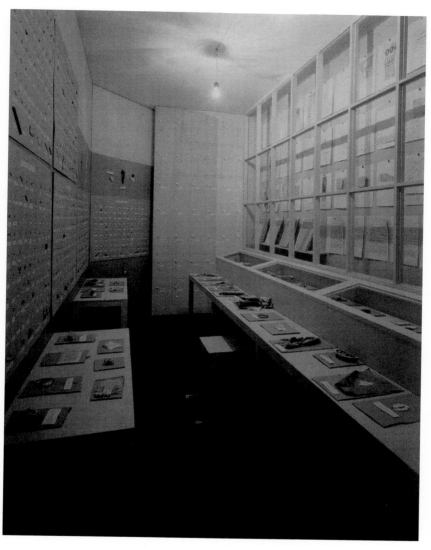

7. Ilya Kabakov, *The Man Who Never Threw Anything Away* (1981–88), Installation for Museet for Samtidskunst, Oslo (1995).

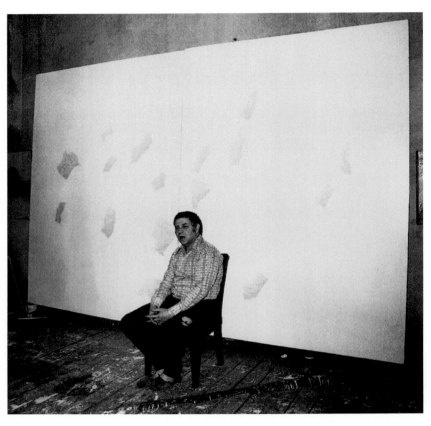

8. Ilya Kabakov in front of the painting *Orchard* (1978).

9. Ilya Kabakov, *Carrying Out the Slop Pail* (1980).

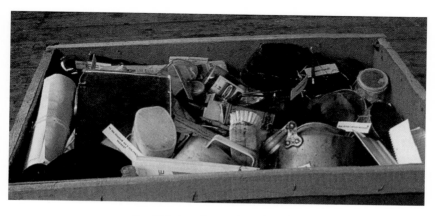

10. Ilya Kabakov, *Box with Garbage* (1982).

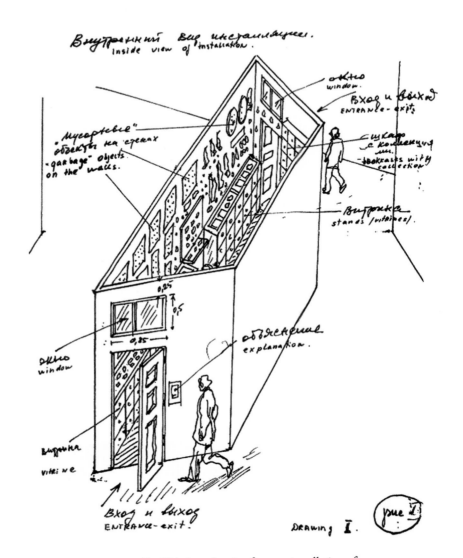

Внутренний вид инсталляции.
Inside view of installation.

окно.
window.

Вход и выход
ENTRANCE - exit;

"Мусорные"
объекты на стенах
"garbage" objects
on the walls.

шкафы
с коллекцией...
bookcases with
collection

Витрина
stands /vitrines/.

0,25
0,5

0,25

объяснение
explanation.

окно
window

витрина
vitrine

Вход и выход
ENTRANCE - exit.

DRAWING I.

рис I

11. Ilya Kabakov, drawing from an installation of
The Man Who Never Threw Anything Away (1994).

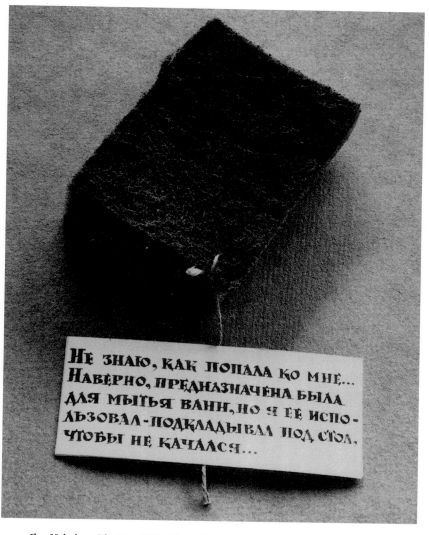

НЕ ЗНАЮ, КАК ПОПАЛА КО МНЕ...
НАВЕРНО, ПРЕДНАЗНАЧЕНА БЫЛА
ДЛЯ МЫТЬЯ ВАНН, НО Я ЕЕ ИСПО-
ЛЬЗОВАЛ-ПОДКЛАДЫВАЛ ПОД СТОЛ,
ЧТОБЫ НЕ КАЧАЛСЯ...

12. Ilya Kabakov, *The Man Who Never Threw Anything Away*, detail of washing pad (1981–88).

Cultural Interactions
Studies in the Relationship between the Arts

Edited by J.B. Bullen

Interdisciplinary activity is now a major feature of academic work in all fields. The traditional borders between the arts have been eroded to reveal new connections and create new links between art forms. Cultural Interactions is intended to provide a forum for this activity. It will publish monographs, edited collections and volumes of primary material on points of crossover such as those between literature and the visual arts or photography and fiction, music and theatre, sculpture and historiography. It will engage with book illustration, the manipulation of typography as an art form, or the 'double work' of poetry and painting and will offer the opportunity to broaden the field into wider and less charted areas. It will deal with modes of representation that cross the physiological boundaries of sight, hearing and touch and examine the placing of these modes within their representative cultures. It will offer an opportunity to publish on the crosscurrents of nationality and the transformations brought about by foreign art forms impinging upon others. The interface between the arts knows no boundaries of time or geography, history or theory.

Vol. 1 Laura Colombino: Ford Madox Ford: Vision, Visuality and Writing
275 pages. 2008. ISBN 978-3-03911-396-5

Vol. 2 Graham Smith: 'Light that Dances in the Mind': Photographs and Memory in the Writings of E. M. Forster and his Contemporaries
257 pages. 2007. ISBN 978-3-03911-117-6

Vol. 3 G.F. Mitrano and Eric Jarosinski (eds): The Hand of the Interpreter: Essays on Meaning after Theory
370 pages. 2009. ISBN 978-3-03911-118-3